Contested Image

Laura M. Holzman

CONTESTED IMAGE

DEFINING PHILADELPHIA FOR THE
TWENTY-FIRST CENTURY

TEMPLE UNIVERSITY PRESS
Philadelphia • Rome • Tokyo

TEMPLE UNIVERSITY PRESS
Philadelphia, Pennsylvania 19122
tupress.temple.edu

Parts of Chapter 4 originally appeared as Laura Holzman, "A Question of Stature: Restoring and Ignoring *Rocky,*" *Public Art Dialogue* 4, no. 2 (2014): 249–265. They are reprinted here with permission by Taylor & Francis.

Library of Congress Cataloging-in-Publication Data

Names: Holzman, Laura M., 1984– author.
Title: Contested image : defining Philadelphia for the twenty-first century
 / Laura M. Holzman.
Description: Philadelphia, Pennsylvania : Temple University Press, 2019. |
 Includes bibliographical references and index. |
Identifiers: LCCN 2018030501 (print) | LCCN 2018034558 (ebook) |
 ISBN 9781439915899 (E-Book) | ISBN 9781439915875 (cloth : alk. paper) |
 ISBN 9781439915882 (pbk. : alk. paper)
Subjects: LCSH: Art and society—Pennsylvania—Philadelphia—History—
 21st century. | Group identity—Pennsylvania—Philadelphia—History—
 21st century. | Philadelphia (Pa.)—Civilization—21st century.
Classification: LCC N72.S6 (ebook) | LCC N72.S6 H655 2019 (print) | DDC
 709.748/110905—dc23
LC record available at https://lccn.loc.gov/2018030501

♾ The paper used in this publication meets the requirements of the American National Standard for Information Sciences—Permanence of Paper for Printed Library Materials, ANSI Z39.48-1992

Printed in the United States of America

9 8 7 6 5 4 3 2 1

For my grandfather Fred,

who knew that I would write a book

long before I ever did

Contents

Acknowledgments

THIS IS A BOOK about how different voices and perspectives came together to create a new image for Philadelphia and new meanings for important artworks in the city around the turn of the twenty-first century. Similarly, the process of bringing this book into being involved contributions from numerous individuals and institutions.

I developed many of the ideas and arguments in *Contested Image* while working on my doctoral dissertation in the Visual Studies Program at the University of California (UC), Irvine. Cécile Whiting, my dissertation advisor, was—and continues to be—a source of endless encouragement and invaluable feedback. Bridget Cooks and Victoria Johnson, my other generous mentors, unwaveringly supported me as I transformed a quirky idea into scholarship.

My research took me to several Philadelphia-area institutions, where staff members helped me access key resources, including some that had not yet been formally processed for study. Barbara Beaucar and Amanda McKnight at the Barnes Foundation, Susie Anderson and Norman Keyes at the Philadelphia Museum of Art, Josue Hurtado and John Pettit at the Special Collections Research Center at Temple University, and Hoang Tran at the Pennsylvania Academy of the Fine Arts deserve special thanks for their assistance.

Beyond my work in the archives, Susan Holzman helped me better understand the legal complexities related to the Barnes Foundation, and David

Gorvits and Xiao Sun helped me track down and decipher legal citations. Owen Dwyer taught me how to make a map. I received additional research assistance from IUPUI Museum Studies students Catherine Harmon and Madison Hincks, who brought order to my images, to the permissions, and to the Bibliography. Mary Cox, Becky Ellis, Eric Hamilton, Laura Kernodle, Makeda Lands, Geneva Sanders, and Lola Thompson provided administrative support for financial matters and travel.

I am fortunate to have received grants and fellowships that enabled me to travel for research, dedicate time to writing, pay for image rights and permissions, and navigate the publication process with advice from designated mentors. At UC Irvine, a Chancellor's Fellowship and a Summer Dissertation Fellowship funded the early phases of this project. At IUPUI, I received support from the Museum Studies Public Scholars Fund, the IUPUI Arts and Humanities Institute, and the Enhanced Mentoring Program with Opportunities for Ways to Excel in Research (EMPOWER) at the IUPUI Office for Women. In conjunction with the EMPOWER grant, Craig McDaniel and Jean Robertson guided me through writing my first book proposal.

I am deeply grateful to the colleagues, mentors, and friends who read and responded to drafts of my work and, in doing so, made my writing and my thinking stronger. For their feedback on some of my earliest ideas, which I sketched out in seminar papers, workshops, and class discussions, I thank Robert Alford, Victor Becerra and the engaged scholars group at UC Irvine, Kim Beil, Anna Leach, Eric Morrill, Amy Powell, R. Radhakrishnan, Fatimah Tobing Rony, Peter Schweigert, and Lara Schweller. For their feedback on later versions of the work, I thank Alan Braddock and the art history reading group at Temple University, Rachel Buurma, Abbey Chambers, Emily Cooper Moore, David Cooper Moore, Meredith Goldsmith, Deanna Kashani, R. Patrick Kinsman, Anna Kryczka, Elizabeth Kryder-Reid, Modupe Labode, Min Kyung Lee, Rebekah Massengill, Randall Miller, Anna Pruitt, Jean Robertson, Eric Song, and Lala Zuo. I am especially appreciative of Wendy Vogt and my anonymous peer reviewers for their extensive comments on multiple portions and versions of the manuscript. Ali Boyd, Caitlin Butler, Holly Cusack-McVeigh, Anne Hunter, Teresa Jaynes, Elee Wood, and Larry Zimmerman were also valued interlocutors during my work on this project, as were the many people who shared their opinions, hopes, and frustrations about Philadelphia and its visual culture with me at professional events, at social gatherings, or while waiting for the train.

I am privileged to have worked in supportive and inspiring academic settings while writing this book. First, as a visiting member of the Art Depart-

ment at Swarthmore College and then as a professor in the Art History and Museum Studies programs at IUPUI, I benefited from conversations, encouragement, and welcome distractions from students and colleagues that made the process of completing this book all the more enjoyable.

Sara Cohen at Temple University Press was a generous and thoughtful editor. I am grateful to her and her colleagues for their roles in making this publication a reality.

Finally, my friends and family deserve boundless credit for supporting me throughout this long, challenging, and rewarding project. They talked through half-formed ideas with me, shared their guest rooms and camaraderie during research trips, and gave me wonderful excuses to take breaks from my work. My parents, Susan and Alan; my sister, Sarah; and members of my extended family asked questions that alternately kept me on my toes and helped me keep everything in perspective. Levi brought extra joy as I prepared the final manuscript for publication. Patrick, my husband, remains my most trusted reader from first to final draft.

Contested Image

Introduction

CALL IT PROMOTIONAL, call it sentimental, call it modern alchemy. This is the story of the complex and at times mystifying processes that transformed three objects in powerful ways around the turn of the twenty-first century. As the city of Philadelphia underwent an important pivot in its identity and reputation, historical art became contemporary, private art became public, and a painting, a sculpture, and an entire art collection—already famous for other reasons—came to speak uniquely for the city where they were displayed. This book is about preexisting items made anew, changed through acts of reception: through the ways that viewers looked at these objects, talked about these objects, and used these objects to define their city around the year 2000.

The objects in question were the subjects of the most intense and wide-reaching public conversations about visual culture in Philadelphia that occurred between approximately 1990 and 2010. These spirited exchanges erupted on call-in radio shows, in newspaper columns, at public hearings, and, eventually, on blogs and in website comments sections. They ostensibly revolved around determining the appropriate location for three key items: the art collection under the stewardship of the Barnes Foundation; Thomas Eakins's 1875 painting, *The Gross Clinic*; and a statue of fictional boxer Rocky Balboa that was made in 1980 as a prop for a Hollywood film.

Although these three pieces were not initially linked in any formal way, they eventually became both symbolically and spatially connected. When

people discussed whether and where to display these items, they participated in crucial dialogues about how to balance the city's celebrated historic past with its more recently acquired negative image in order to shape the Philadelphia of the future. Through these negotiations, Philadelphia and its public image changed. The objects at the center of these conversations changed as well. Physically, they each found long-term homes along the Benjamin Franklin Parkway, a mile-long boulevard that leads from City Hall to the Philadelphia Museum of Art (Figure I.1). Functionally, they took on new roles in representing Philadelphia. They contributed to shifting the city's identity from one rooted in challenges to one rooted in cultural achievements.

In many ways late twentieth-century Philadelphia was a far cry from the popular image of the eighteenth- and nineteenth-century city as an impressive center of artistic, scientific, and political achievement. Its standing as one of the country's foremost cultural centers declined nearly a hundred years ago when New York emerged as a hub of American modernism filled with artists, museums, and galleries dedicated to testing the limits of creative expression. After World War II, Philadelphia encountered political and economic difficulties brought about by deindustrialization, failed public policies, and population shifts. Many white middle-class residents fled to the suburbs in an escape from what they viewed as a collapsing city. Some locals and outsiders came to see Philadelphia as a sleepy town marred by political corruption. Others regarded the city as a gritty urban expanse with crumbling infrastructure, high crime rates, and stark racial and class divisions. While many American cities struggled during the second half of the twentieth century, these images of Philadelphia in decline struck a particularly sharp contrast with the lingering vision of the city's former prominence.[1]

Philadelphians who possessed political, financial, or cultural power had long been invested in promoting a more positive image of their city to reframe and (in some cases) combat its problems. Around the year 2000, efforts to represent the city as a thriving metropolis worthy once again of national acclaim took hold more powerfully than they had in the past. A significant portion of that shift involved positioning Philadelphia as an internationally relevant center of culture, with offerings in the arts that could entice visitors from around the world. Although the challenges of helping Philadelphians be safe, informed, and financially stable persisted, they became less visible in the city's public image.[2] Philadelphia's new reputation, reflected in the way that locals and outsiders talked about the city, revolved instead around a set of ostensibly less daunting challenges: interpreting the city's present and past,

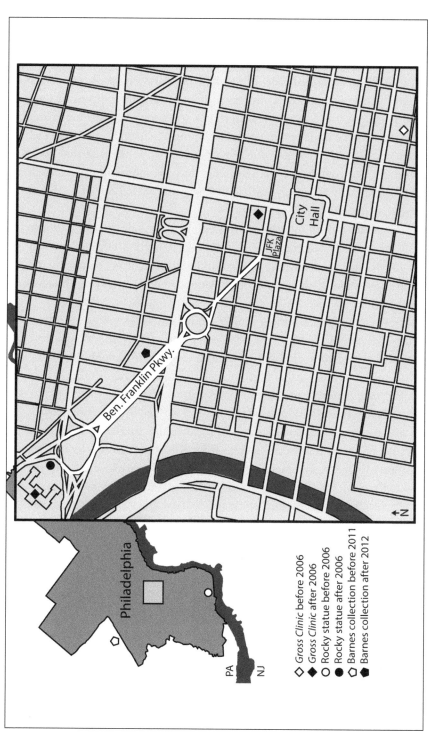

Figure I.1. Map of Philadelphia, featuring the locations of the Barnes collection, *The Gross Clinic*, and the Rocky statue. (Created by Laura Holzman, 2018.)

defining what makes art accessible, and simultaneously honoring Philadelphia's resources in the fine arts and its recognizability in popular culture.

When scholar Richardson Dilworth reflected on Philadelphia's reputation in 2012, he explained that "a big city's reputation is of course always a fiction in that it cannot describe much of what actually happens in such a large place, but it is also very real in that it sets people's expectations and defines their shared understanding of the community in which they live and work, and which others visit—or choose not to visit, as the case may be."[3] Accordingly, Philadelphia's reputation relied on a combination of concrete and symbolic factors. It emerged from efforts that were both official and unofficial, deliberate and happenstance.

Much of the official momentum for reinvigorating Philadelphia's image around the turn of the century grew out of revitalization efforts launched in the 1990s. State and federally funded initiatives sought to create jobs and housing throughout the city. Like other American cities, many of Philadelphia's programs focused on making the Center City District appealing to businesses and tourists.[4] Planning projects and tax incentives aimed to attract investors to Center City, while publicity campaigns promoted Philadelphia's historic district, cultural establishments, and nightlife. Although these projects had mixed results, leaders interpreted the successes as helping return Philadelphia to its former status as a vital urban center.[5]

At the same time, individuals who lived and worked in the region participated in less-formal efforts to determine Philadelphia's reputation. This book focuses primarily on unofficial aspects of Philadelphia's turn-of-the-twenty-first-century image management. The conversations about where to locate the Barnes collection, *The Gross Clinic,* and the Rocky statue intersected with the city's official efforts to boost local spirit and reshape Philadelphia's reputation, but they were also broader, more organic, and more impassioned than those initiatives. Competing voices from across and beyond Philadelphia raised important, if often unspoken, questions that pointed to the fraught relationships between city and suburb, past and present, and high and low. Rather than debating the merits of Philadelphia's reputation shift, participants in these conversations helped establish how culture would be included in the city's new image. In doing so, they rendered three historic items powerful tools for defining Philadelphia's future.

Studying the discourse that surrounded three objects deemed of high local importance offers an opportunity to think more carefully about the ways in which a region's cultural resources affect its reputation. Many books and articles have approached this task by focusing on places such as New

York, Los Angeles, and Chicago.[6] Philadelphia's stories, which reflect the different shape of that city's history, have much to contribute to the existing landscape of scholarship. This book, however, is not just about expanding the scope of understanding to include the unique circumstances of another American city. Beyond the specific ramifications for Philadelphia and the three objects in question, the conversations I examine here illuminate the messy process of public envisioning of place. They chart the ways in which public dialogue shapes public meaning—of cities and of the objects that inform urban identity.

Pictures for the City

Image. In this word, character and reputation fuse with the visual. When Kevin Lynch published *The Image of the City,* his foundational urban design study, in 1960, he was concerned with how people visualized a city based on their experiences in the urban environment. For him, a navigable city was a legible city, and one that held the potential to produce strong symbolic associations for those who encountered it. Others who have taken up the question of city images have focused not on the built environment but on depictions of that environment and the messages they convey about its character. As an abstract sense of place, a city's "image" can be rooted in the appearance of the place, someone's experience of the place, or representations of the place. It can be derived from factors that are material or intangible, observed or imagined.[7]

When images and objects work on behalf of a city, when they actively shape its identity, they become pictures for the city. "Picture" broadly signifies the act of representation, both concretely and abstractly. "Picture" can mean "photograph," or it can refer to an idea, a concept, or an impression. (Get the picture?) When we call someone "the picture of health" or "the picture of evil," a person is a picture. Describing something—a painting, a sculpture, a collection of objects—as a "picture for the city" emphasizes its role in representing the place. Around the year 2000, pictures for the city enabled Philadelphians to reassess the region's history, navigate contemporary urban life, and imagine what their city could become.

When I refer to "pictures for the city," I aim to describe a fluid set of images and objects that define, in this case, Philadelphia. This grouping extends beyond a basic collection of mimetic illustrations of Philadelphia's residents, built environment, and natural resources. It includes as well items that, over time, come to represent and recast that less-tangible element of city spirit. Pictures *for* the city—not just those *of* and *about* it—can make meaningful

statements about Philadelphia regardless of where they were made or what subject they show. Items transition into and out of this category based on the conditions of their use.[8]

That use can take a range of familiar forms. When a sports broadcast shows footage of the skyline in the home team's city before cutting to a commercial break, that skyline is a picture for the city. When a painting by a local artist appears in the city's tourism campaign, that painting is a picture for the city. When the mayor makes a speech about the future of the city while standing in front of a public monument, that monument is a picture for the city. When a survey exhibition takes the pulse of a city's contemporary art scene, the pieces on view—individually and taken together—are pictures for the city. When images and objects provide a visual anchor for people's ideas about an urban place, they become pictures for the city.

Pictures for the city reflect a symbiotic relationship between object and place, where the meanings of each are negotiated simultaneously. For that reason, pictures for the city can easily become tied to reevaluating the balance of negative and positive impressions of a city. Similarly, because of their role in representing place, pictures for the city can become flashpoints for examining or suppressing societal tensions. While the pictures for the city that I examine here were associated with efforts to present a more positive image of Philadelphia, the discourse surrounding them concerned some difficult matters typically omitted from boosterish promotional materials, such as questioning where in the region cultural attractions belong, who shapes cultural memory, and which aspects of the city's visual culture deserve to be recognized in its public image.

The most potent pictures for the city become city icons. They emerge as such when their status becomes so deeply intertwined with their ability to represent a place that the two appear inextricably linked. For art historian Martin Kemp, truly iconic images (like the *Mona Lisa* or a Coca-Cola bottle) have "transgressed the parameters of [their] initial making, function, context, and meaning."[9] While this trait is not required for a city icon, it is a key attribute of each of the pictures for the city in this book. Part of what makes the Barnes collection, *The Gross Clinic,* and the Rocky statue so compelling are the ways in which they became unhinged from, and, in some cases, later rehinged to, their original function.

One of the most recognizable pictures for the city in Philadelphia is Robert Indiana's sculpture *LOVE* (Figure I.2). Based on a design from 1964, it is a work of bold simplicity, with the capital letters L, O, V, and E stacked in a square prism that packs a powerful one-two punch of universality and

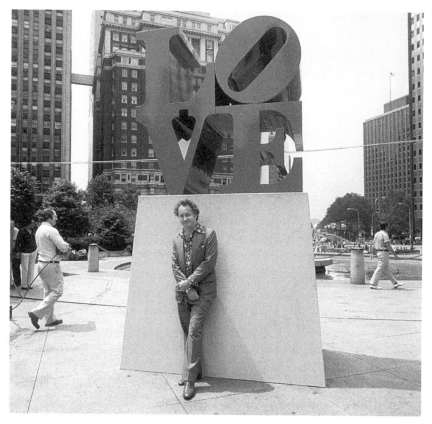

Figure I.2. Robert Indiana with his sculpture *LOVE* in 1976. To the right of the sculpture, the Philadelphia Museum of Art is just visible in the distance, at the end of the Benjamin Franklin Parkway. (Special Collections Research Center, Temple University Libraries, Philadelphia, PA.)

specificity. Many viewers, including scholars and Indiana himself, discuss *LOVE* as a networked project that exists outside of a fixed time and place. Like the amorous feeling, which strikes many people but in different ways, Indiana's design has abundant manifestations—including as a greeting card, a postage stamp, and a series of sculptures.[10] Even though *LOVE* appears in towns and on T-shirts across the globe, it has also acquired deep and distinct associations with Philadelphia, the City of Brotherly Love.

On the occasion of the 1976 bicentennial, Indiana lent one of his *LOVE* sculptures to Philadelphia. It was installed in centrally located John F. Kennedy Plaza near City Hall, where it stayed for two years. In 1978 city representatives decided not to purchase the piece for permanent display, asserting that the estimated $45,000 price was more than the city could afford to spend.

Indiana's gallery took the sculpture back to New York to hold for a potential buyer. But in those two years Philadelphians had grown attached to the artwork. After public outcry over the sculpture's disappearance, Fitz Eugene Dixon Jr. (owner of the 76ers basketball team and chair of the city's Art Commission) purchased the object for $35,000 and donated it to the city. Shortly after the sculpture returned to Philadelphia, Indiana told one reporter, "it is the City of Brotherly Love, [so] Philadelphia should have the biggest and best-est *LOVE* of all."[11] Since then it has appeared in countless publicity images, local publications, and tourist photos. Although *LOVE* was not initially made to represent Philadelphia, and although other versions of the artwork have no affiliation with the city, it became, indisputably, a Philadelphia icon.

Contested Images

In the decades surrounding the turn of the twenty-first century, Philadelphians put other old objects to new uses as pictures for the city that challenged Philadelphia's status as a place past its prime. The three most notable pictures for the city to emerge at the time were the Barnes collection, *The Gross Clinic,* and the Rocky statue. These items became recognizable elements of Philadelphia's visual culture not long after they were first created, but they acquired a new symbolic status around the year 2000, when proposals to install or move them sparked passionate, often oppositional, public discourse. Two of these objects, *The Gross Clinic* and the Rocky statue, were so bound up in debates about how Philadelphia should present itself to its residents and to the world that they became city icons, the most prominent sort of pictures for the city. As such, they joined the ranks of established city icons like *LOVE.*

There are, however, some important ways in which the pictures for the city that I focus on in this book are distinct from objects like *LOVE.* Foremost, the Barnes collection, *The Gross Clinic,* and the Rocky statue all emerged as pictures for the city around a particular historical moment at the turn of the twenty-first century, when Philadelphia's protracted efforts to manage its image were finally starting to take hold. That context is significant. As Philadelphia was positioning itself more successfully as relevant, vibrant, and welcoming to new residents and visitors, these three historical objects, more than any others, became about Philadelphia and, like the city itself, addressed expanded publics and became newly relevant to contemporary life.[12]

In addition to their shared historical context, the pictures for the city at the center of this book are also linked by the substantial role that public

dialogue played in shaping their new status. While impassioned public exchanges contributed to retaining *LOVE* as a picture for the city, the public discourse concerning the Barnes collection, *The Gross Clinic,* and the Rocky statue was the driving factor in their change of status. For these three cases public dialogue was less a result or an indicator than it was the mechanism of transformation. Dialogue rendered each item a picture for the city and generated its early twenty-first-century public significance.

The public discussions surrounding the Barnes collection, *The Gross Clinic,* and the Rocky statue were the most extensive conversations about visual culture in Philadelphia during the late twentieth and early twenty-first centuries. I make this assertion based on the thousands of press clips, letters, and blog posts that I analyzed while working on this book, but I would be remiss to overlook the impact that my personal experiences have had on bringing me to this understanding, as well. I first learned of each of these cases between 2002 and 2007, when I lived in the Philadelphia area. It was difficult to ignore the frequent stories on the radio or the conversations that I overheard on the train that pertained to these emergent pictures for the city. After I began to study this topic formally, I found that when I mentioned my interest in the Rocky statue or the sale of *The Gross Clinic,* people would immediately ask if I had also considered writing about the Barnes collection. Through media outlets like newspapers, radio programs, and websites as well as through the more casual avenue of word of mouth, discourse about these Philadelphia objects spread far beyond the city. Whether I was in California, Vermont, Texas, or Indiana, people I spoke with often identified one or more of these major episodes before I even had the chance to say that they were the specific focus of my work. My informal exchanges reinforced my treatment of these pictures for the city as a three-piece set.

Contested Image is structured around three case studies, each dedicated to the story of a different picture for the city. Chapter 1 provides historical context for the three cases by surveying Philadelphia's changing status and sense of civic pride over the course of the city's history. The chapters that follow offer a focused analysis of the Barnes collection, *The Gross Clinic,* and the Rocky statue, respectively. Some aspects of each case overlap with strands from the others. Timelines intertwine. Major figures from one chapter make minor appearances elsewhere. The Philadelphia Museum of Art is tied to each object, sometimes as a benefactor and sometimes as a rival. The city's growing tourism industry, which increased by a third during the period covered in this book, is a common thread throughout each chapter.[13] I reflect on additional—at times uncanny—intersections among these pictures

for the city in the Conclusion. Taken together, the Barnes collection, *The Gross Clinic,* and the Rocky statue illuminate a constellation of matters that converged to form Philadelphia's emergent reputation as an internationally relevant center of culture. Individually, each object brings a different moment from Philadelphia's past into the process of constructing Philadelphia's twenty-first-century future. Each case also presents a different inflection of how a picture for the city can operate.

The Barnes collection, as a picture for the city, was a vehicle for charting cultural geography and articulating a sense of place in Philadelphia. When Albert Barnes put his peerless art collection in the protection of a foundation in the 1920s, he stipulated that none of the artwork in his galleries could be moved after his death. Citing the need to increase revenue from admission fees, the Barnes Foundation trustees skirted the restriction in 2002 and took formal action toward transporting the meticulously curated collection from its historic home in Merion, Pennsylvania, to a Center City Philadelphia site that would accommodate more visitors. The proposed move set off a venomous dispute between people who wanted to keep the collection in Merion and those who supported reinstalling the art in Philadelphia proper. Both groups argued that their preferred location would give the collection greater significance. Instead of discussing the legality of the move, as many scholars and critics have done, I turn my attention to the public conversations about cultural resources, local identity, accessibility, and tourism that permeated debates about the ethics of relocation. Although the decision to send the Barnes collection to Philadelphia countered the urban exodus that had characterized the city for decades, it revealed, rather than resolved, anxieties about the cultural identities of the suburbs and the city and the roles that each location should play in shaping Philadelphia's image.

The case of *The Gross Clinic* is a reminder that an object does not become a picture for the city simply because its creator positions it as one. I argue that although Thomas Eakins created *The Gross Clinic* to function, in effect, as a picture for the city, the painting did not truly serve that purpose until the twenty-first century. Philadelphians recognized *The Gross Clinic* as a picture for the city in 2006 after Jefferson Medical College, which had owned the artwork for more than a hundred years, put it up for sale. The school offered Philadelphia institutions forty-five days to purchase the painting for $68 million; otherwise Jefferson would award the masterpiece to an Arkansas-based collector who had already proffered the hefty sum. The Philadelphians and other allies of the arts who rallied to accumulate enough funds to buy the painting justified their effort by claiming *The Gross Clinic* as a keystone of

the city's cultural patrimony: Philadelphia, they explained, was the painting's only legitimate home. In that moment, Philadelphians embraced *The Gross Clinic* and the circumstances surrounding its sale to combat their gritty image, assert their identity as a sophisticated region, and step out from the shadow of nearby New York. Moving beyond the matter of identifying Philadelphia on a local level, here individuals and institutions harnessed high culture to elevate Philadelphia's national status within the broader context of the mid-Atlantic region.[14]

In contrast to *The Gross Clinic,* the Rocky statue's role as a picture for the city reflects the tensions between fine art and popular culture in Philadelphia's identity. Deciphering the case of the Rocky statue involves considering the way Philadelphia has been represented on screen and how that image reflects, responds to, and influences the city's appearance in actuality. The bronze sculpture of fictional boxer Rocky Balboa was initially created as a prop for Sylvester Stallone's 1982 movie, *Rocky III.* After Stallone presented the sculpture as a gift to Philadelphia, local officials, residents, and Stallone himself clashed over whether it belonged on display at the Philadelphia Museum of Art, where individuals flocked daily to reenact Rocky's iconic run up the museum's steps. Critics who identified the statue as a movie prop, not a work of fine art, argued that it would be more appropriately installed at the city's sports complex. For more than twenty years, the statue was shuffled around Philadelphia as the filming and premiere of additional *Rocky* movies periodically reignited controversy. When traditional media outlets presented a reduced version of events that pitted everyday *Rocky* fans against elitist art snobs, the statue became lodged at the intersection of class-related conflict in the city and the city's attempts to navigate its relationship to an imagined cultural heritage.

By 2012, in some way or another, all three of these pictures for the city had been gathered along the Benjamin Franklin Parkway. *The Gross Clinic* had been jointly purchased by two arts organizations, and it would split its exhibition time between a gallery just blocks from City Hall and the art museum at the far end of the Parkway. Nearby, the Rocky statue had been installed at the base of that museum's prominent steps. At the other end of the street, the Barnes Foundation had opened a new facility to display its historic collection.

Positioned on the Parkway, these pictures for the city supported the image of twenty-first-century Philadelphia as a cultural hub. The city's 2012 tourism report, entitled "The Art of Collaboration," echoed that sentiment in its name and on its cover, which featured a full-bleed photo of the Parkway

Figure I.3. Cover of *The Art of Collaboration: Greater Philadelphia Tourism 2012. A Report to the Region.* The 2012 tourism report celebrated Philadelphia's role as a center for art and culture. (Greater Philadelphia Tourism Marketing Corporation, 2012. Image courtesy of Visit Philadelphia.)

from the museum's steps to City Hall (Figure I.3). On the pages inside, the report introduced a new campaign to harness the excitement surrounding the "culturally rich" Parkway and cement Philadelphia's growing status as "a cultural king."[15] Philadelphia's publicists, civic leaders, and philanthropic organizations envisioned transforming the Parkway into a district for cultural

tourism that would provide a geographic counterbalance to the historic Old City district situated to the southeast and anchored by attractions like Independence Hall and the Liberty Bell.[16] Their goal echoed that of the idealistic men who first conceived of the Parkway in the late nineteenth century as a symbol of "New Philadelphia." The diagonal boulevard, lined with cultural and civic buildings in the Beaux-Arts style, was to reflect Philadelphia as a beautiful, modern city in contrast to the rote and rectangular city grid and brick structures that were the legacy of colonial era urban planning and architecture.[17] More than a hundred years later, the presence of the Barnes collection, *The Gross Clinic,* and the Rocky statue along the Parkway would attract visitors to the site and contribute to a vision of Philadelphia that again highlighted the city's contemporary significance, not just its historic value. It is difficult to predict whether—or for how long—these objects will continue to function as pictures for the city after Philadelphia and its publics grow accustomed to associating them with their new, shared location. But *Contested Image* is less about predicting Philadelphia's future than it is about how individuals and organizations attempted to shape that future during a specific historical moment.

Public Dialogue

It is widely recognized that dialogue can be an important tool in making and making sense of art. In recent decades a popular wave of artistic practice has focused less on producing tangible or visual objects and more on using creative work to foster meaningful conversations among people who become participants and co-creators rather than passive onlookers. Numerous scholars have also examined how controversial public art projects in particular have created important openings for individuals to examine and debate the values, concerns, or aspirations that exist in their communities. The conversations that arise when groups of people come together to make, view, or fund art can be just as significant as (if not more significant than) the objects that spark those conversations.[18] Even so, dialogue does not transform objects, ideas, or communities simply because it occurs. It is transformative because of how it occurs, who is involved, and the outcomes of those exchanges.

Public dialogue played a powerful role in generating the trio of pictures for the city examined in this book and the place-based identities to which they corresponded. Dialogue, put simply, is the exchange of ideas. Public dialogue, as I approach it here, features two dimensions of publicness. It is a public sharing of ideas about matters of public interest. It can be tempting to think of the

"public" in public dialogue or public space as including "everybody," but that approach risks overlooking the fact that individuals experience public activities differently and someone is always left out. It is important to remember that the "public sphere," as some call it, is not a monolithic space. Complex power dynamics involving factors such as race, gender, and class shape the way people speak, listen, and behave in public. At times it can be difficult to determine precisely how identity and circumstances affect what happens in public or why someone is excluded.

Throughout this book I refer to the people involved in public dialogues as "publics," "communities," and "Philadelphians." These words offer ways of describing sets of people by identifying factors that they have in common, even if there is no inherent likeness among the individuals in a particular grouping.[19] While these terms can be interchangeable, they also have unique meanings.

Publics are groups of people, some of whom are strangers, who are, in the words of theorist Michael Warner, "organized by nothing other than . . . the discourse that addresses them."[20] Publics emerge in relation to a particular text, such as a printed document, an image, spoken words, or even the social fabric of a city.[21] Environmental factors, relationships, and individuals' traits can further determine how those publics take shape. Thinking about publics in this way recognizes that discourse can create a sense of belonging or not belonging, and that people can belong in different ways. Considering publics in the plural, and defining them as I do, allows for the diverse set of experiences and perspectives that people can have in response to a text, and it underscores the role of the text as a catalyst for determining these groupings. The Barnes collection, *The Gross Clinic,* and the Rocky statue, as well as the discourse that surrounded them, were key texts around which the publics I discuss in this book formed.

Potentially more intimate than a public, a community may be best understood as a group of people who are connected by shared conditions. Communities can comprise people who live in the same neighborhood, work in similar professions, are fans of the same sports team, or hold similar political beliefs. These groupings are neither fixed nor, necessarily, mutually exclusive. People can move into or out of communities as activities, beliefs, or other factors change. People often belong to multiple communities at the same time. A large community like the citywide community of Philadelphians encompasses an assortment of smaller ones, like the Philadelphia Museum of Art staff, or the residents of the gentrifying area of Kensington. It also intersects—but does not completely overlap—with other communities, like the journalists who covered the public controversies for local, national, or

international media outlets. Rather than focusing exclusively on the senti-
ments that individuals expressed in the conversations that I study, I think
about the way voices converged and diverged as they represented different
communities in the city.

"Philadelphians" is the term I use to describe the broad group of indi-
viduals who lived in, worked in, or otherwise identified themselves with the
city. Philadelphia is a large urban center with a diverse population, and I
recognize that not all Philadelphians took the same position in the debates
that I discuss. Thanks to the city's diversity and the wide-reaching nature of
the conversations at the core of this book, the case studies in *Contested Image*
reflect a range of perspectives, including voices from the city's sizeable and
heterogeneous black population, white working-class residents, and advocates
for people living homeless. Even so, people's opinions about the objects under
discussion did not necessarily fall along lines determined by race, gender, or
even class. This may be partly due to the fact that many Philadelphians, par-
ticularly those who have been historically marginalized, were left out of the
discussions altogether. The perspectives that I analyze are limited to those of
people who had access to platforms for sharing their ideas. Some were already
in positions of power, leading major cultural organizations or corresponding
with those leaders. Others maintained their own blogs, commented on web-
sites, displayed signs on their lawns, or spoke with reporters seeking quotes.
The decisions of editors, archivists, and individuals who self-censored further
shaped the content and the extent of the discourse available for study. At
times I question why certain voices were omitted from the ostensibly citywide
conversations, but my exploration of this theme is far from comprehensive. In
each chapter I focus mainly on examining the dominant conversations that
occurred surrounding these emergent pictures for the city because, in the end,
this project is about the city's public image, and the ideas that received the
most attention ultimately had the largest impact on how the city appeared in
the press and in actuality. I would be thrilled if this book launched further
study of the perspectives that were underrepresented in these important public
conversations.

I chart the scope of public discourse by analyzing substantial written
materials, including press coverage, letters, and blog posts. I also examine
visual and verbal elements from sources such as films, promotional materials,
and the treatment of urban space. Press releases and archived correspondence
among cultural leaders demonstrate how those directly responsible for making
decisions about the Barnes collection, *The Gross Clinic,* and the Rocky statue
approached their tasks. Unsolicited letters to newspaper editors or arts admin-

istrators, as well as user-generated website content, indicate how individuals outside of the decision-making process felt about the emergent pictures for the city. Many of the dialogues I consider here occurred just before social media platforms like Facebook and Twitter became popular, but it was not uncommon for people to publish their thoughts outside of formal media outlets by writing blogs and leaving comments on websites. Created by people with specialized knowledge of arts management and the objects in question as well as by those whose expertise lay elsewhere, my sources represent an array of the voices from these heated public conversations. They include offhand remarks and carefully crafted statements. My analyses evaluate the arguments, accuracy, and word choice in these public dialogues. By getting into the weeds, I chart the structure of the forest.

Becoming Public, Becoming Contemporary

Through a combination of impassioned public dialogue and physical relocation, the objects at the core of this book became public, developed new contemporary significance, and became more deeply tied to Philadelphia around the turn of the twenty-first century.

While a private art collection or a painting in a museum might not fit the typical model of what constitutes public art, by the time the Barnes collection, *The Gross Clinic,* and the Rocky statue emerged as pictures for the city they had also become public entities. This process has its roots in changing understandings of what public art is and how it operates. Traditionally, public art has been glossed as art that appears in public places—out on the street, as opposed to inside the home or the museum. In the United States, for example, late nineteenth-century memorials erected in public squares honored individuals who died in the Civil War. During the New Deal, artists installed murals celebrating the local flowering of the American spirit in municipal buildings like post offices and libraries. In the 1960s and 1970s, sculptors working in the language of minimalism and pop art extended the space of the gallery onto the street when they installed large-scale metal sculpture in parks and in plazas. In all of these cases the physical object and its location were among the primary features of the public artwork. More recently, however, artists, scholars, and forward-thinking administrators have pushed for an expanded understanding of public art that places even stronger emphasis on the role that the public plays in making or making sense of the artwork. In contrast to publicness pertaining to the object's location, publicness came to refer to who is involved in creating or interpreting the work.

In describing the objects in this study as public works, I follow the lead of scholars, artists, and administrators who transitioned from defining "public" as a quality of the exhibition environment to "public" as a way of identifying the individuals who are affected by the work. When describing the power of public art, art historian Patricia C. Phillips explains that "public art can convene a constituency to engage in collective exploration—even difficult interrogation—of public ideas, individual requirements, and communitarian values."[22] She later expands this definition to include a more abstract notion—that art is public when "it is a manifestation of art activities and strategies that take the idea of public as the genesis and subject for analysis. It is public because of the kinds of questions it chooses to ask or address."[23] This approach to public art downplays concrete factors like who made it and where it is displayed and emphasizes instead the more conceptual qualities of the work. It suggests to me that artworks can pass into or out of the category of public art as they become more useful or less useful tools for inviting audiences to examine the nature of public issues and publicness. The objects at the center of this study became public art when they catalyzed the large debates that allowed Philadelphians to negotiate how they wanted their city to be known.

Recognizing the Barnes collection, *The Gross Clinic,* and the Rocky statue as historical objects that shaped Philadelphia's identity around the year 2000 requires recognizing them as not only public works but also contemporary public works. Some readers may find it odd that I identify a collection assembled before 1951, a painting made in 1875, and a sculpture from 1980 as contemporary. But as pictures for the city, uniquely relevant to Philadelphia's identity at the turn of the twenty-first century, they are contemporary, both to each other and to the current moment. When introducing his book on the history of studying contemporary art, Richard Meyer reminded readers, "We need to recognize that all historical art was once current and that all contemporary art will soon be historical. We also need to grapple with how the art of the past informs and reconfigures the contemporary moment."[24] That grappling is precisely what this book does. As I analyze the dialogues that transformed the Barnes collection, *The Gross Clinic,* and the Rocky statue into pictures for the city, I chart the processes that harnessed elements of the objects' histories in ways that made those items newly relevant to audiences at the turn of the twenty-first century. Rather than lingering on the moment when these objects were made, I ask how their significance changed over time as I examine the ways Philadelphians injected meaning about place-based identity into these works years after their creation. This

approach underscores how objects and the collections that contain them can function as ever-contemporary, not just as items that teach about the past.[25]

As the Barnes collection, *The Gross Clinic,* and the Rocky statue acquired their new public and contemporary significance, they became more deeply tied to Philadelphia. Put differently, they became site-specific works. As pictures for the city these three objects derived their meaning from being physically located in Philadelphia, and they shaped the meaning of that place in return. Each object came under particular public scrutiny because of tensions about exactly where (or if) it belonged in the city.[26] Heated public exchanges explored how these objects interacted with the precise settings of a neighborhood, a gallery, or a nearby landmark. More abstractly, as each picture for the city became intertwined with the conversations that shaped its new meaning, it became specific to the site of that discourse, as well. Art historian Miwon Kwon has shown that the site of an artwork need not be limited to a geographic location. Site can be an institution, a network of ideas, or a conversation.[27] Echoing her argument that art is embedded in some sites that cannot be charted on a map, I approach the public exchanges that I study here as vital sites for the objects they concerned. The objects in this study function symbiotically with tangible and intangible sites simultaneously. Philadelphians accessed the less concrete sites of historical context, community, and political concerns through physical location. The deep connection between these objects and Philadelphia's identity relies on their achieving a degree of specificity both to their sites in Philadelphia and to the sites of the conversations people had about them in the late twentieth and early twenty-first centuries.

Joining the Discussion

I recognize that in writing about these public conversations in particular and Philadelphia's reputation more generally I am writing about objects, events, and issues that were—and likely still are—deeply meaningful to many people on a personal level. Rather than attempting to speak over these voices, I view this book as a way of joining the discussion. This project started from a place of wanting to better understand—and wanting to help other stake holders better understand—the questions and answers that were circulating about the appropriate locations for the Barnes collection, *The Gross Clinic,* and the Rocky statue. While I do aim to correct the record on some misreported or misremembered facts, my goal is not to have the last word on these important topics. Instead, this book is about simultaneously expanding and

refocusing the conversation. Even though countless individuals followed or participated in the public exchanges about moving the emergent pictures for the city, few stepped back to consider the underlying issues at stake in each dispute. With this project I invite those who contributed to these discussions to question how their rhetoric and lines of argument corresponded to broader issues about Philadelphia's identity.

My desire to speak with rather than for the diverse stakeholders who make up the audience for this book reflects the goals of growing numbers of researchers who frame their work as public scholarship. The richest forms of public scholarship typically involve trusted collaboration between academic researchers and partners outside the university who work together for outcomes that benefit all involved parties.[28] The products of public scholarship make meaningful contributions to academic discourse and to the lives of community partners. This book represents a hybrid practice. Following the model of much traditional scholarship, I have not collaborated directly with specific community partners. But, in the spirit of public scholarship, my research questions emerged from conversations taking place outside of academic circles, and I do my best to honor the perspectives of people outside of academia who contributed to those conversations.

I am particularly invested in the way that academic work, especially in the humanities, can be pertinent to the world outside of the university. It is for this reason, in part, that I have chosen to study big debates that engaged broad publics. This book is not only for scholars and students but also for civic leaders, arts administrators, and people who want to better understand how images and public discourse shape the identity of a place. The chapters that follow examine how images become contested, how meaning changes, and how public dialogue contributes to a city's reputation. By deciphering the wide-reaching conversations surrounding the Barnes collection, *The Gross Clinic,* and the Rocky statue, I demonstrate how three historical objects became potent images for Philadelphia's future.

1

Relevance and Reputation

IMAGE CONSCIOUSNESS is in Philadelphia's bones. Founder William Penn designed the city to be a symbolic place, where the built environment and the actions that transpired there would represent to the world what a community of religious tolerance and "brotherly love" could be.[1] Later generations of Philadelphians inherited a sensitivity to the image that their city projected to its residents and to outsiders. Since at least the nineteenth century, promotional efforts, journalism, creative projects, and other reflections on the city's identity have measured contemporary Philadelphia against its colonial-era counterpart. The city's national and international relevance—whether framed as lost, reclaimed, or enduring—has been a recurrent theme. Philadelphia was an important political, economic, and cultural center as the United States took shape, but many layers of its accomplishments peeled away during the nineteenth and twentieth centuries. As the twenty-first century approached, scholars described Philadelphia as "a city permanently caught between a valuable past and a promising future," noting that it "is by turn jealous, proud and ignorant of what it once was."[2]

Creating Philadelphia's identity, or the identity of any place, is an ongoing process. It is a dance of parsing, embracing, and ignoring aspects of both the past and the ever-changing present. It also involves envisioning the future, imagining how a place could be. While there is a great deal of nuance in the process through which a city's identity forms, the identity that manifests

is necessarily a generalization. It is the result of the stories that gain the most traction among the people who have the power to tell them and be heard.

The groups of vocal Philadelphians who participated in public dialogues about the appropriate locations for the Barnes collection, *The Gross Clinic,* and the Rocky statue contributed to articulating a new, positive identity for their city around the year 2000. Those conversations transformed the three notable objects into pictures for the city—images that played important roles in representing Philadelphia. These processes, which I analyze in detail in the following chapters, were part of a long history of crafting Philadelphia's identity and taking stock of the city's relevance. They also occurred in a contemporary moment marked by other efforts to redefine Philadelphia.

This chapter provides context for interpreting the public envisioning of place that is the focus of this book. I sketch the arcs of Philadelphia's identity from its founding in 1682 through the early twenty-first century. In doing so, I demonstrate how the themes and methods involved in generating new pictures for the city and reinventing Philadelphia around the year 2000 had deep historical roots. What I offer is not a comprehensive survey but rather a selective history that highlights key aspects of politics, culture, medicine, and the economy that affected Philadelphia's prominence. They additionally provide meaningful points of reference for the controversies surrounding the Barnes collection, *The Gross Clinic,* and the Rocky statue. The role of the visual arts in maintaining or degrading Philadelphia's status is an especially dominant thread in this chapter because the city's emergent identity in the early twenty-first century revolved around celebrating cultural accomplishments.[3]

A Model City

Art historian Elizabeth Milroy has written that "Philadelphia was a picture before it was a city."[4] Her words refer to the circumstances under which Philadelphia developed. It was designed—drafted as an image—before it was constructed. Surveyor General Thomas Holme's 1683 *Portraiture of the City of Philadelphia* envisioned the commercial center of Penn's colony as a grid of streets and public squares between the Delaware and Schuylkill Rivers. The goal of the geometric plan was to instill physical and social order in the city while also signaling to current and future settlers that Philadelphia was a community of tolerance and well-being.[5] Colonial Philadelphia was based on an image and imbued with symbolic meaning. In a way, then, the matter of representation was embedded in Philadelphia from its earliest days.

Philadelphia flourished during its first century. It grew to be the largest city in the colonies and one of the largest in the British Empire. With the biggest port on the Eastern Seaboard, it became the financial center of the colonies as well. European writers, even some who had never been to Philadelphia in person, extolled the city's beauty. It was hailed as an exemplary Enlightenment city and as the epitome of the modern city.[6]

Philadelphia was indisputably a place of national and international significance during the colonial era and early republic. Home to the Continental Congress, it was a gathering place for the men who issued the Declaration of Independence in 1776. Building on that legacy, the city served as the capital of the new country between 1790 and 1800. When Philadelphia was the headquarters of the fledgling representative democracy, the government actions that took place there indicated what would transpire for all the citizens of the nation. This positioned Philadelphia as a synecdoche for the rest of the country, the valuable part that could stand in for the whole.[7] When later generations of Philadelphians fretted over their city's reputation, they did so beneath the lingering specter of the city's previous symbolic and functional role as the hub of national representation.

Shifting Status

Those who tell Philadelphia's story as one of early success and later decline point to a series of losses that Philadelphia incurred at the turn of the nineteenth century as key contributors to the city's diminished status. In the course of a year, the state capital moved west to Lancaster and the national capital moved south to Washington, D.C. No longer at the administrative or symbolic center of politics in Pennsylvania or in the union, Philadelphia's inhabitants risked losing their ties to regional and national governance. In 1829, New York surpassed Philadelphia in number of residents. In the 1830s, the national banks moved from Philadelphia to New York. Some cite poor political leadership and regional disputes in Pennsylvania in the 1830s and 1840s as chief factors in Philadelphia's loss of prominence. Historians disagree about whether these episodes cemented Philadelphia's negative self-image in the early nineteenth century, but these events certainly provided later generations of Philadelphians with evidence of the city's early decline.[8]

Of course, the nineteenth century was speckled with highs as well as lows. Eighteenth-century Philadelphia's strong communities of free and enslaved black people positioned nineteenth-century Philadelphia as the center of social, religious, and political activity for free African Americans. The

city attracted migrants from other parts of the country and served as a base
for political engagement in national issues such as abolitionism.[9] A boom
in industry facilitated Philadelphia's emergence as a vital "second city," one
that was internationally significant although not recognized as a chief global
power. Even as the city reluctantly ceded its top population status to New
York, the number of residents grew, and Philadelphia celebrated its continu-
ing importance in several fields, including education, medicine, and art.[10]

Art and Medicine

Eighteenth-century Philadelphia was a cultural hub, and this role continued
into the nineteenth century. The Pennsylvania Academy of the Fine Arts
(PAFA), located in Philadelphia and founded in 1805, was for decades a lead-
ing center of artist training in the United States. As such, it attracted promis-
ing artists to the city.[11] Philadelphia's community of artists, coupled with the
city's historic role in American politics, earned it the nickname, "the Athens
of America." As noted architect Benjamin Henry Latrobe explained in an
1811 address to the city's top art instructors and students, the Athenians were
known for their perfection of democracy, but they also left a legacy of fine art
that was especially celebrated in the neoclassical work that PAFA fostered and
exhibited. Latrobe's overarching goal was to challenge current skepticism of
government-supported art by demonstrating that art was a vital component
of democratic society. But his speech also implied that if Philadelphia could
retain its role as a bastion of academic art, it could, perhaps, preserve some
of its political significance as well. Language like this helped tie the arts to
Philadelphia's reputation.[12]

Art practice and art education in Philadelphia remained strong through
the nineteenth century. Despite financial challenges in the 1830s and unrest
caused by the Civil War during the 1860s, PAFA flourished as a unique-
ly American variation on the academies that had trained artists in Europe
since the 1600s. Nationally and internationally prominent painters including
Thomas Eakins, Mary Cassatt, Cecilia Beaux, and Henry Ossawa Tanner
studied at PAFA during the mid-nineteenth century. The academy was pres-
tigious, but Philadelphia's elite did not celebrate creative success as much as
they honored work in other fields, like medicine.[13]

Just as Philadelphia was a center of cultural activity in the eighteenth
century, so too was it a hub for scientific inquiry and medical practice. Ben-
jamin Franklin and Thomas Bond founded the first hospital in the colonies
in Philadelphia in 1751. In 1765, the College of Philadelphia, which would

change its name to the University of Pennsylvania in 1779, became home to the first medical school in the colonies. Benjamin Rush, a preeminent doctor and civic leader during the colonial period and early republic, aggressively treated patients during the yellow fever epidemics of the late eighteenth and early nineteenth centuries and took early interest in the study and treatment of mental illness. Continuing into the nineteenth century, Philadelphia was the most highly regarded center of medicine in the United States. Prominent surgeons, anesthesiologists, and anatomists like Samuel Gross, Hayes Agnew, and Joseph Leidy practiced and taught at Philadelphia institutions. By the end of the Civil War, important advancements in medicine were emerging out of other American cities, including Charleston, Boston, New Haven, and New York, but, as scholar Sarah Gordon has observed, "men of science remained a respected force in society and a keystone of the city's identity and civic pride."[14]

In many cases, scientific pursuits were intertwined with activity in the creative sector. For example, Charles Willson Peale, a founder of PAFA, began his career as a painter but was also deeply concerned with the maintenance of the body and mind. His own museum was dedicated to natural history, not fine art (although he did exhibit paintings), and he notably named his children after famous artists and scientists.[15]

Thomas Eakins traversed similar boundaries in the mid-to-late nineteenth century. A painter by trade, he embraced photography as a tool for documenting and analyzing the body.[16] He observed anatomy lessons and surgical demonstrations at Jefferson Medical College to improve his ability to render figures in his artwork. Eakins additionally produced several portraits of prominent Philadelphians who had ties to the fields of science and medicine. His portrait of Samuel Gross, the subject of Chapter 3, falls into this category. Eakins submitted the painting for display at the Centennial Exhibition, the 1876 world's fair, which Philadelphia hosted. Many who organized and contributed to the event (including Eakins) viewed it as an important opportunity to showcase Philadelphia's accomplishments in medicine, art, industry, and more, as people from across the globe gathered to mark the United States' first hundred years. The fair celebrated a century of American achievements, and by highlighting Philadelphia's successes on this milestone anniversary, the Centennial Exhibition had the potential to remind visitors of Philadelphia's many contributions to helping the nation develop and thrive.[17]

Philadelphia's cultural status began to decline in the early twentieth century when New York earned attention as the center of American modernism. Artists such as William Glackens and John Sloan, who began their training

in Philadelphia, relocated to New York in search of an environment that could better support their interest in bustling city life.[18] European artists who worked in New York after World War I similarly celebrated the dynamic commercial culture that they found there. Together with American-born artists who were also invested in exploring a sense of place through their work, they formed the loosely defined New York avant-garde, which has been characterized foremost by an overarching interest in defining "Americanness." With their project of capturing a national spirit, and their geographic ties to New York City, these artists effectively made New York, not Philadelphia, synonymous with American culture. Philadelphia's art scene, funded by a conservative elite and structured around a traditional art academy, was too grounded in the past to receive the attention that the modernists in Manhattan garnered.[19]

This was the context in which Albert Barnes built his unparalleled art collection, the subject of Chapter 2. Like Charles Willson Peale and Thomas Eakins, Barnes's interests combined art and science. Before opening a school for art appreciation, he trained in medicine and worked in the pharmaceutical industry. One of his early art acquisitions, purchased from PAFA in 1914, was a study Eakins made for his famous medical portrait, *The Agnew Clinic* (1889).[20] Between 1912 and 1951, Barnes used modern art and modernist, nearly scientific, approaches to art analysis as a tool for educating area residents, including artists and the workers he employed at his factory. He was often frustrated by Philadelphia's cultural climate, and in 1950 he lamented that "the local corrupt political machine . . . [had] kept Philadelphia in the educational and cultural cellar for fifty years."[21] During the remainder of the twentieth century, modern art advocates occasionally surfaced in Philadelphia, but their efforts did not win back the cultural status that the city had lost.[22]

In contrast to Philadelphia's receding prominence in the visual arts, the city's music industry did gain national recognition in moments throughout the twentieth century. In the early decades, the Philadelphia Orchestra earned international acclaim under the direction of Leopold Stokowski. He cultivated what came to be known as the "Philadelphia Sound," characterized by a richness that emerged from a more relaxed performance style. Through recordings and international concerts, the Philadelphia Orchestra built a reputation as one of the best in the world. Around mid-century, Philadelphia set national trends in popular music as the home of *American Bandstand* for the first five years of the television show's broadcast. In the 1970s, the city was recognized for the unique variety of soul music known as "The Sound of Philadelphia,"

which was recorded and distributed by Philadelphia International Records. "TSOP," a song named for the music style, was the theme for the television show *Soul Train*, further linking Philadelphia's music to the national scene. These episodes, while significant, were nonetheless limited in their effect on the city's overarching reputation.[23]

Managing Philadelphia's Image

In the early decades of the twentieth century, Philadelphia's identity was decidedly multivalent. While the city could no longer lay claim to the cultural status it once possessed, it remained a powerful industrial center. Philadelphia clung to its role as the "Workshop of the World," a reminder that the city's manufactories and the workforce that fueled them produced goods vital to national and international markets. Meanwhile, the Republican political machine, backed by corrupt businessmen, dominated local government. Journalist Lincoln Steffens, reflecting on this situation, famously labeled Philadelphia as "Corrupt and Contented." He reported that people in other American cities considered Philadelphia "the worst-governed city in the country."[24] Throughout the twentieth century, Philadelphians seized milestone anniversaries as opportunities to challenge the negative aspects of their city's reputation.

As the sesquicentennial anniversary of the Declaration of Independence approached, some local businessmen and politicians sought to reinvigorate the city's reputation by organizing a world's fair. Remembering the successes of the Centennial Exhibition, leaders conceived of the 1926 Sesquicentennial International Exposition (the Sesqui, in local parlance), an event they hoped would advertise Philadelphia, attract tourists, and boost the local economy. The fair itself was a disappointment. Competing visions among the fair's organizers were one of many factors that undermined the project. One group of planners saw the Sesqui mainly as a business venture. Another group approached it foremost as a valuable opportunity to elevate Philadelphia's reputation. William Vare, the infamous political boss whose vision for the festival ultimately dominated, viewed the Sesqui chiefly as a way to bring resources to his district in South Philadelphia. What is important here is not so much the outcome of the Sesqui, but the fact that some Philadelphians were invested in leveraging the fair to promote a more positive image of the city. Historian Thomas Keels has written that the Sesqui was, among other things, "the story of planners and architects who hoped to liberate Philadelphia from its grimy industrial shell and transform it into the City Beautiful."[25]

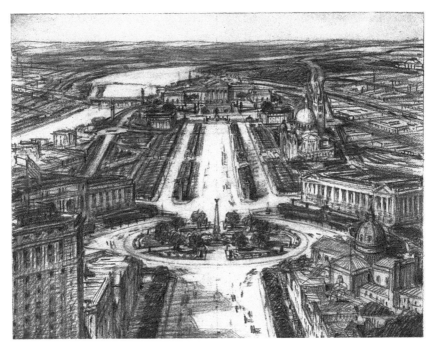

Figure 1.1. Jacques Gréber, Parkway view made from City Hall tower, drawing, 1919. (Photo courtesy of PhillyHistory.org, a project of the Philadelphia Department of Records.)

The City Beautiful movement aimed to improve urban life in the United States by developing landscapes with strong symbolic power, such as open, elegant public spaces anchored by buildings designed in the Beaux-Arts style. One notable legacy of this movement that coincided with planning for the Sesqui was the Fairmount Parkway, built mainly between 1917 and 1928 and renamed the Benjamin Franklin Parkway in 1937. The City Council initially approved plans for a parkway connecting Philadelphia's City Hall with Fairmount Park in 1892. In 1907 lead architects Paul Philippe Cret, Clarence Zantzinger, and Horace Trumbauer presented city leaders with a plan for the Parkway that would replace dense neighborhoods with an open boulevard lined with educational, cultural, and civic institutions. Construction was slow and fraught. Mayor J. Hampton Moore, one of the early Sesqui organizers, infused the project with new energy and funding in the nineteen-teens. He and many of the fair's other planners identified the Parkway as a perfect location for future fairgrounds. Architect Jacques Gréber joined the planning initiative and expanded the earlier design to include traffic circles and new green spaces (Figure 1.1). While the fair was ultimately moved to

a site in South Philadelphia, by 1927 the Parkway was home to prominent institutions, including what would later be known as the Philadelphia Museum of Art.

By mid-century, some city leaders began to look to the 1976 bicentennial as another opportunity to reinvigorate the city (and to make up for the embarrassment of the Sesqui). Writing in 1959 in support of a strong bicentennial celebration, city planner Edmund Bacon published a landmark essay, "Philadelphia in the year 2009," in which he envisioned Philadelphia's potential to be a leader in the twenty-first century and argued that a sensational bicentennial was a key to facilitating that future. Bacon conjectured that "downtown Philadelphia is well on its way to becoming the most interesting and beautiful center city in the country, and, with a little push, will truly become so."[26] Reputation was an important component of this vision for the city. Bacon thought "that everything is affected by the prestige or lack of it, which the city has both in the eyes of the world, and, perhaps more important, in its own eyes."[27] By that time, however, Philadelphia's self-esteem was waning.

Although local boosters persisted in their desire to promote the city's accomplishments, Philadelphia became known more widely for a self-deprecating attitude. The complexities of that contrast were encapsulated in a now-famous billboard that appeared on the Schuylkill Expressway just outside of Philadelphia in January 1970. The sign proclaimed, "Philadelphia isn't as bad as Philadelphians say it is" (Figure 1.2). Advertising executive Elliott Curson drafted the slogan on behalf of a group of local businessmen who called themselves Action Philadelphia. Although many people mistook the billboard for part of a witty tourism campaign, Curson described the project as an effort aimed at area residents and designed to generate city pride.[28] In one clever phrase, the billboard seemed to simultaneously celebrate Philadelphia's negative image and call for its revision.

Attempts to refresh Philadelphia's identity in the 1970s fell flat. The 1976 bicentennial celebrations were even more fraught than the sesquicentennial was. Described alliteratively by one scholar as "Philadelphia's failed Fair,"[29] the bicentennial suffered from planners' difficulty agreeing on the scope of the festivities, the location of the fair site, and whether the city's bicentennial events should be a full-fledged world's fair. Many considered the fair a flop that exacerbated the city's already unfavorable reputation as a place that just could not win. This was the context in which the first *Rocky* film was made and released. As the movie depicted the struggles of its Italian-American working-class protagonist, it also captured a sense of perseverance, if not suc-

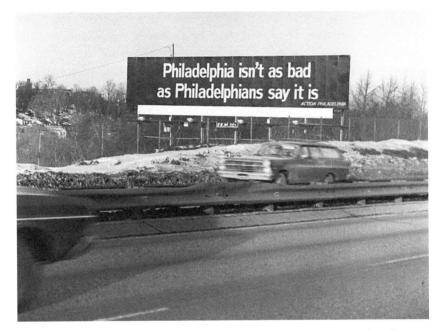

Figure 1.2. Philadelphia Isn't as Bad as Philadelphians Say It Is, billboard on the Schuylkill Expressway, near Exit 37, west of Conshohocken, Pennsylvania, January 15, 1970. (Photo by Tinney for the Philadelphia Evening Bulletin, courtesy of the Special Collections Research Center, Temple University Libraries, Philadelphia, PA.)

cess, that came to be associated with Philadelphia. I discuss the relationship between *Rocky* and Philadelphia in more depth in Chapter 4.

When Philadelphians marked the city's tercentennial in 1982, it may have seemed that few aspects of contemporary urban life were worth celebrating. Like many other American cities, Philadelphia had been losing residents (and their tax dollars) since the 1950s, when the suburban boom drew many white middle-class Philadelphians out of the city. By 1982, gentrification had begun to reinvigorate some urban neighborhoods, but it also created tension between new and old area residents. Philadelphia had long been a demographically diverse city, but its neighborhoods were often composed of members of a single racial or ethnic group. As neighborhood borders shifted, conflicts between those communities increased. Aggressive policing and blatantly racist practices during Frank Rizzo's terms as mayor between 1972 and 1980 only aggravated circumstances. At the same time, the city lacked adequate funds to support public education, update its aging infrastructure, and provide much-needed support services to its struggling residents.[30]

Some optimistic Philadelphians viewed the start of the city's fourth century as an opportunity for improvement. In this spirit, the tercentennial celebrations were presented as the Century IV festival, a name that looked forward rather than focusing on the past. Historian and librarian Edwin Wolf II, writing in anticipation of Century IV, viewed it as "a hopeful celebration." He explained that "by looking at the richness of the city's past and appreciating and exploring the vitality of the present, it will, it is hoped, set Philadelphia on course for a bright future." The exhibitions, events, and messaging of Century IV were geared toward correcting the failures of previous anniversary celebrations like the bicentennial. They were also designed to reset Philadelphia's image after Mayor Rizzo's departure from office. Wolf hoped that Century IV would draw national attention to the city's livability, its recovering economy, and its creativity, although for many the future still looked bleak.[31]

Planning and publicity projects launched in the late 1990s and early 2000s overtly embraced the new century as a decisive moment of change. In 1999, the Office of the City Controller published the report *Philadelphia: A New Urban Direction*. With the goal of making Philadelphia a "preferred place" in the twenty-first century, the document offered a framework that encouraged readers "to look forward, to decide where we are going as a city, and to make people think about how we can act now as we move into the future . . . and how this city can thrive in the next century."[32] The following year saw the implementation of Philadelphia 2000, a wide-reaching, nonpartisan effort designed to show off Philadelphia's best side when it hosted the Republican National Convention that summer. By incorporating the date into the very title of the organization and the project it undertook, Philadelphia 2000 called attention to the year as a significant aspect of (and, perhaps, motivation for) the city's fresh face.[33]

Rebound

Much of this activity built on the strengthened economy of the 1990s and policies put in place under the leadership of charismatic mayor Ed Rendell. Rendell encouraged businesses and developers to invest in Center City, and he won crucial federal funding for Philadelphia. Vice President Al Gore even dubbed Rendell "America's Mayor," an act that, at least symbolically, reestablished Philadelphia as a city with the potential to be a synecdoche for the nation. Life in the region remained far from perfect, however. Violent crime

continued to plague the city, and many working-class Philadelphians found themselves jobless when, in 1995, the U.S. government closed the naval shipyard that had been in operation on the city's waterfront since the Civil War. Buzz Bissinger compellingly described the contrast between Philadelphia's successes and setbacks during this time in his popular book *A Prayer for the City,* an account of Mayor Rendell's first term in office.[34]

One transformation that occurred under Rendell's oversight is especially relevant to this book: In 1996, the City of Philadelphia established the Greater Philadelphia Tourism Marketing Corporation (GPTMC), a nonprofit organization designed to promote Philadelphia and its neighboring counties as an appealing destination for potential visitors. While private groups had worked to generate tourism in Philadelphia since at least the sesquicentennial, GPTMC was notably a government creation, established by a partnership between the city and the state. As Philadelphia began to rely increasingly on revenue from the tourism and hospitality industry, its reputation became a crucial factor for its economic success.

In places including and beyond Philadelphia, urban promoters dealing in image and reputation had long sought to sell their intangible goods in the service of boosting local economies. These powerful but ephemeral products often imposed a single symbolic sense of place on a district, overlooking the variety of people, features, and experiences that shaped it in actuality.[35] Philadelphia's promoters presented the city's eighteenth-century history as a highlight of what it could offer to visitors.[36] On the Fourth of July in 1993, after the city had begun to reinvigorate its brand, but before it formally established the GPTMC, Philadelphia literally welcomed America back to the city when it hosted the first annual multiday Welcome America! Fourth of July celebration.[37] It was this momentum that offered Philadelphians a sense of optimism as the twenty-first century approached.

Activating the Arts

By the end of the twentieth century, arts-related activity was connected to economic growth in the city as well as to the growing feelings of local pride. Between 1990 and 2000, areas of the city where people reported frequently attending plays, concerts, museums, or art classes (for example) experienced significant population increases, but areas without that same degree of cultural activity saw their populations decline.[38] In 2006, when the Greater Philadelphia Cultural Alliance released a report on the economic impact of the nonprofit culture sector, one of the chief underwriters of the project intro-

duced the report by declaring that "anyone who has witnessed Philadelphia's transformation over the past decade understands that arts and culture are at the heart of our rebirth."[39] According to a report issued by the RAND Corporation in 2007, "while there [is] some disagreement among [leaders of Philadelphia's arts and culture community] about whether the vitality of the arts sector was a by-product or a cause of that transformation, there was no disagreement that the city's thriving arts scene had contributed to making the city a more attractive and exciting place to live and visit."[40]

One of the organizations dedicated to improving Philadelphia on a local scale that also garnered national attention was the City of Philadelphia Mural Arts Program, which now operates as Mural Arts Philadelphia. Founded in 1984 as an antigraffiti initiative, it used art to beautify the city, strengthen communities, and call attention to sites that deserved more care. In its first thirty years, Mural Arts facilitated the creation of more than three thousand murals by bringing together neighborhood groups, local muralists, internationally known artists, and funders.[41] In art and urban development circles across the country, Mural Arts became celebrated as a model public art initiative.[42] But it was just one element of Philadelphia's expanding culture sector.

In 2008, the Greater Philadelphia Cultural Alliance counted 904 arts and culture organizations in the city, with nearly 2,000 identified across the five-county Greater Philadelphia area. On the roster were entities such as theaters, history museums, art museums, music schools, dance companies, arboretums, and public broadcasting stations. Like the Welcome America! activities, they, too, connected the city's present and future to the past. Many of the cultural organizations that existed at the turn of the twenty-first century were founded during the first half of the nineteenth century, when Philadelphia was still recognized as the nation's cultural capital.[43] These cultural groups and the activities they sponsored contributed to shifting Philadelphia's identity away from grit and toward cultural achievement.

In the early twenty-first century, Philadelphia's leaders leveraged culture to attract attention from outsiders, including through a number of arts festivals that drew publicity and visitors from beyond the city. These endeavors often blended cultural innovation with ties to the city's history. Some programs explored the city's history directly, such as the Hidden City Festival in 2009 and 2013, which combined art and local history to uncover overlooked aspects of Philadelphia's past. Others, such as Philagrafika 2010, an international festival of contemporary printmaking, celebrated modes of cultural production that had a history of excellence and innovation in the region. Visit Philadelphia, the renamed GPTMC, channeled the momentum surrounding these

and other activities in its 2014 annual report. Entitled "Philadelphia's New Confidence," the report boasted that the city had become "a #1 destination for arts and culture."[44] Conversations about the appropriate locations for the Barnes collection, *The Gross Clinic,* and the Rocky statue simultaneously drew from and contributed to this new image of the city. Through the fraught processes of gathering each of these objects along the Benjamin Franklin Parkway, Philadelphia reasserted its ties to historical episodes and cultural resources that had made the city famous.

Rebranding

The City of Philadelphia officially rebranded itself in November 2009. Its new logo featured an abstracted silhouette of the Liberty Bell accompanied by a tagline that bore echoes of the Declaration of Independence: "City of Philadelphia: Life, Liberty, and You" (Figure 1.3). Project leaders hoped that the brand would provide Philadelphians with a singular, yet versatile, symbol to unite behind, thereby strengthening civic identity and generating a positive image of the city that would attract tourists and new businesses.[45] They asserted that by defining contemporary Philadelphia in terms of its eighteenth-century past, the new logo would emphasize the city's "timeless" character.[46] Critics found that relying on sources so strongly associated with the colonial era and the independence movement made the city instead appear stuck in time, unable to shrug off its eighteenth-century past and celebrate more recent accomplishments.[47]

The new logo did more than just embrace relics from the 1700s to define the twenty-first-century city, however. It also staked Philadelphia's claim to two national icons. The Declaration of Independence was written in Philadelphia, but it was designed to speak on behalf of the colonies as a whole, not Pennsylvania or the city of Philadelphia in particular. In contrast, the Liberty Bell had once chiefly represented the region, but it later acquired a broader significance. The State House Bell, as it was initially known, was forged in 1751 to honor Pennsylvania's fiftieth year as a colony. An inscription from Leviticus 25:10 added to its message: "Proclaim Liberty throughout all the Land unto all the inhabitants thereof." Initially an object of uniquely Pennsylvanian relevance, its meaning eventually expanded in part because it hung in the building that hosted the Continental Congress. In the mid-nineteenth century, abolitionists embraced the bell and its inscription as an indicator of the great irony of a nation that celebrated freedom but permitted slavery. Throughout the nineteenth and twentieth centuries, the Liberty Bell,

Figure 1.3. City of Philadelphia, "Life, Liberty, and You" logo and wordmark, 2009. In 2016, under a new mayoral administration, the city adopted a new logo with the colors and layout modified slightly and the "Life, Liberty, and You" wordmark removed. (Office of the City Representative.)

as it came to be called, emerged as a powerful symbol for different groups of Americans as they fought for rights that they found represented in the bell but not always recognized by cultural or political practices.[48] As a national icon, the bell appeared at world's fairs across the United States, signaling that it had been dislodged from its earlier function and regional specificity.[49]

When Philadelphia claimed (or, in the case of the Liberty Bell, reclaimed) these national symbols as local icons in 2009, the city reasserted its role as a nationally significant force. Both the bell and the text hearkened back to a time when Philadelphia played an indisputably important role in what would become the United States. While embracing the Liberty Bell as a symbol for Philadelphia understandably called back to the object's original function, harnessing words from the Declaration of Independence to speak on behalf of Philadelphia invoked an awkward logic of transitivity. The tagline implied that if the words that drive the country also drive Philadelphia, then Philadelphia should be recognized as a nationally significant driving force.

As with the pictures for the city at the core of this book, Philadelphia's new logo and tagline appropriated historic items to represent the twenty-first-century city as an important and relevant place. But there are key differences between the items in Philadelphia's official brand and the sculpture, painting, and art collection that became unofficial pictures for the city. While the Barnes collection, *The Gross Clinic,* and the Rocky statue acquired their new status by being moved from one place to another, the bell and text stayed put as their morphed likenesses circulated. Becoming pictures for the city

expanded the public role of the Barnes collection, *The Gross Clinic,* and the Rocky statue. In contrast, the public role of the Liberty Bell and the phrase from the Declaration of Independence narrowed when they appeared in Philadelphia's brand and spoke for Philadelphia rather than the entire nation. Most significantly: the pictures for the city that I focus on in this book acquired their symbolic function indirectly through wide-reaching, informal, and often grassroots public discussions. Philadelphia's brand emerged instead from the direct, formal work of a committee appointed by City Hall staffers. When Mayor Michael Nutter launched the new brand, he remarked that, through the words "And You," the city invited all residents and visitors to take an active role in forming twenty-first-century Philadelphia.[50] But, in many ways, Philadelphia's residents and visitors had been shaping the city and its identity throughout Philadelphia's history. More recently, they had done so when they spoke out about their beliefs regarding the appropriate locations for the Barnes collection, *The Gross Clinic,* and the Rocky statue. By focusing on the ways in which three key historical objects took on new roles as pictures for the city, the chapters that follow shed new light on the long lives of powerful objects and the struggle to shape the identity of one of the country's longest-lived cities.

2

Locating the Local

AROUND THE TURN OF THE TWENTY-FIRST CENTURY, Philadelphia's reputation shifted from one defined by urban grit to one defined by cultural resources. Entangled in this transformation was an ongoing public debate about the art collection under the stewardship of the Barnes Foundation. These two cultural threads were deeply intertwined. Each matter responded to and informed the other. Extensive, impassioned discourse about the Barnes collection articulated new public perceptions of where Philadelphia was, what Philadelphia should look like, and which activities belonged there. A large portion of the debate and its ties to Philadelphia's changing identity hinged around plans to move Albert Barnes's modernist assemblage of paintings, sculpture, and furniture. For nearly ninety years, the peerless collection and the school that it served were housed on the grounds of an arboretum in the old and wealthy Philadelphia suburb of Merion, Pennsylvania. After much planning, the Barnes—as it is often called—closed its historic galleries on July 3, 2011, and began final preparations to move into a new space six miles away, on the Benjamin Franklin Parkway in Center City Philadelphia (Figure 2.1). The distance was small, but the significance was large.[1]

Relocating the collection was contentious. In 2000, Barnes Foundation administrators announced that the institution was in danger of running out of operating funds. They approached local and national foundations with a plea for extra support, and after several months of fund-raising, research, and conflicting public statements, they determined that they might be better

able to draw revenue from admission fees and attract large donations if the institution were based in Philadelphia proper and not in the suburb.[2] Merion residents, art enthusiasts, civic leaders, lawyers, and the Foundation's trustees were sharply divided over whether reinstalling the collection in Philadelphia was a desirable, appropriate, or even legal option.

Although ostensibly pertaining to a range of topics and themes, many of the debates about the Barnes revolved around the notion of place. They concerned both placement, the relative proximity of objects to one another, and sense of place, the culturally inflected qualities of a particular location.[3] Environmental context, accessibility, and cultural status were key themes in these conversations. Stakeholders with access to cultural and financial resources fell on each side of the argument. Their language and opinions varied depending on their beliefs about the Barnes Foundation and their relationship to Philadelphia.

As interested parties discussed where the collection belonged, they simultaneously defined the borders and the character of the region. Their arguments tapped into a vast network of ideas and anxieties about Philadelphia's cultural identity on both a global and a local scale. By examining the language of those debates in detail, this chapter charts the process through which the Barnes collection, as a whole, became a picture for the city, an object that represented Philadelphia. In that new capacity, the Barnes projected an image of Philadelphia as a place with world-class cultural resources that, along with the diverse parties that sought to take advantage of them, belonged exclusively in the urban core.

The branch of controversy that I address here extends from a single sentence in the Barnes Foundation's bylaws: "All the paintings shall remain in exactly the places they are at the time of the death of Donor and his said wife."[4] In 1926 the Barnes Foundation trustees voted to add this sentence to a revision of their governing documents. These words simplified and clarified a clause from the original document, which was penned in 1922 and modified several times before and after 1926. This particular phrase remained unaltered in subsequent versions. While Barnes and the other trustees found the sentence straightforward enough to avoid rewriting it when they tweaked other parts of the document, readers in the late twentieth century became divided over what it truly meant. Did "exactly the places" apply to the way that the paintings were hung in relation to one another, or in relation to the building in which they were installed? Would transporting the collection to Philadelphia violate the terms of the document? As nonprofit administrators, philanthropists, legal experts, Merion residents, students, and scholars (among others) haggled over

the best way to interpret this apparently unclear phrase in the 1990s and early 2000s, they directly and indirectly defined where and what Philadelphia was.

Debate over moving the Barnes collection swelled to engage a range of themes including (but not limited to) nonprofit management, donor intent, and old grudges among Philadelphia's elite. Trust and estate lawyers parsed the legal matters behind interpreting and potentially revising the bylaws.[5] The foundation's trustees and former executives came under suspicion for mismanaging their organization so severely that reevaluating the bylaws had become a necessary option.[6] Development experts considered the ways in which straying from or changing the bylaws would affect the Barnes Foundation's ability to meet its budgetary needs.[7] Philanthropy specialists discussed whether deviating from Barnes's indenture would discourage other wealthy individuals from founding and funding nonprofit organizations because benefactors might be concerned that an organization would one day ignore the terms of a donation.[8] Skeptics from a variety of fields proposed that moving the collection to Philadelphia was little more than a power grab by wealthy families that had feuded with Barnes decades earlier.[9] Although many conversations about these matters were carried out behind closed doors, all of these debates found audiences in the public arena of the press. International, national, and local media outlets latched onto each of these issues, lending particular attention to criticism of the Barnes Foundation's leaders, concerns about donor intent, and conspiracy theories about the link between the collection and local power dynamics. Finding clarity amid this cacophony of ideas and opinions is a daunting task.

My goal here is not to resolve the intense and highly specialized debates that surround the Barnes Foundation. Those matters have been, and surely will continue to be, parsed by experts and other interested individuals in their respective fields. Instead of intervening directly in those exchanges or judging whether it was right to move the collection, this chapter focuses solely on the theme of place, which, as a combination of cultural practices and spatial geography, weaves its way through the dense web of dispute. When civic leaders, arts enthusiasts, Merion residents, and local administrators shared their ideas about the Barnes in public conversations, they generated and articulated an understanding of Philadelphia that was caught between regional interests and the interests of smaller municipalities within the region. In other words, public discourse repositioned the Barnes collection as a picture for the city. Some statements explicitly connected Philadelphia's future to the future of the Barnes collection. But even when they were not directly addressing Philadelphia's reputation, many statements about the Barnes revealed implicit beliefs about what the city and its suburb should be like. Approaching the

Barnes collection through the lens of location may incidentally help untangle the knot of controversy that encircled the organization because it facilitates a better understanding of why the move was so divisive. But, more significantly, it provides valuable insight into the complexities of place in Philadelphia during the late twentieth and early twenty-first centuries.[10]

After introducing the collection in more detail, I present a close analysis of the language about place that emerged during key phases of dispute. I demonstrate that although conversations about the Barnes initially envisioned the City of Philadelphia and adjacent Merion as part of a unified region, they eventually articulated a disconnect between those two locations based on competing ideas about which context should be the long-term home of the foundation's galleries. In turn, while the Barnes collection technically remained within a private gallery, when it became a picture for the city it acquired a new, undeniably public dimension.

A Singular Collection

A 1922 charter filed with the County of Montgomery Court of Common Pleas established the Barnes Foundation "to promote the advancement of education and the appreciation of fine arts."[11] Over the next three years Albert Barnes shepherded his gallery and school into being. He developed a progressive art appreciation curriculum based on prominent scholars' ideas. It combined William James's theories of psychology and intelligence, George Santayana's studies of aesthetics, and John Dewey's philosophy of education and social reform.[12] Dewey, a close friend of Barnes, served as honorary director of education for the young institution. Official instruction began in 1924.

Just as Barnes carefully developed the pedagogical framework for his school, he also invested in a strong physical plant. He hired the renowned Beaux-Arts architect Paul Philippe Cret to design an exhibition space, administrative offices, and residential quarters on a recently acquired plot of land in Merion, Pennsylvania (Figure 2.2).[13] Only a few years earlier, in 1917,

FACING PAGE, TOP TO BOTTOM:

Figure 2.1. The Barnes Foundation on the Benjamin Franklin Parkway in Philadelphia, Pennsylvania, designed by Tod Williams Billie Tsien Architects, completed in 2012. (Michael Moran/OTTO.)

Figure 2.2. The Barnes Foundation in Merion, Pennsylvania, designed by Paul Cret in 1922, completed in 1925. This photograph shows the north face of the gallery building from the front lawn circa 1960. (Unidentified photographer. Photograph Collection, Barnes Foundation Archives. Philadelphia, PA. Image © 2018 The Barnes Foundation. Reprinted with permission.)

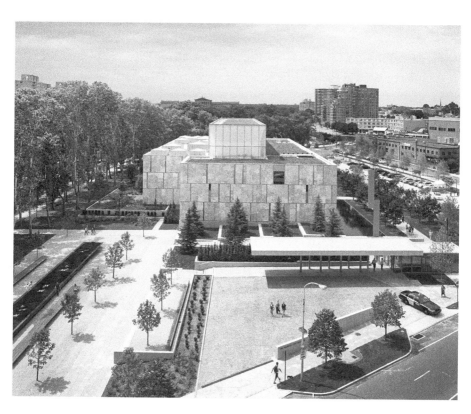

President Theodore Roosevelt had extolled "Model Merion" as an exemplary suburb rendered as such by the efforts of a dedicated civic association headed by Edward Bok, editor-in-chief of the widely read *Ladies' Home Journal*.[14] Many who lived in Merion were wealthy landowners who built grand estates there after the Pennsylvania Railroad laid its Main Line tracks through the region in the nineteenth century. It was a common practice for area residents to commission their elaborate homes from celebrated architects.[15] Barnes, a particularly engaged client, worked carefully—and often tensely—with Cret throughout the planning and construction process to ensure that the foundation's buildings met all of its patron's precise specifications.[16] By 1925 the project was complete, and at a dedication ceremony in March of that year a lineup of prominent intellectual and cultural figures welcomed the institution with speeches and celebration.[17]

At the core of Barnes's curriculum and exhibition space was a large and growing collection of paintings, sculpture, pottery, and furniture. By the time of Barnes's death in 1951, it boasted more than a thousand objects that the collector obtained for the foundation during approximately three decades in the early twentieth century. Those items ranged from world-renowned paintings by European modernists, including Paul Cézanne, Henri Matisse, Paul Seurat, and Vincent van Gogh to more than a hundred nineteenth- and twentieth-century African sculptures; the largest known holding of works by Pierre-Auguste Renoir; and numerous other pieces by European and American artists. A massive digitization project and a new open-access policy have made images of these items readily available on the organization's website, but for many decades the works were accessible only as selected illustrations in the foundation's publications or in the Merion galleries, where photography was prohibited.[18]

Barnes purchased the objects in his collection with profits he earned as a chemist and businessman in the pharmaceutical industry. Born in 1872 to a working-class Philadelphia family, Barnes advanced his social and economic status by earning a medical degree from the University of Pennsylvania, working as a chemist in Germany, and developing, in collaboration with Herman Hille, a highly marketable antiseptic, Argyrol. In 1908 Barnes established his own firm, A. C. Barnes Company, where he continued his success in pharmaceuticals and began to experiment with progressive education in his small West Philadelphia factory. Already remarkable in its time for having an integrated staff where African American men and women worked alongside white laborers, the A. C. Barnes Company set aside two hours in each eight-hour work day for philosophy and aesthetics.[19] In addition to studying the works

Figure 2.3. Angelo Pinto, photograph of the main gallery of the Barnes Foundation in Merion, Pennsylvania, view of north wall, west side, circa 1952. (Photograph Collection, Barnes Foundation Archives. Philadelphia, PA. Image © 2018 The Barnes Foundation. Reprinted with permission.)

of William James, Bertrand Russell, John Dewey, and George Santayana, Barnes's employees were encouraged to apply the ideas they encountered in written texts to the analysis of art. Barnes began bringing paintings by American artists like William Glackens (who was also his friend from high school) into the workplace for his employees to study in person.[20] He sold the A. C. Barnes Company in 1926, shortly after the Barnes Foundation opened, to focus his full attention on expanding his collection, publishing studies of the art it contained, and running the school that was built around it.[21]

The eclectic array of items in Barnes's collection were distributed around the galleries in ever-changing "wall ensembles," balanced arrangements of paintings accompanied by small metal objects like embellished hinges, dental tools, or keys (Figure 2.3). In some rooms, three-dimensional objects not affixed to the walls, like furniture, pottery, and sculpture, complemented or anchored the wall ensembles. Other than the metal nameplate affixed to each elaborate frame, no additional expository text indicated the artist, title, medium, or history of the works in Barnes's collection. Such a manner of display

emphasized each object's visual and material qualities by downplaying other aspects like the historical circumstances surrounding its production. This approach supported Barnes's theory of art appreciation, which prioritized the careful, nearly scientific analysis of what he termed "plastic form"—the fundamental design elements of line, color, light, and space. He arranged and rearranged the wall ensembles to illustrate different lessons about how these elements operated within and across works of art.[22]

Beginning nearly a decade earlier, famed gallerist and photographer Alfred Stieglitz similarly experimented with exhibition techniques that grouped works according to formal features instead of by theme or historical context.[23] While Stieglitz mainly featured work by the American and European artists who were his contemporaries, Barnes further dislocated art from its historical contexts by juxtaposing works from different cultures and time periods. As one journalist observed in 2002, "A late Renoir hangs with French primitives, a skinned rabbit by Soutine with a Rubens and a folkish Horace Pippin, a Durer with a Chinese print, a Puvis de Chavannes near a Milton Avery, an erotic Egyptian bas-relief from 300 B.C. with a 14th-century Hispanic horse, a Bosh with a Cezanne and a Bonnard over an American lowboy."[24] By discouraging viewers from reading the objects in his galleries in terms of history or isolated narrative, Barnes elevated the significance of his vacuum-like gallery context as the place for making sense of the work on view.

Barnes's recontextualizing, eclectic displays invited synchronic readings of the items in his wall ensembles. Rather than study each object independently, viewers were to consider the visual interactions among the pieces in the installation. Building on this concept, scholar Jeremy Braddock has gone as far as to propose that Barnes constructed autobiographical statements as he arranged the objects on display. By reading the wall ensembles in one room at the foundation through a psychoanalytic lens, Braddock found meaning in Barnes's juxtapositions of objects just as one might find meaning in the juxtapositions of colors, figures, or materials in a single painting, sculpture, or collage. Extending Braddock's approach a step further, when I discuss the Barnes collection's emergent function as a picture for the city, I consider it as a single entity that operates as more than the sum of its impressive parts.[25]

Investing in Place

When Barnes established his galleries as a closed context in which to view carefully arranged objects, he embedded the matter of location in the core of his institution. In this case location manifested as the placement of collection

objects in relation to one another and the visual and institutional context of his galleries as a place for seeing art. Beyond his galleries, Barnes had additional concerns related to more abstract matters of location. Namely, he positioned his work as an investment in the region's reputation. The twenty-first-century discourse about the Barnes mostly overlooked this historical aspect of the collection's ties to Philadelphia's identity. I recall it here to deepen the significance of the Barnes collection's emergence as a picture for the city decades later.

Barnes had a notoriously acerbic personality, and he waged many sharp-tongued critiques of Philadelphia, the city's institutions, and prominent individuals in the region. Some of these salty exchanges were precipitated by criticism of his collection or his educational philosophy, while others stemmed from Barnes's disapproval of others' engagement with art and culture. He often positioned his cultural and financial resources against those of the people and institutions he deemed part of the Philadelphia establishment. In a 1924 letter to the Pennsylvania Academy of the Fine Arts (PAFA), Barnes explained that "outsiders say that Philadelphia is noted for its abysmal ignorance of and hostility to educational and artistic movements that are recognized everywhere else as sound and progressive. They deride our outworn institutions. . . . But a new era has arrived and it will be the job of a group of modern Philadelphians to try to remove the stigma from our city."[26] Barnes saw himself as part of that group of modern Philadelphians. He viewed his collection and the pedagogy he deployed at his foundation as important tools in the fight against Philadelphia's negative image.

In 1927, just three years after the Barnes Foundation began offering courses in art appreciation, Barnes invited Merion residents to consider the cultural value of having his institution in their town. At the time, he was embroiled in a heated dispute with Lower Merion Township commissioners because a developer had been granted permission to build several small homes on a tract near Barnes's land. Barnes objected to the construction plan, arguing that the presence of small homes would devalue property throughout Merion. Never one to shy away from a dramatic confrontation, Barnes threatened to move his collection away from Merion if the town permitted the developer to proceed with his construction plans. To calm Barnes, the Merion Civic Association passed a resolution "that we regard the Barnes Foundation as a valuable civic asset and would deplore the loss of either its art or collection, or its school."[27] Two weeks later Barnes cheered that "the brains and back-bone of Merion are linked to maintain its present prestige of the suberb [sic] both as a residence section and as an internationally famous art centre."[28]

But the matter of the small houses persisted, and Barnes dug in his heels with flair. He issued a public statement that declared, "If the small houses are built, I shall move to New York to continue the educational work the politicians have driven out of Merion. I shall be an humble and unworthy follower of great people—like Stokowski, Mary Cassat [*sic*], Abbey, Henri, Sloan, Glackens, and many others—who leave Philadelphia to get a breath of fresh air—and never come back."[29] In threatening to leave the region and take his foundation with him, Barnes invoked the names of noteworthy cultural figures who had also fled Philadelphia in recent years. (Stokowski, the cherished conductor of the Philadelphia Orchestra, did return to the city just a few months later.) This rhetorical move allowed Barnes to position himself and his foundation as key elements of the region's cultural landscape. He promised that his departure would be just as disappointing as that of other figures who, had they remained local, would have done wonders for Philadelphia's culture scene and reputation. Needless to say, the dispute was resolved and the Barnes collection stayed put.

Just as Barnes positioned his own work as a positive contribution to Philadelphia, at times when he objected to other institutions' practices he framed their work as detrimental to the region. For example, when scandal broke in 1937 around the Pennsylvania (now Philadelphia) Museum of Art's purchase of an unfinished scene of bathers by Cézanne for $110,000, Barnes asserted that the museum's actions reflected poorly on the entire city, not just the institution.[30] In a pamphlet entitled "A Disgrace to Philadelphia," he wrote that, thanks to the museum's decision, "Philadelphia now stands as a symbol for ignorance and gullibility in matters of art."[31] In the context of this study it is irrelevant whether his language was earnest or purely rhetorical. Barnes was a masterful wordsmith, and it is revealing that in documents like these he positioned himself as a watchdog charged with protecting and elevating Philadelphia's reputation.

Public Access

The notion of access—another central theme in this chapter—was also a prominent aspect of the foundation in its early years. Concerns about access played out in two intertwined strands that would reemerge in the controversy over the collection around the turn of the twenty-first century. One strand pertained to Barnes's desire to grant his students access to fine art and deep art appreciation. The other involved accusations from outsiders that Barnes did not make his collection accessible enough to those who were not enrolled

at his school. The subject of access at the Barnes Foundation could fill several volumes on its own, but a few notable historical details provide particularly useful background for this analysis of the role that public discourse about the Barnes played in defining place in twenty-first-century Philadelphia and repositioning the collection as a picture for the city.

As a private school, the Barnes Foundation was initially open to only its students and invited guests. Barnes's target audience included working-class people, African Americans, and artists, although he also hosted many wealthier, white students and visitors. While it is difficult to determine the socioeconomic background, education level, or ethnicity of the foundation's actual audience, attendance records indicate that in 1927, for example, students came from as far as Wilmington, Delaware, and Brooklyn, New York, as well as from areas throughout the Philadelphia region. Many of their addresses were located in wealthy residential neighborhoods, but approximately one third were in industrial sectors of the city where there were high or rising numbers of working-class immigrants. This information suggests that the Barnes Foundation served a diverse student body, although the details of that diversity remain foggy.[32]

The gallery admission policy allowed other individuals interested in visiting the collection to send the foundation a written request, accompanied by a stamped envelope in which callers would receive Barnes's response to their inquiry. In 1946 Barnes remarked that "the effect of this [procedure] is a widespread rumor that we are discourteous; the fact is that we mean business and are not engaged in affording a place for entertainment or diversion for triflers."[33] Barnes frequently turned away potential visitors. Among those denied entry to his collection were art historian Meyer Schapiro, collector Walter P. Chrysler Jr., and novelist James Michener.[34] Some would-be visitors apparently received "no thank you" letters from Barnes's dog, Fidèle.[35] Barnes maintained that by denying admission to some, he was able to preserve his institution as a place for people who did not otherwise have ready access to art. To support this aim, a 1946 addition to the Barnes Foundation bylaws explicitly stated that "it will be incumbent upon the Board of Trustees to make such rules and regulations as will ensure that the plain people, that is, men and women who gain their livelihood by daily toil in shops, factories, schools, stores and similar places, shall have free access to the art gallery and the arboretum upon those days when the gallery and the arboretum are to be open to the public."[36]

The historical tension regarding visitors to the collection points to one of the Barnes Foundation's intriguing complexities: it blended modes of cultural

practice that typically remain stratified. It was simultaneously a challenging, nuanced intellectual and aesthetic exercise; a collection of European paintings that eventually had broad appeal; and an effort to make art accessible to people who were typically excluded from fine art settings. I suspect that many people have been troubled by the Barnes because they want it to be either highbrow or middlebrow, but, because of the objects in the collection, the way they were assembled, and the way they were used, it resists such clear classification.[37]

If the Barnes Foundation appeared unwelcoming to some potential visitors during the 1930s and 1940s, it became even more inaccessible after Barnes's unexpected death in a 1951 car accident.[38] Classes continued under the direction of Violette de Mazia, Barnes's longtime collaborator, but visits from outsiders were limited. Although by 1961 the Barnes Foundation was required to permit members of the public to visit the galleries in order to retain its tax-exempt status, the organization remained relatively cloistered until the late 1980s, after de Mazia and the foundation's other original trustees had died.[39] The events of the decades that followed contrasted sharply with the foundation's decidedly inward orientation during the mid-twentieth century.

International Impact

Barnes had grand visions for his foundation. When he invited Merion Township leaders to visit one of his classes in 1927, he revealed his goal of earning international renown. He enticed his guests: "See for yourselves how far we have advanced in two and a half years and imagine what a few more years will do when the results of our program are felt in the world at large."[40] And yet, in 1991, *New York Times* writer Michael Kimmelman described the Barnes Foundation as "one of the most eccentric and reclusive of American art institutions."[41] Those words did not reflect the widespread impact that Barnes predicted several decades earlier, but they did mark a turning point in the foundation's popularity. The newfound attention that the organization would receive from people outside and inside the Philadelphia region contributed to refashioning the Barnes collection as a twenty-first century picture for the city.

The Barnes Foundation returned to the public eye in the early 1990s, shortly after Richard Glanton was appointed as its president. When Glanton took the helm, the Barnes faced serious financial challenges, and the galleries were in need of significant renovations. As Glanton and his colleagues

explored options for reinvigorating the institution, they generated more na-
tional press coverage (positive and negative) than the Barnes had received in
decades.[42] Widespread interest in the Barnes truly arose when the founda-
tion's administrators proposed resolving its financial challenges by organizing
an international tour of selected paintings from the collection. At that time,
to return to Barnes's words, the foundation's actions—if not the specifics of
its educational programs—were indeed "felt in the world at large."

Although critics believed that even a temporary traveling exhibition was
in violation of the mandate that no works be moved after Barnes's death, local
courts granted a "one-time deviation" that allowed some of the paintings
from the collection to travel, provided that they returned to their traditional
places in the Merion galleries at the end of the tour.[43] Glanton oversaw the
planning and execution of this traveling exhibition between 1993 and 1995,
while the famed local architecture firm led by Robert Venturi and Denise
Scott Brown designed and managed gallery renovations that updated climate
control and other features. The exhibition traveled to the National Gallery
in Washington, DC; Toronto's Art Gallery of Ontario; the Musée d'Orsay in
Paris; Tokyo's Museum of Western Art; the Kimbell Museum in Fort Worth,
Texas; the Haus der Kunst in Munich; and Philadelphia, where it was shown
at the Philadelphia Museum of Art. At many of these venues, the exhibition
attracted so many visitors that it broke attendance records. The mid-nineties
tour was the first time that any of the paintings had been shown outside of
the Barnes galleries in decades. Promotional materials presented the exhibi-
tion as a once-in-a-lifetime opportunity to see the art outside of Merion.
People who might not have been able to travel to the Philadelphia area came
out in droves to see the show when it arrived in their region.

The international tour raised $17 million, which more than covered the
nearly $12 million price of renovating the galleries. Those who tell the story
of the Barnes as one of recurrent financial woes have been quick to clarify
that a court ruling prohibited the foundation from using the surplus funds
to augment its endowment or expand its operating budget, and so, despite
the popularity of the tour, the foundation's economic challenges continued.[44]
But institutional finances need not be the chief measure of the tour's success.
Its greatest accomplishment lay far beyond the details of bookkeeping. The
crowds that came to see the show in cities like Munich, Tokyo, and Paris in-
dicated that Philadelphia possessed a resource with tremendous global value
that was both monetary and cultural. The Barnes collection, a recognized
product of the Philadelphia region, could earn revenue and acclaim in inter-
national markets. At the end of the twentieth century, when Philadelphia had

lost its status as a cultural center and hub of industrial production, the tour validated contemporary Philadelphia as a place of cultural and economic significance. This outcome lay the groundwork for the Barnes's more sustained role in the public envisioning of twenty-first-century Philadelphia.

As the Barnes Foundation helped spread to national and international audiences the image of Philadelphia as a region with rich cultural resources, it also shaped Philadelphia in a more local and palpable way. The proposal to send selected works on tour in the 1990s, the debate that ensued upon the collection's return to Merion, and the controversy surrounding the institution's eventual move to Center City Philadelphia had repercussions that extended far beyond the institution and its immediate audiences. By examining these different phases of dispute and the competing definitions of place that emerged from this public discourse, I show that conversations about the Barnes collection ultimately defined the geographic borders and cultural function of Philadelphia on a local, national, and international scale.

Thinking Regionally

In the 1920s Barnes asserted that he and his foundation would help define Philadelphia. By the mid-1990s the institution was finally on its way to playing such a role. It is significant that Barnes referred to "Philadelphia" as the place and culture that his Merion-based foundation would help change. This word choice suggests that Barnes conceived of "Philadelphia" as a region, not just the area that fell within the city limits. In turn, it expanded the importance of his work. He was operating on a scale that mattered beyond Merion. As the Barnes regained prominence in the early 1990s, discourse about the institution articulated a similarly regional outlook. Notably, this was a moment when many Americans were particularly concerned with the relationships between cities and their suburbs. That historical context adds extra significance to language about the Barnes that subtly revealed ideas about the unity of the region.

Echoing Barnes's regional language from decades earlier, Philadelphia Museum of Art curator Joseph Rishel observed in 1995 that two of Paul Cézanne's three largest paintings of female bathers "are in Philadelphia."[45] One, the subject of Barnes's critical 1937 pamphlet, was in Rishel's museum's collection, and the other belonged to the Barnes Foundation. (The National Gallery in London owned the third.) Although the Barnes collection was technically located in Merion, just outside of Philadelphia proper, Rishel's

comment presented the city and its suburb as, in essence, one and the same. This broad view of Philadelphia grouped together the resources of the region, elevating the degree of Philadelphia's cultural riches by doubling the local count of *Large Bathers*. But it also conveyed a broader sense of unity between city and suburb.

A local headline from January 1995 underscored this regional outlook even more significantly. When the international tour of European paintings from the Barnes collection arrived at the Philadelphia Museum of Art, an article in the *Philadelphia Inquirer* declared, "Barnes Exhibit Comes Home."[46] Certainly the *Inquirer* staff was not confused about the distinction between Merion and Philadelphia; if anyone knew the difference between the two municipalities it would be local journalists and their readers. What this headline indicates is that the collection's "home" was general and inclusive: its home was the greater Philadelphia region. In early 1995 it was unremarkable to describe Philadelphia as the collection's home because the distinction between city and suburb was not meaningful in the way it would become by the end of that year.

Language from the mid-1990s that incidentally presented the City of Philadelphia and its adjacent suburb as effectively the same place is worth particular attention because it occurred against a nationwide backdrop of tension between cities and their surrounding suburbs. At that time, many journalists, policy makers, and scholars were debating whether wealthier suburbs needed to support nearby, often languishing cities in order to thrive.[47] When advocating for thinking regionally in 1995, Theodore Hershberg, founder of the Center for Greater Philadelphia at the University of Pennsylvania, explained that "the issue is not whether the city and suburbs are tied together in a regional economy—they are—but how to ensure that the region will prosper in the future."[48] Hershberg recognized that suburban municipalities were reluctant to enter into formal arrangements with Philadelphia because they viewed the city's social and economic woes as something beyond their own interest. In order to dismantle this misguided belief, Hershberg emphasized the region as a vital unit in a global economy and called for increased, sustained collaboration throughout the Philadelphia region. He appropriately noted that "words such as city and suburbs suggest monoliths where none exist; they give rise to false, but powerful images of We/They and Us/Them."[49] And yet, as academic and economic interest in regional cohesion expanded, discourse about the Barnes shifted in the opposite direction, articulating instead a new rift between Philadelphia and its neighboring suburb.[50]

Rupture

Borders are often where distinctions between places and perspectives are sorted out.[51] The geographic border between Merion and Philadelphia was just a few blocks from the Barnes Foundation's historic campus on Latch's Lane. When the paintings from the international tour truly "came home" and were reinstalled in Merion, public discourse about the Barnes reframed "Philadelphia" as the area strictly contained within the city limits. Conversations about the Barnes Foundation articulated the suburbs as exclusive, difficult to find, intimate, and peaceful; in contrast, they presented the city as busy and impersonal, yet easily accessible. By differentiating the city from its suburb, and by leading to the ultimate relocation of the Barnes galleries to the Parkway in Philadelphia, these exchanges established the Barnes as a key element in Philadelphia's redefined twenty-first-century image.

The divisions emerged with force on the evening of November 11, 1995, the night of the Barnes Foundation's reopening gala, when a long line of cars stretched down residential Latch's Lane. An article in the following day's *Philadelphia Inquirer* described the scene as the realization of neighbors' "nightmares of traffic jams" taking over their quiet street.[52] As cars and tour buses continued to transport visitors to the Barnes galleries in the months that followed, Latch's Lane residents Robert and Toby Marmon recorded the traffic with their home video camera. They shared their footage several years later with producers of *The Art of the Steal*, a popular documentary film released in 2009 that criticized how the Barnes Foundation was managed in the years leading up to the move to Philadelphia. In an interview for the film, Robert Marmon recalled that the spike in activity at the Barnes was "absolute chaos. Nothing had ever happened like that in the eighteen years we'd lived here." He and his wife had asked themselves, "Our neighborhood has now changed to this?"[53] Marmon's concerns about "change" reflected more than his remembered fears from 1995. They also pointed to the shift that had occurred in the years since the episode he recalled—a shift that pried Merion apart from Philadelphia by emphasizing the characteristic differences between the two neighboring places.

The way that Marmon and others discussed the increased traffic at the Barnes suggested that their quiet suburban neighborhood was not the appropriate place for the bustling activity typically found in a more urban environment. Their reactions reflected dismay that the Barnes was opening up to larger audiences and becoming more publicly oriented. Other nearby

institutions regularly hosted numerous people, but visitors to the Barnes galleries differed from those who gathered at local schools and religious centers. The people who filled the classrooms and sanctuaries were regular attendees and members of a defined community anchored around the institution. Beyond that, they had ties to Merion or some other nearby neighborhood. In contrast, gallery goers at the newly renovated Barnes Foundation were more likely to be outsiders, coming just for the afternoon, unlikely to return until their next vacation to the Philadelphia region.[54]

When the Barnes Foundation proposed building an on-site parking lot to accommodate its visitors and prevent tour buses from having to park on the street, several neighbors also opposed that action. While the Barnes viewed the parking lot as a way to alleviate congestion on Latch's Lane, the neighbors viewed it as a step toward even more unwelcome activity.[55] A parking lot would legitimize the increased numbers of visitors who were coming into Merion to see the Barnes. It would indicate that traffic from outsiders would be an accepted and long-term feature of the previously quiet street. Despite neighbors' objections, the Barnes eventually managed to break ground for its parking lot. In a press release, the foundation described the parking lot as one part of a broader effort "to find new ways to maintain serenity of [sic] this beautiful area."[56] Such language suggested that the Barnes and its neighbors had a shared interest in preserving tranquility in Merion. Even so, it could not belie the rancor that was growing between the two parties.

Conflict with its neighbors, growing legal fees from a series of lawsuits regarding its operations, and other prolonged budgetary challenges were among the factors that prompted the Barnes Foundation to explore the possibility of moving its galleries from Merion to Philadelphia.[57] Talk of a potential move began to circulate in the press in 2001. By 2002 the foundation's lawyers filed a petition to modify its bylaws in several ways and to relocate the galleries.[58] In December 2004, Judge Stanley Ott issued a statement that granted permission for the collection to move to Philadelphia.

Judge Ott's decision has particularly meaningful implications for characterizing "place" in the Philadelphia region because of the way he interpreted the requirement that the artworks remain in "exactly the places" after Dr. and Mrs. Barnes died. In a statement issued in January of that year, Ott acknowledged that "it is difficult to dismiss Dr. Barnes' choice of venue as a minor detail," but he ultimately determined that "the present location of the gallery is not sacrosanct, and relocation may be permitted *if necessary* to achieve the settlor's ultimate purposes."[59] Ott did require, however, that

the art be hung in the Philadelphia galleries in precisely the arrangement in which it appeared in Merion. Based on this decision it is apparent that, for Ott, the notion of "places" pertained chiefly to the relationship among objects in the collection, not to the gallery building, the arboretum grounds, the local soil, or the neighborhood in Merion. His ruling determined that those other factors could shift without destroying the function, mission, or integrity of the institution.

During and after the legal process, many people publicly weighed in with their own opinions about whether the Barnes should or could move its galleries. Initially, the major opponents to moving the collection were a cadre of scholars and art critics who warned against dismantling the historic institution and a small group of former Barnes students and teachers who were committed to preserving the historical structure and operations of their beloved school. Early supporters of the move included local philanthropists and civic leaders as well as many of the foundation's neighbors on Latch's Lane—until their stance shifted.

In late 2003, as lawyers prepared for court hearings about moving the collection, Barnes neighbor Walter Herman told one *Philadelphia Inquirer* reporter that "the Barnes is a grand gesture of genius. . . . [But] if you had a 24-karat gold splinter in your [backside], you would not be sorry to have it removed."[60] In that moment it seemed clear: Barnes leaders wanted to relocate, and their neighbors would be glad to see them go. Less than six months later, however, Herman revised his opinion when he told the *Inquirer,* "We do not want the Barnes to leave."[61] He and his wife had become leaders in the effort to keep the Barnes in Merion. Along with several other Merion residents, they had joined forces with the Barnes faculty, students, and alumni who opposed moving the collection. They came together as the Friends of the Barnes Foundation, a group dedicated to preserving the Barnes collection in Merion.[62]

Why the sudden change of heart? I suspect that Judge Ott's January 2004 statement prompted the neighbors to reconsider their position. When Ott suggested that the Barnes collection was not inextricably bound to Merion, the collection's departure became a very real possibility. Neighbors like the Hermans may have feared that the influx of visitors to the popular institution would transform their quiet suburb into a more active—and less exclusive— district, but they ultimately viewed keeping the Barnes in their neighborhood as more desirable than letting it go. Apparently the collection's cultural value offered more to the neighborhood than the increased traffic would take away. The neighbors found themselves weighing the character and ambiance of Merion against a desire to harness the extraordinary cultural value of the

Barnes collection. Other interested parties across the field of discourse were considering these issues, as well.

The emergence of the Friends of the Barnes Foundation opened up nearly a decade of intense, often circular debate about the Barnes. The group fueled the debate by sponsoring legal challenges to Ott's December 2004 decision and by voicing their objections loudly in local newspapers, on a website that they operated, and in public protest events. In conjunction with the Friends of the Barnes initiatives, writers, art lovers, lawyers, and museum professionals across the country became even more heavily invested in describing and debating the future of the Barnes. Many opinions emerged out of that swirl of discourse—including important ideas about place in the Philadelphia region. While the court of law may have determined that the only vital element of "place" pertaining to the Barnes was the arrangement of collection objects in relation to one another, the court of public opinion maintained that the issue was much more complex.

Suburban Specificity

Many advocates for keeping the Barnes galleries in Merion argued that, contrary to Judge Ott's findings, the Barnes collection was indeed a site-specific work that was inextricably linked to the building that housed it and the grounds on which it was situated. These invocations of site specificity foreshadowed the Barnes collection's future role as a picture for the city that was specific to its new site in Philadelphia and to the conversations I describe in this chapter. Not long after Judge Ott ruled that the Foundation would be permitted to move its collection, *New Yorker* art critic Peter Schjeldahl wrote that "altering so much as a molecule of one of the greatest art installations I have ever seen would be an aesthetic crime."[63] For him and the many others who shared this perspective, the Barnes Foundation was a site-specific installation in which the experience of trekking to an early twentieth-century mansion in the suburbs was a central part of understanding the objects on view there.

Harold Cyr, an attorney representing the Friends of the Barnes Foundation, embraced Schjeldahl's position and asserted that Paul Cret's building was an important component of Barnes's displays. As one reporter summarized, Cyr presented "taking the collection out of Merion as not only too risky financially, but as the ruin of a masterpiece created by founder Albert C. Barnes both inside and outside the trademark limestone gallery."[64]

Years later, on the eve of the move, *Philadelphia Inquirer* art critic Edward

Figure 2.4. Entrance to the Barnes Foundation in Merion, Pennsylvania, with tile work inspired by African sculpture from the collection. (Photograph by Laura Holzman, 2010.)

Sozanski added to Cyr's point when he wrote that moving the collection would invariably leave behind key elements that had previously contributed to the especially rich exhibition environment in Merion. For example, the main entrance to the Merion gallery building was embellished with tile work featuring figures inspired by the African sculpture held within (Figure 2.4). By raising this issue, Sozanski implied that the architectural and decorative setting in Merion uniquely activated the collection in a manner that could not be replicated elsewhere.

Jay Raymond, a former Barnes student and one of the more vocal Friends of the Barnes Foundation, argued that the foundation's educational mission relied on contextual factors in Merion. He explained that

> the design of everything one encounters at the Barnes Foundation is intended to foster . . . [Barnesean inquiry]: the quiet, green setting; the arrangements of the trees, shrubs, gardens and lawns surrounding the galleries; the exterior of the gallery building; the arrangement of the gallery rooms themselves, moving deeper and deeper into the

details of it all. At the Barnes Foundation, in its indivisible form in Merion, anyone can investigate for a lifetime the interplay of the nature arranged by humans and the art created by humans and arranged by Dr. Barnes.[65]

Raymond's statement went beyond illustrating a link between the foundation's activities and Cret's building. For Raymond, the visual, material, and aural features of the arboretum grounds played an important role in furthering the Barnes's mission.

With a slightly different rhetorical tack, historian Robert Zaller emphasized the absurdity of moving the collection away from Merion. Zaller, a resident of a neighboring Main Line suburb, warned, "Our loss cannot be your gain, anymore [sic] than it would be our gain to put Independence Hall or the Liberty Bell in one of our town squares."[66] Just as Philadelphia's colonial-era landmarks were understood to belong uniquely to the Old City locations where they stood when the United States was founded, so too, he believed, should the Barnes collection be understood as most meaningful in the location where it existed since it was founded. Furthermore, by referring collectively to "our loss," Zaller claimed a shared identity for Main Line suburbs that included and extended beyond Merion. In contrast to earlier statements by Barnes and others that collapsed the distinction between suburb and city, Zaller's language sharply differentiated Philadelphia from the Main Line suburbs, while grouping together those suburbs into a cohesive entity with a shared stake in the game. His language of "us versus them," uttered more than a decade after Hershberg cautioned against the proliferation of such "false but powerful images," underscored that a regional split had occurred.[67]

While for Schjeldahl site specificity was grounded in aesthetics, for Raymond it was linked to education, and for Zaller it was based in history, writers also introduced an understanding of the Barnes Foundation's site specificity that stemmed from a natural connection between the collection and its environment. In addition to supporting Cyr's claim about the relationship between the Barnes collection, its building, and the grounds, Sozanski argued that the collection "can't be relocated organically any more than a giant redwood can be cut off at the knees and stuck in a giant tub on the sidewalk."[68] In his view, the connection between object and place was as crucial as the relationship between a magnificent plant and the soil from which it grows.

New York–based cultural journalist Lee Rosenbaum also embraced a botanical metaphor when describing the plan to move the Barnes: "The collection will be uprooted from Leafy Latch's Lane and replanted along

Philadelphia's unlovely main thoroughfare, the Benjamin Franklin Park-way." For Rosenbaum, "Leafy Latch's Lane" was the best possible setting for Barnes's collection, and, as she put it, "there's no way an enlarged Barnes in downtown Philadelphia could come close to matching the serene setting of the original."[69] Her quote also pointed to an important distinction between Philadelphia and Merion. It was not just that Merion was the natural setting for the Barnes. It was also that Merion, home to "Leafy Latch's Lane," was a particular type of setting—lush, "lovely," "serene"—and many believed that the Barnes belonged in that kind of location. Philadelphia may have been founded as a "greene country towne," but in conversations about moving the Barnes, those traits were typically reserved for the suburb, not the city.[70]

At the same time, some advocates for moving the Barnes collection har-nessed the notion that Merion was secluded and peaceful as the basis for another suggestion about the sense of that place: It was difficult to locate and difficult to navigate. As the *Voice of America News* reported in 2003, "Just finding the Barnes [c]ollection is a challenge: what would be considered a major tourist attraction virtually anywhere in America is hidden in a residen-tial community of mansions and expensive lawns. There are no signs leading the way from Philadelphia—just a small, weathered plaque outside an impos-ing fence and gate surrounding the Barnes gallery."[71] This quote exemplified the idea that Merion was exclusive, hard to find, and hard to reach, while the city, which began just yards away from the Barnes Foundation's front door, offered an environment that was physically, socially, and directionally easier to access.

Sozanski objected to this view when he wrote later that year that "the canard that the Barnes must move because it's remote and inaccessible, and because it lacks sufficient parking, needs to be permanently retired." In his column he pointed out that visitors could park off-site five minutes away from the galleries and that the 44 bus, which ran from Old City Philadel-phia to the suburb, dropped off passengers within walking distance of the Barnes campus. He proposed instead that a different type of inaccessibility was to blame for the trouble at the Barnes Foundation: "The foundation is severely hobbled by Lower Merion Township, which, under zoning laws, restricts visitors to 400 a day, three days per week—and unreasonably counts students from its own public schools against that number."[72] Indeed, zoning regulations in Merion limited the number of visitors that the Barnes could host, and when the foundation petitioned the courts to expand that number, Merion residents opposed the Barnes's motions.[73] Supporters of the move explained that because of increased space and different zoning policies, a

Philadelphia gallery would accommodate five times more visitors than the Merion location could.[74]

Sozanski's argument was well founded, but these conversations about zoning laws and accessibility are more related than he acknowledged. They encapsulate the challenge posed by the Barnes's shifting status from inwardly oriented education center to outwardly oriented exhibition space. Both topics are steeped in implicit notions about the nature of the city and the suburbs, and conflicting ideas about the kinds of organizations, individuals, and activities that can and should flourish in urban and suburban environments.

Almost a decade later, the theme of Merion's geographic inaccessibility persisted. Architect Billie Tsien, whose firm was designing the new Barnes Foundation building on the Parkway, described her own "pilgrimage" to the Merion campus in similar terms. It was "eye opening to say the least because it's not easy to get there. . . . We took the train and then we took a cab and then the cab got lost and then . . . we were sort of driving around and finally we got to Latch's Lane."[75] Some readers may suspect that Tsien's words were little more than spin designed to continue making the case for moving the galleries away from Merion. I am willing, however, to believe that her words reflected a genuine perception that Merion was inaccessible. With that in mind, the difference between her perception and the actuality that Sozanski described warrants closer attention.

While working on this book I made several visits to the Barnes Foundation's Merion campus. I traveled by bus, by car, and by train, often without the aid of a smartphone, always arriving with minimal difficulty. And yet, each time I emerged in Merion (or just across the city's border at the train station in the Overbrook section of Philadelphia), I did feel far away from the Center City station or South Philadelphia address where I had begun my trip. There was more space between buildings, there were fewer pedestrians, it was quieter, and, especially in the summer months, there was the lovely fresh smell of recently cut grass. I suspect that when people reported directional challenges to getting to Merion, they were really responding to the environmental contrast between the suburb and the parts of the city from which they departed. Although it is fairly easy to get from Center City to the Barnes Foundation in Merion, there are clearly different senses of place in each area.

As recently as the early 1990s it was logical to overlook those distinctions in favor of conceptualizing Merion and Philadelphia as intertwined because of features including geographic proximity, economic connections, and social ties. The debates about the Barnes Foundation, however, brought characteristic differences between the two places to the fore. While it had

previously been beneficial to minimize the differences between Merion and Philadelphia and claim the Barnes Foundation's assets and activities for the entire region, emphasizing the distinctions between the two places raised the stakes of the arguments on both sides of the Barnes debate in the early 2000s. Opponents of the move could point out just how drastically and detrimentally different a setting Philadelphia would provide for the collection. At the same time, the distinction between Merion and Philadelphia also made Merion seem that much more distant and inaccessible, which enabled relocation supporters to further justify the necessity of moving the collection elsewhere. Through these conversations, the Barnes came to play an important role in characterizing Philadelphia and its suburb, setting the collection on its way to becoming a picture for the city.

Renewed Urbanism

As people identified features of Merion that made it either an appropriate or inappropriate setting for the Barnes's future success, they simultaneously crafted an image of Philadelphia as Merion's opposite. For this reason, the idea that Merion was inaccessible was particularly potent in the early 2000s, when city leaders were pushing hard to make Philadelphia appear open and welcoming. Describing the city as the right location for the Barnes collection allowed advocates to highlight aspects of urban life that they found desirable for Philadelphia's new identity and to downplay some of the city's starker realities.

Consider the image of downtown Philadelphia that Pennsylvania governor (and former Philadelphia mayor) Ed Rendell conjured in 2006: "By moving the Barnes collection to the city, we will make these brilliant [works] accessible to the thousands of people who already visit downtown Philadelphia each day."[76] Here, with the help of the Barnes collection, Rendell described downtown Philadelphia as a place filled with people. Populated by visitors and locals from many walks of life, it was, in his view, a bustling district that embraced outsiders. In this context, access was envisioned as being available to many different kinds of people in a place that already had a large population and diversity. While Merion residents like Robert and Toby Marmon once worried about large numbers of visitors coming to see the Barnes in their town, in Center City Philadelphia outsiders—and many of them—were welcomed.

Much of this language can be linked to the city's revitalization initiatives, which were expanding during the period in question. As I discuss in the

Introduction to this book and in Chapter 1, twentieth-century deindustrial-ization contributed to social and economic hardship in the city. Middle-class Philadelphians moved from the city to the suburbs in large numbers in the wake of World War II, and that shift in population was detrimental to the urban core. When wealthier white residents left, they took their tax dollars with them and, with time, neighborhoods across the city were in dire need of funds to support new infrastructure, education, and crime prevention. In the 1990s, suburbanites began to move back into the city. This reversal was facilitated by a number of factors, including redevelopment plans that re-ceived extensive support from private funders as well as from state and federal agencies. Early redevelopment efforts focused on the Center City District, which aimed to generate business investment in the city in the hope that it would help rebuild the downtown area and attract residents who wanted to live closer to their offices.[77] In a way, we can interpret the relocation of the Barnes collection from suburban Merion to Center City as a concrete mani-festation of this trend.

One particularly apt metaphor for understanding the relocation of the Barnes as part of Philadelphia's redevelopment comes from the site that it was selected to inhabit in Center City: the grounds previously occupied by the Youth Study Center, a juvenile detention facility located on the Benjamin Franklin Parkway. In September 2002, Barnes Foundation administrators, local philanthropists who supported moving the collection to Philadelphia, and city officials began discussing the possibility of moving the Youth Study Center facilities to an alternate location and reassigning the address on the Parkway to a new gallery space for the Barnes Foundation. In May 2007, the Fairmount Park Commission, which managed the space of the Parkway, de-veloped a ninety-nine-year lease that granted the Barnes Foundation access to the Youth Study Center lot for a ten-dollar fee. Crews razed the building that had previously housed the Youth Study Center, and the City of Philadelphia made plans to open a replacement facility in West Philadelphia. The Barnes Foundation took charge of the site and broke ground for their new building in November 2009. By exchanging the Youth Study Center for the Barnes galleries, Philadelphia literally replaced evidence of urban problems with a relocated suburbanite.[78]

Soon after joining the Barnes Foundation's expanded Board of Trust-ees in 2006, internationally known, Philadelphia-based businessman Joseph Neubauer stressed the cultural value of the collection. He stated: "Great art is the signature of great civilizations. With the addition of The Barnes Foundation to the Benjamin Franklin Parkway, Philadelphia strengthens its

claim as one of the world's premier cultural cities."[79] His words implied that, because of its global relevance, the Barnes belonged in Philadelphia. It was not sufficient simply to have such a significant cultural resource located in the region—to have full impact it must be in the urban center. Neubauer's quote suggested that moving the Barnes to Philadelphia was the best way to recognize the great value of the collection and, for that reason in particular, having the institution in Philadelphia would in turn solidify the city's status as an international center of culture. His embrace of the Barnes as a picture for the city reflected a desire to supercharge the city's reputation as a cultural hub and return twenty-first-century Philadelphia to its former status as the Athens of America.

Supporters of relocating the Barnes collection were not the only ones who recognized the role that the Barnes could play in redeeming Philadelphia's reputation as a cultural center. In fact, some members of the Friends of the Barnes Foundation, writing in protest against relocating the collection, explicitly argued that moving the galleries from the suburbs to the city indicated a lack of cultural understanding that would make Philadelphia the laughingstock of the international arts community. Speaking at a 2007 hearing about the Barnes move, painter Barbara Rosen asked, "How can Philadelphia claim to be a world class city and do something like this?"[80] Her rhetorical question demonstrated that the stakes were high on both sides of the debate.

The conflict between Neubauer's perspective and Rosen's perspective again reflects the challenge presented by the Barnes collection's simultaneous appeal to highbrow and middlebrow preferences. While Rosen's critique appears anchored in her belief that advocates of the move were missing the nuance of the collection's highbrow function, Neubauer's celebration of the Barnes seems to rely on a combination of the collection's excellence and its widespread, although perhaps less sophisticated, appeal. In any case, for both parties the location of the Barnes collection, whether in Merion or Philadelphia, was integrally linked to Philadelphia's status as an aspiring internationally significant city.

Tourism

Many conversations about the Barnes collection's role in elevating Center City's cultural clout were linked directly to Philadelphia's expanding tourism initiatives. The new home of the Barnes on the Parkway was not far from the Franklin Institute, the Academy of Natural Sciences, the Free Library of

Philadelphia, the Rodin Museum, and the Philadelphia Museum of Art. City leaders hailed the planned addition of the Barnes Foundation to the community of institutions lining the Parkway as an important contribution to Philadelphia's cultural tourism industry. Much of the push to reinvigorate Center City was also tied to supporting the city's growing tourism sector, which had become an essential source of revenue in the late 1990s. With Philadelphia's transition to a tourist economy, the city's brand became a primary resource. Efforts to reshape the city's reputation were directly linked to the city's investment in this new industry, and opening the Barnes galleries in Philadelphia was part of that endeavor.[81]

In 2004, as city leaders contemplated repurposing the Youth Study Center property for a gallery building, they envisioned the Barnes Foundation on the Parkway not only as an added resource for people who were already in Philadelphia but also as a draw for potential visitors to the city. As one local journalist reported, "The Barnes and the Art Museum . . . [on the Parkway] would be a must-see for any serious art lover in the world."[82] It is unclear whether these "serious art lovers" were the twenty-first-century equivalent of the "triflers" Barnes despised or folks who, like Barnes's invited guests, "mean business" when they come to learn from the collection.[83] Cultivating the appropriate visitor experience would be the foundation's responsibility regardless of its galleries' location. Either way, the sense in 2004 was that, with two impressive art collections on a single stretch of road, Philadelphia could earn a slot in national and international tourists' itineraries. Furthermore, such a cultural center might rival the appeal of other East Coast American cities like New York, which Philadelphia viewed as a competitor for tourist dollars and cultural clout. Rebecca Rimel, head of the Pew Charitable Trusts, explicitly stated, "My goal would be that Philadelphia would be the destination for European visitors, and they would make a side trip to New York. . . . We have all the assets to make that happen. I believe all those assets coalesce on the Parkway."[84] In this view, the Parkway district was the gateway to the future of tourism in Philadelphia, and the Barnes collection, as a picture for the city, was the keystone that would ensure its stability.

Interestingly, Philadelphia was not the only city to use the Barnes collection to assert its cultural prominence. When Toronto's Art Gallery of Ontario hosted the international tour of paintings from the Barnes collection in 1994, local civic and cultural leaders pointed to the exhibition as evidence of the city's expanding cultural importance. Recognizing the boon to tourism that the Barnes exhibition could offer, Ontario's provincial government provided financial support that enabled the Art Gallery of Ontario to cover up-front

expenses associated with hosting the exhibition. One consultant hired to help the museum raise funds for the Barnes show commented, "The Barnes will put Toronto on the map in the art world."[85]

Despite beliefs that Barnes Foundation galleries on the Parkway would solidify Philadelphia's future as a chief tourist destination, claiming the Barnes collection for the city proper by removing it from Merion was in some ways at odds with Philadelphia's overarching tourism initiative. The Greater Philadelphia Tourism Marketing Corporation (GPTMC), as its name suggests, operated on behalf of Philadelphia broadly defined. It was not the "City of Philadelphia" Tourism Marketing Corporation, but a group created to promote the five counties that included and surrounded the city. It is perplexing that in the early 2000s city promoters argued that moving the Barnes collection from Merion to Philadelphia would be a major asset for the tourism industry because GPTMC, at least ostensibly, operated with a regional agenda, not a local one.

Relocating the Barnes foreshadowed more changes to come. In late 2013, GPTMC announced an official rebranding: from that point onward it would be known as Visit Philadelphia. The official reason for changing the name was to keep up with trends in city tourism across the country, to get rid of the clumsy mouthful of their previous acronym, and to better represent the group's visitor-oriented position, which it surely does. Some might further argue that after years of promoting "Philadelphia and The Countryside" (a trademark registered to the organization), it was no longer necessary to be explicit about the group's regional outlook. Even so, in light of the discourse about place that emerged from the Barnes debates, we can also read the name change as an erasure of the city's surroundings from its chief promotional goals. Whether intentionally or not, the new name of "Visit Philadelphia" solidified a separation between city and suburb that debates about the Barnes had signaled.[86]

Art on the Parkway

When the Barnes collection moved from Merion to Philadelphia, its new form, setting, and operations supported its role as a picture for the city. Although the Barnes remained a private collection, it had come to operate in the highly public manner of representing Philadelphia's mainstream cultural significance to area residents, tourists, and potential visitors. While many aspects of the new campus established continuity between the Barnes in Philadelphia and

Figure 2.5. Construction screen at the site of the Barnes Foundation's Parkway campus. (Photograph by Laura Holzman, 2010.)

the collection's previous home in Merion, the Barnes on the Parkway undeniably reflected the tensions and transformations from the decades leading up to the move.

The foundation cued audiences to its new public status before it broke ground on the urban campus. In mid-2009, crews erected a construction screen around the site of the former Youth Study Center. In addition to the expected chain link and plastic mesh, smooth temporary walls undulated between the plane trees that peppered the Parkway (Figure 2.5). The graceful structure displayed life-sized prints of sections from Barnes's wall ensembles, accompanied by quotes about the collection. The installation was at once a decorative façade for messy urban development, an advertisement for the foundation, and a street-side gallery that invited passersby to step up and examine the images on view. Having long been the subject of public debate, snippets of the Barnes collection now appeared in the most public setting of the city street.

Even as the billboard gallery obscured the activities of the construction site, it suggested an element of transparency. The paintings and metalwork that typically remained behind thick walls and admission fees were temporarily out on the street, available for all in the area to see. Or, at least, images

of them were. In a way, this very public display of pieces of the Barnes collection offered a counterpoint to the accusations of closed-door conspiring that critics of the move leveraged against government officials and the foundation's leaders. It additionally signaled that the new campus would present the Barnes collection as a public resource.

In May 2012, the Barnes Foundation celebrated the opening of its Parkway campus (see Figure 2.1). The 4.5 acres of grounds featured a new building by the noted firm Tod Williams Billie Tsien Architects, with landscape design by the widely respected team at OLIN. The new facilities would be the center of the foundation's art education initiatives, while the arboretum site in Merion would primarily serve the foundation's horticultural programs.

As it debuted its expanded facilities and welcomed the arrival of its permanent collection in Philadelphia, the Barnes also augmented its education programs and visitor services in ways that echoed contemporary trends in visitor-oriented museum practice. Of course, the Barnes representatives were always careful not to call their institution a museum, but by this point the distinction was in the details. For gallery visitors, the Barnes improved its docent services and its audio guide, which diverged from strictly Barnesian methods but provided exceptional insight into the collection. The foundation continued to offer its traditional courses, but it also introduced new education programs, which included additional classes for adult learners and educational partnerships with the School District of Philadelphia.[87]

More significantly, the building spoke the language of a publicly oriented space. Like most major museums, it included visitor amenities such as a café, a library, and ample restrooms. There were large spaces for sitting alone or convening with a group, including a vast interior "light court" (with a footprint nearly the same size as the entire ground floor of Cret's gallery building), which could be easily converted into a reception space for special events. These features created a context notably distinct from the grand but domestic scale and setting in Merion. Taken together, they accentuated the new public inflection that the Barnes collection acquired as a picture for the city.

At the same time, the design of the new site, as well as the materials that promoted it, emphasized connections between the Barnes on the Parkway and the original Merion facilities and function. Like Albert Barnes had done ninety years earlier, the foundation recruited leading architects and designers to envision the new campus. Tod Williams and Billie Tsien's building featured a limestone exterior, just as Cret's did. In homage to the African motifs that adorned the Merion building, the Philadelphia structure also included tile work and patterning inspired by African art and design. Although

the Philadelphia site had additional features like the classrooms, the café, and a special exhibitions gallery, Williams and Tsien also incorporated Cret's historical gallery design into their building. Publicity materials for the opening festivities noted that the permanent collection gallery in Philadelphia "preserve[d] the scale, proportion and configuration of the original Merion gallery."[88] As required by Judge Ott's 2004 decision, the permanent collection was reinstalled in Philadelphia just as it had appeared in the Merion galleries for decades. Newspapers reported that the objects' positions in the new galleries were within one-eighth of an inch of their relative placement in Merion.[89] The one notable exception was Henri Matisse's large painting, *Le Bonheur de Vivre* (1906), which was moved from a stairwell landing to a gallery that purportedly accommodated easier viewing. Designers and curators responsible for that decision either did not know of or did not heed scholar David Carrier's argument that Barnes deliberately installed *Le Bonheur de Vivre* in the transitional space of a stairway.[90]

Installation decisions aside, Williams and Tsien did make a bold intervention in Cret's gallery layout. The architects inserted a courtyard garden with an overlooking windowed walkway and seating area between two of Cret's original rooms on the eastern wing of the building (Figures 2.6 and 2.7). They balanced this new feature with a classroom for seminar-style gatherings on the western side. The glassed spaces offered visitors a place of respite between stimulating galleries, where they could pause, sit, and look at nature. Although visually, materially, and spatially these additions were markedly different from the Merion galleries, the architects, Barnes representatives, and scholars interpreted them as a tribute to the arboretum experience of the Barnes in Merion.

These new features were a key component in Williams and Tsien's overarching concept for the Barnes on the Parkway as a "gallery within a garden and a garden within a gallery."[91] Both their structure and OLIN's landscape design strove to bring the arboretum setting of the Merion campus to the Parkway grounds. The gardens that surrounded the galleries ensured that visitors who looked out the windows as they moved from room to room would glimpse leaves or bark before they spied the city street several yards away. Some of the new plantings were even inspired by the artworks in the galleries. OLIN's gardens, which complemented the preexisting plane trees that had lined that stretch of the Parkway for many years, strengthened the connection between the new Parkway development and the landscape that predated it.

Architectural historian David Brownlee wrote about the Barnes campuses

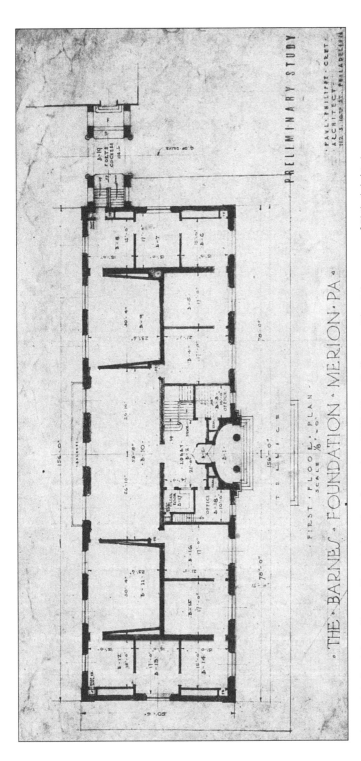

PRELIMINARY STUDY

PAVL · PHILIPPE · CRET
ARCHITECT
112 · S · HOWW · ST · PHILADELPHIA

· THE · BARNEJ · FOUNDATION · MERION · PA ·

· FIRST · FLOOR · PLAN ·
SCALE ⅛″ = 1′-0″

Figure 2.6. Paul Cret, Barnes Foundation, first-floor plan, 1922. (Cret Collection, The Athenaeum of Philadelphia.)

FACING PAGE: Figure 2.7. Tod Williams Billie Tsien Architects, Barnes Foundation, first-floor plan, 2012. Note the additional spaces that Williams and Tsien's team inserted into Cret's layout: on the western side, a seminar room; on the eastern side, a courtyard with a garden. They made comparable additions on the second floor. (Image courtesy of Tod Williams Billie Tsien Architects | Partners.)

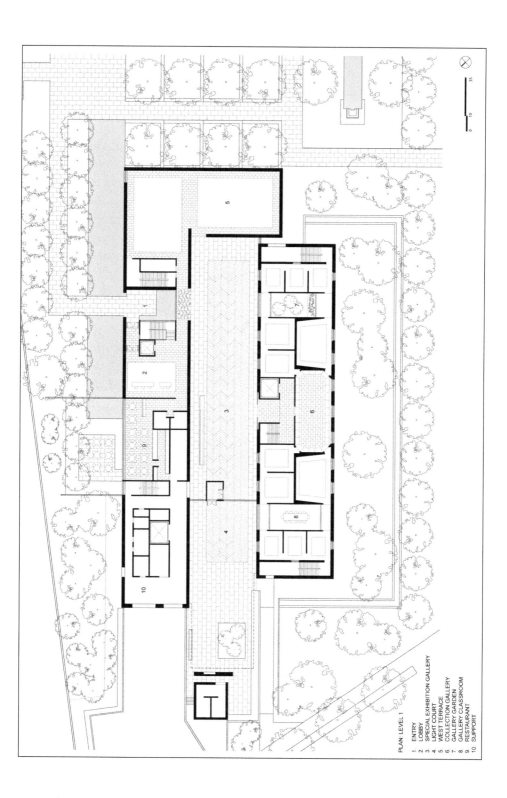

PLAN: LEVEL 1

1 ENTRY
2 LOBBY
3 SPECIAL EXHIBITION GALLERY
4 LIGHT COURT
5 WEST TERRACE
6 COLLECTION GALLERY
7 GALLERY GARDEN
8 GALLERY CLASSROOM
9 RESTAURANT
10 SUPPORT

in *The Barnes Foundation: Two Buildings One Mission,* a short book that the Barnes Foundation published in 2012. His text, like the title, emphasized the connections between the two buildings, which he described as "kindred spirits."[92] Brownlee asserted that the controversy over moving the collection "had little bearing on the architecture" of the new building.[93] The evidence I present in this chapter, however, suggests otherwise. Williams and Tsien's additions to the historical building design reflected the public orientation of the collection that grew out of the debates. Furthermore, without the intense, often intractable conflict surrounding the move, it is unlikely that there would have been such a need to emphasize the continuity between the new and old campuses. Public debate about the Barnes shaped the Parkway campus design and, in turn, the design of the Parkway campus supported the new vision of Philadelphia that those debates also articulated.

The discourse about place and Philadelphia that circulated during the debates is a crucial lens for understanding the Parkway campus. The new campus's emphasis on nature brought to the Parkway a slice of the place specificity of Merion that the critics of the move had described. Although the court ruled that, to observe Barnes's requirement that his paintings remain in "exactly the places" where they were when he and his wife died, the foundation simply had to retain the composition of the wall ensembles, critics argued that the true concept of "place" was more broadly defined. By emphasizing the role of nature in the new Barnes building, the foundation acknowledged that a garden setting was a vital component of the Barnes experience. Incidentally, designers and promoters of the Barnes also privileged more abstractly "green" features of the new building, such as recycled construction materials and a water-reclamation system. The U.S. Green Building Council awarded the Barnes on the Parkway the top level of Leadership in Energy and Environmental Design certification just months after the new facility opened.[94]

As a building notable for its green features and gardens, the new Barnes updated the Benjamin Franklin Parkway in a manner consistent with what the boulevard's designers (including Paul Cret) had envisioned a century earlier. The Parkway was created as a green space that connected city hall to civic and cultural institutions along a verdant boulevard that led to Fairmount Park. It was to be a symbolic space that represented Philadelphia as a center of rational thought, beauty, and civil discourse. Modeled after Parisian grand boulevards, the Parkway was to articulate Philadelphia's successes in a visual and spatial language that placed the city's achievements on par with the European accomplishments that the wealthy patrons and critics admired. Echoing this earlier embrace of fine art and this eye toward Europe, the twenty-first-

century Barnes brought an impressive collection of European modernist art to the Parkway. The new Barnes additionally revised this Eurocentric orientation by accentuating its historical and current relevance to African American culture, particularly through elements of the building's design and through special exhibitions featuring contemporary art of the African diaspora. But, most notably, the Barnes on the Parkway indicated that the verdant features of a wealthy suburb could also exist in Center City. Those suburban trappings additionally enabled the city to claim for itself the sense of safety and security that characterized wealthy suburban environments.

Although scholarship and publicity materials about the new Barnes, in addition to the architecture and landscape design of the Parkway campus, stressed the connections between the sites in Merion and Philadelphia, they could not fully erase the divisions that had emerged during the preceding two decades of debate. When *New York Times* art critic Roberta Smith reviewed the new Barnes campus in May 2012, she found that the reinstallation of the collection in Williams and Tsien's building was an overwhelming success. She wrote that Williams and Tsien managed to capture the spirit of Cret's Merion galleries without creating a phony reproduction, and she championed the vastly improved lighting in the exhibition space, which enabled visitors to physically see the art in ways that they never could before. Especially telling, however, is that Smith ended her article by observing that the Barnes "has been liberated from Merion."[95] Contrary to the foundation's efforts to establish continuity between its life in Merion and its life in Philadelphia, the sense of schism remained.

Further evidence of the divide lingered in the subtlest differences between the permanent collection galleries in Philadelphia and their predecessors in Merion. One of the more satisfying rewards for close looking in Merion came from a Magnavox Victrola record player encased in a mahogany cabinet in the main gallery on the ground floor (Figure 2.8; see also Figure 2.3). The furniture item featured a running wave pattern along its frieze, which connected to a similar motif that appeared on the ironwork both inside and outside of the gallery. If a viewer faced the Victrola and looked up, she could spot the pattern in the iron railing along the upstairs balcony (Figure 2.9). If she turned her back toward the music player and looked through the grand windows, she would find the same pattern on the railing just outside (Figure 2.10). This delightful connection between object and architectural setting disappeared in the Philadelphia building, where there were no railings on the exterior windows, and balcony ironwork was replaced with glass (Figure 2.11). Small factors like this provided reminders that some connections to place were inevitably lost in the move.

Figure 2.8. Record player, mid-twentieth century, Magnavox 1917– , mahogany and brass, 37.25 x 47.25 x 16.75 in. (94.6 x 120 x 42.5 cm). Note the running wave pattern along the frieze above the drawers. (Inventory number 01.01.08. Image © 2018 The Barnes Foundation. Reprinted with permission.)

Figure 2.9. Ensemble view, balcony, southeast view, Merion, Pennsylvania, 2008. The balcony overlooks the main gallery and is visible from the floor below (see Figures 2.3 and 2.11). Note the ironwork with a running wave pattern along the railings in the archways. (Image © 2018 The Barnes Foundation. Reprinted with permission.)

Figure 2.10. The running wave pattern on the ironwork outside the Barnes Foundation gallery building in Merion, Pennsylvania. (Photograph by Laura Holzman, 2010.)

Figure 2.11. Ensemble view, Room 1, north wall, Barnes Foundation, Philadelphia, 2012. Note the absence of ironwork in the railing separating the mezzanine from the main gallery. (Image © 2018 The Barnes Foundation. Reprinted with permission.)

When the Barnes galleries finally relocated to the Parkway, those who had led the effort to get them there aimed to tell a cohesive story that underscored the continuity between the collection's life in Merion and its new home in Philadelphia. But the distinctions between Merion and Philadelphia that emerged during the preceding decade of debates had played an important role in facilitating the move, and they could not be effaced so easily. Even while the landscape design and architecture of the Barnes's Parkway campus reflected elements that had been present in Merion, they also bore reminders of the distinction between the new grounds and the historic exhibition site. This play of similarity and difference tied the new installation of the Barnes collection to the debate about place that had brought it to the Parkway.

It is imperative to remember that although supporters envisioned the move as a way of opening up the collection, the project resulted as well in a kind of closing off—it divided public opinion and forged a conceptual split between city and suburb. Debates over moving the collection figured Philadelphia and Merion as two distinct locations, separate from and in competition with each other, rather than as collaborative parts of a unified region. In turn, they suggested that Philadelphia's urban core was to be the primary source of the region's cultural identity. In the new public image of the city, "Philadelphia" pertained to the area anchored in Center City that could offer diverse residents and visitors access to world-class culture in a vibrant, green setting. Installed in a large public facility, interpreted through expanded public programs, and positioned in close proximity to other major cultural institutions, the Barnes on the Parkway became a symbol of that vision for the city.

3

Dr. Gross Heals Philadelphia

Establishing twenty-first-century Philadelphia's reputation as a vibrant center of culture was no straightforward task. Boosting the city's image as a cultural hub required demonstrating that Philadelphia could hold its own when compared with other major U.S. cities. It also required contending with the poverty and violence that affected the lives of many Philadelphians and had long dominated characterizations of the place. These concerns converged around a single nineteenth-century painting that emerged as a picture for the city working on behalf of Philadelphia in late 2006. Through this potent object, Philadelphians strengthened the connection between the twenty-first-century city and its nineteenth-century accomplishments in order to assert that the current city's cultural assets were worthy of national attention, even in comparison to its neighbor, New York.

In 2002, *New York Times* art critic Michael Kimmelman hailed *The Gross Clinic,* painted by Thomas Eakins in 1875, as "hands down, the finest 19th century American painting."[1] The renowned portrait of Dr. Samuel Gross depicts an operation in which one of Philadelphia's most celebrated surgeons oversees the removal of a section of infected bone from his patient's thigh (Figure 3.1).[2] An anesthesiologist holds a chloroform-soaked compress over the patient's face, while a quintet of assistants steadies the small body and carries out the procedure. A woman, perhaps the patient's mother, sits to the left of this group and shields her face in horror while an audience of medical students looks on with responses that range from fascination to boredom.

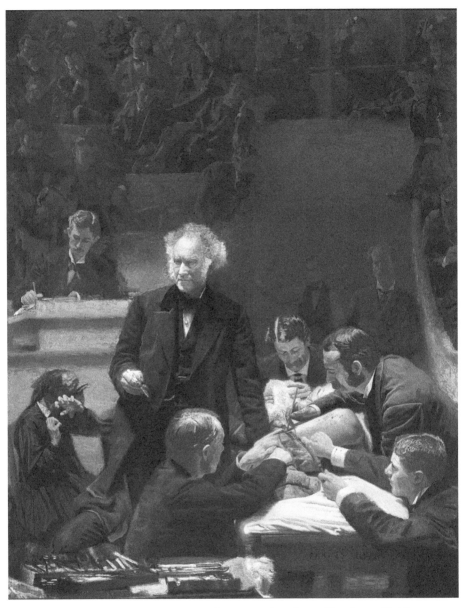

Figure 3.1. Thomas Eakins, *Portrait of Dr. Samuel D. Gross (The Gross Clinic)*, 1875, oil on canvas, 8 ft. x 6.5 ft. (243.8 x 198.1 cm). (Philadelphia Museum of Art, Gift of the Alumni Association to Jefferson Medical College in 1878 and purchased by the Pennsylvania Academy of the Fine Arts and the Philadelphia Museum of Art in 2007 with the generous support of more than 3,600 donors, 2007-1-1.)

Eakins put himself in the crowd, too. He is seated in the audience to the far right, pencil in hand, his body cropped by the edge of the canvas. Dramatic lighting heightens the intensity of the scene by spotlighting Gross's head, his bloody fingers, and the operating table, while other elements recede into the carefully modeled tones of darkness. Details such as Gross's scalpel and watch chain are meticulously rendered, while other parts of the image—including the surgical tools in the foreground and the faces of some audience members—are more loosely sketched in paint.[3] This scene has been interpreted in many ways. For numerous art historians, the portrait has offered insight into a variety of nineteenth-century issues, spanning from American scientific achievements to the sexual politics of Eakins's personal life.[4] Eakins painted the portrait largely to make a bold statement about Philadelphia's accomplishments in art and medicine, but it did not truly fill that role until the twenty-first century, when it became the subject of impassioned public discourse. At that time, it emerged as not only a picture for the city but also as a new city icon, a contemporary cultural object deeply linked with Philadelphia's identity.

In early 2007 the Philadelphia Museum of Art and the Pennsylvania Academy of the Fine Arts (PAFA) jointly purchased *The Gross Clinic* from nearby Thomas Jefferson University, which had owned the painting of its esteemed faculty member since 1878. The sale was contentious in part because the museum and PAFA were competing with a deep-pocketed buyer from outside the region. Unlike the controversy over the Barnes collection, which was highly divisive in the Philadelphia area, the intense public exchanges about *The Gross Clinic* brought together an array of stakeholders in and around the city who fought to keep the painting local. The public discourse surrounding the sale transformed *The Gross Clinic* into a city icon that played a crucial role in negotiating Philadelphia's reputation in the early years of the twenty-first century. Other scholars have noted that the circumstances of the sale reaffirmed the object's relevance for contemporary viewers. The painting became linked to contemporary civic pride in Philadelphia as people talked about, wrote about, and even donated money to support the museum and PAFA's purchase of the artwork.[5] And yet, existing scholarly accounts of the sale of *The Gross Clinic* leave unanswered two of the most compelling questions about the case: Why did the painting generate as much discourse about local pride as it did? And how did that surge of enthusiasm affect the painting in return? In the context of this book, those questions are even more pressing because their answers illuminate nuanced aspects of the joined processes of shifting Philadelphia's identity and creating city icons.

The Gross Clinic became the subject of extensive public discourse in large part because of the historical circumstances that characterized Philadelphia around the time of the painting's sale. Fueled by impressive grassroots efforts and institution-led public relations campaigns, widespread discussions about *The Gross Clinic* allowed area residents to redefine Philadelphia as a sophisticated metropolis during a time when individuals and institutions across the city were particularly invested in reshaping the region's reputation. If the public debate surrounding the Barnes collection was in part about identifying Center City as the place for culture in Philadelphia, the public campaign surrounding *The Gross Clinic* demonstrated how the city could value its cultural resources in their Center City setting.

The ideas circulated in press releases, newspaper articles, published letters, radio programs, and blog posts transformed the painting from an American masterpiece into a Philadelphia icon. In one especially meaningful inflection of this public commentary, many individuals shared their personal memories of the painting. The private significance that *The Gross Clinic* held for these Philadelphians became evidence of the object's deep ties to Philadelphia and a catalyst for the painting's emergence as an important public image. In contrast to the case of the Barnes collection, in which public discourse congealed an array of objects into a single symbolic entity, *The Gross Clinic* was a single object that conversations infused with a multitude of memories, which then generated the object's iconic status.

This chapter begins with an overview of the painting's sale and the flood of public discourse that developed around it. After addressing relevant aspects of the painting's history, I examine the ways in which the painting provided a valuable tool for rallying local pride and elevating the city's reputation. I then consider in more detail the specific role that crafting and recalling memories played in the two-year saga of buying the portrait of Dr. Gross. Ultimately, this chapter tells the story of a tangled archive crafted around, including, and illustrated in *The Gross Clinic,* a twenty-first-century city icon.

The Announcement

News of the painting's sale broke on the front page of the *Philadelphia Inquirer,* announced by the headline, "City Art Icon About to Be Sold." On November 11, 2006, Jefferson University publicly declared that it would sell *The Gross Clinic* for $68 million, a record-breaking sum for an American painting made before World War II.[6] To raise funds for a major expansion project, the university had negotiated a sale arrangement with the National Gallery of Art

in Washington, D.C., and Alice Walton, heiress to the Wal-Mart fortune, who was in the process of collecting American art for the new Crystal Bridges Museum in Bentonville, Arkansas.[7] The deal included a clause, however, stipulating that if a local institution could match the $68 million price within a period of forty-five days, the painting would remain in Philadelphia.

Many Philadelphians, in particular members of the arts and medical communities, responded to Jefferson's announcement with outrage and surprise. They identified *The Gross Clinic* as a local icon and began a grassroots effort to keep the painting in the city. Within one week, the Philadelphia Museum of Art and PAFA, in partnership with other prominent local organizations and civic leaders, collectively launched a formal drive to raise the $68 million necessary to keep the painting for the city's cultural legacy.[8]

For some participants, this effort called to mind another campaign from a decade earlier, which had blocked a historic mosaic from being sold away from Philadelphia. *The Dream Garden* (1914–1916) was an impressive collaboration between artist Maxfield Parrish and Louis Comfort Tiffany's renowned glass studio. Commissioned by publisher Edward Bok for the lobby of his headquarters building, *The Dream Garden* had been on view in Philadelphia since 1916. In 1998 the building's owner announced plans to sell the mosaic to casino magnate Steve Wynn, who planned to move the work to Las Vegas. After public outcry about the sale, local institutions managed to halt the transaction. PAFA, with major support from the Pew Charitable Trusts, bought the artwork instead, allowing it to remain at the site it was designed for. In 1998 it took $3.5 million for Philadelphia to retain *The Dream Garden*. While this was no negligible amount, the $68 million price tag on *The Gross Clinic* far surpassed it.[9]

A major public relations campaign helped develop and sustain support for the daunting task of purchasing *The Gross Clinic* for Philadelphia. Local newspapers published a series of articles examining the various facets of the painting's history, its ties to Philadelphia, and the terms of the sale. Public broadcasting station WHYY dedicated radio programming to exploring the issues at hand and hosted public discussions about the sale. It also established *The Sixth Square,* a current events blog where the station posted an Eakins-related entry each day, accompanied by a reminder of the time remaining until the December 26 money-match deadline.[10] In the comments section of the blog, arts enthusiasts, lawyers, and other people who had a vested interest in either celebrating *The Gross Clinic* or examining the significance of keeping it in Philadelphia found a forum in which to share their thoughts about the sale. Several other media outlets, including local weeklies, national press

wires, and a seemingly limitless number of blogs created buzz that, for those embroiled in the local culture scene, amounted to something more of a roar.

I, too, participated in this process. In November 2006, I worked at the Philadelphia Museum of Art, where I spent three months buried in piles of relevant press clips, swept up in the excitement of the moment, and positioned in an in-between space where I simultaneously facilitated a movement to keep *The Gross Clinic* in Philadelphia and watched from the sidelines as the story developed around me. As a junior member of the press relations team I had little if any involvement in generating formal language about the painting or the project, but I paid close attention to the ways in which people outside the institution were talking and writing about our work. Much of my curiosity about visual culture and Philadelphia's reputation grew out of what I observed during this experience. It followed me to graduate school, where I began to approach these matters from a scholarly perspective, and it expanded into the research project that became *Contested Image*.

A Philadelphia Icon?

The most remarkable characteristic of the public discussions concerning *The Gross Clinic* was the oft-invoked language of local pride, communicated through testimonials grounded in personal memories. Throughout this process, the Philadelphia Museum of Art, PAFA, and their partners celebrated *The Gross Clinic* as "a tremendous work of immeasurable value to Philadelphia," and regularly discussed it as a masterpiece emblematic of the city's rich cultural history. In a much-needed opportunity for community spirit building, Philadelphians were invited to unite in an effort to prevent what was considered the theft of a local treasure. In one interview, Philadelphia Museum of Art director Anne d'Harnoncourt stated boldly and clearly, "This is about saving a Philadelphia icon."[11]

The Gross Clinic had long been recognized as one of the great works of American art, but d'Harnoncourt's comment represented a new type of statement about the painting. Although many people described *The Gross Clinic* as a Philadelphia icon that fall, the painting had not previously served such a function. Those very conversations in late 2006 were what transformed *The Gross Clinic* from an icon of American art and an important Philadelphia painting into a city icon. Word choice and rhetoric, supercharged by current events and bolstered by collection management decisions, changed the meaning of the object.

In many ways *The Gross Clinic* is, as it has been called, "unarguably a Philadelphia painting."[12] The artist's strong ties to the city are well founded. Born in Philadelphia, Eakins spent most of his career in the city. He studied and taught at PAFA and became director of the school in 1882. He revolutionized the school's curriculum but eventually left his position amid controversy and harsh criticism after using nude male models in a coed classroom.[13]

Years before these events, while Eakins was still establishing himself as an artist, he painted *The Gross Clinic*—a scene from the operating room of the most famous doctor in a city known internationally for its role in medical innovation. Philadelphia was indisputably the early center of medicine in the United States, but, as I note in Chapter 1, by the 1870s other American cities had joined Philadelphia as notable hubs of medical research and practice. Even so, Dr. Gross, a professor at Jefferson Medical College, was widely respected as an exemplary surgeon in the United States and in Europe. By selecting Gross, his colleagues, and his operating room as the subjects of this painting, Eakins encapsulated the sustained medical excellence associated with his hometown.[14]

Eakins created *The Gross Clinic* as a submission for the Centennial Exhibition, the 1876 world's fair held in Philadelphia in celebration of the hundredth anniversary of the country's founding. As other scholars have demonstrated, the fair was a crucial moment for holding up the United States in comparison to its European counterparts. Beyond showcasing American achievements, the Centennial Exhibition also presented an opportunity to highlight the numerous ways in which its host city uniquely contributed to American progress. *The Gross Clinic,* a masterfully rendered depiction of a beloved surgeon overseeing an innovative medical procedure, offered a powerful representation of Philadelphia as a city where both the medical arts and the fine arts thrived.[15] Early commentary about the painting suggests, however, that audiences missed this message.[16]

The selection committee for the Fine Art Gallery at the Centennial Exhibition rejected *The Gross Clinic* for being too gory. The piece appeared instead in an exhibition of medicine-themed objects in the U.S. Army Post Hospital display on the Centennial Exhibition fairgrounds (Figure 3.2). Perhaps the bloody scene proved so unpleasant that it distracted viewers from the message about Philadelphia's excellence that they might have otherwise found in the painting. Those who wrote about the artwork focused instead on its quality as a portrait, its connections to the local medical community, and Eakins's technical abilities. Some early critics hailed the painting for

Figure 3.2. Centennial Exhibition, Hospital of Medical Department USA, Ward no. 1, view from southern end, 1876. At the Centennial Exhibition, *The Gross Clinic* was displayed in a medical exhibition rather than in the art gallery. (Image courtesy of the Library of Congress, Washington, DC.)

being "intensely dramatic," for adeptly capturing the sensation of being in a surgical theater, and for demonstrating the artist's uncanny aptitude for drawing (with the exception of the figure of the patient, which critics argued was an illegible "puzzle").[17]

Two years later, the alumni of Jefferson Medical College bought the portrait for the school's collection.[18] It subsequently traveled to exhibitions around the United States, including the 1879 Society of American Artists Exhibition in New York, the 1893 World's Fair in Chicago, and the 1904 World's Fair in St. Louis. Although reviews described Eakins and Gross as Philadelphians and identified various successes and failures of the painting, the texts I have seen made no explicit connection between the artwork and the nature of the city in which it was painted.[19]

A painting does not automatically become a picture for the city—let alone a city icon—simply because it was made by a local artist and depicts a famous local doctor. Just as national icons must offer "affirmations of a coun-

try's values and . . . evidence for its uniqueness,"[20] a city icon must similarly reflect the values and uniqueness of the place with which it is affiliated. And, like any form of communication, the meaning depends on how the message is received, not only on how it is produced. Although scholars have demonstrated that Eakins painted *The Gross Clinic* as an expression of Philadelphia's greatness, the painting did not achieve city icon status in the eyes of other viewers until more than a century after it was first exhibited.[21]

The Gross Clinic has been perceived predominantly in a hybrid manner, with both local and national significance, but before 2006 those dimensions of significance came together most strongly to make a statement about American art, not about Philadelphia in particular. Art historians have shown that, in much of Eakins's work from the 1870s and 1880s, the artist depicted indisputably Philadelphian people and places in a way that leveraged regional specificity to make a case about national American culture to an international audience.[22] Eakins's skillful renderings of Philadelphia scenes showed that American art could be as compelling as European painting, which was considered the highest form of fine art at the time.[23] While tucked away in a gallery at Jefferson University, the portrait of Dr. Gross acquired an extremely local value as an iconic image for the medical students and professionals affiliated with the school.[24] Concurrently, and more notably, the painting also gained relevance on a national scale, but not exclusively because of its connection to Philadelphia. During the twentieth century *The Gross Clinic* became known as an icon of American painting, but it was still not a Philadelphia icon.

Proving a negative is no easy task. But, if *The Gross Clinic* had been considered a Philadelphia icon before 2006, surely its status would have been acknowledged, perhaps even celebrated, in one of the major museum exhibitions that featured the painting in the preceding quarter-century. Examining two important Eakins exhibitions at the Philadelphia Museum of Art provides no evidence of the painting's role as a city icon. Instead, it is notable that both shows interpreted the portrait as a nationally significant icon of American art.

The Philadelphia Museum of Art marked Philadelphia's 1982 tercentennial with "Thomas Eakins: Artist of Philadelphia," a major retrospective of work by the most famous nineteenth-century artist to emerge from the city. Exhibition materials stressed the unique relationship between Eakins and Philadelphia and asserted that he was "one of the few American artists to be so dedicated to one city."[25] Although Eakins may have been considered a Philadelphia icon within the context of this exhibition, *The Gross Clinic* was not.

The exhibition presented *The Gross Clinic* as a national icon *in* Philadelphia, rather than as an icon *for* Philadelphia that also had national significance. When museum director Jean Sutherland Boggs contacted the president of Jefferson University to request that the school lend *The Gross Clinic* for the tercentennial show, she stated that the painting, "needless to say, would be one of the great stars of the exhibition." But her justification was grounded in "showing our pride in Eakins's work" rather than in any argument that it was vital to have a city icon in an exhibition that celebrated the city's rich artistic history.[26] In an exhibition dedicated to Eakins's relationship with Philadelphia, it would have been logical to interpret *The Gross Clinic* as a city icon if it were one at the time. The absence of such language from the exhibition materials suggests that the painting was not considered a Philadelphia icon in 1982.[27]

Just as the museum brought out Eakins to celebrate Philadelphia's first 300 years, the institution also featured Eakins in its own milestone celebration. "Thomas Eakins: American Realist," presented in 2001 in honor of the museum's 125th anniversary, examined "the career of Thomas Eakins from controversial native son to icon of American art."[28] As with the 1982 exhibition, there was talk of iconicity and Eakins's important connections to Philadelphia. Again, those concepts aligned differently than they did in 2006. One remarkable feature of the 2001 show, however, was that the exhibition asserted a unique and meaningful connection between *The Gross Clinic* and the Philadelphia Museum of Art, expanding the painting's institutional associations beyond Jefferson University. Both the museum and *The Gross Clinic* had their origins at the Centennial Exhibition. At the close of the fair, Memorial Hall, the building that housed the art gallery during the festival, became home to the city's Museum of Art and Industry, which transformed into the Philadelphia Museum of Art in the decades that followed. As an exhibition press release underscored, the museum's 125th anniversary also marked 125 years since "Eakins's decisive emergence as a great and distinctively American artist."[29] Although the exhibition materials stressed Eakins's iconic status and the symbolic relationship between *The Gross Clinic* and the museum, it still did not indicate that the painting was itself a city icon, uniquely charged with representing Philadelphia.[30]

Local Pride and Local Problems

Specific circumstances in Philadelphia in 2006 fostered an environment in which *The Gross Clinic* could become a city icon. The news of the painting's sale pushed the artwork into the spotlight of public awareness, where it

resonated particularly strongly with other matters of public concern during a period of transition in the city. It was a moment when Philadelphia appeared to be pivoting from being weighed down by a reputation as a troubled, gritty city to being elevated in the eyes of select residents and outsiders as a place with a world-class arts and culture sector. The tensions between these visions of Philadelphia played out in the conversations surrounding *The Gross Clinic.*

As the cultural institutions forged ahead with their effort to purchase *The Gross Clinic,* Philadelphians like Sister Mary Scullion, a prominent advocate for people living homeless, reminded those who would listen that other local concerns also deserved significant public attention and fund-raising. Public education, fighting hunger, reducing homelessness, and preventing crime were undersupported initiatives that, if strengthened, could improve life for many Philadelphians. Scullion explained, however, that "the controversy over this painting should not pit the arts against human needs." She noted that the money from the *Gross Clinic* sale would ultimately support Jefferson University (and, consequently, medical research and training). But, perhaps more importantly, the *Gross Clinic* campaign presented an opportunity and, in her view, an ethical requirement for the city to approach the task of strengthening social services beyond the arts with the same enthusiasm that was being directed toward the campaign to help PAFA and the Philadelphia Museum of Art buy Eakins's painting.[31]

As indicated by Scullion's work, this arts movement was necessarily linked to other concerns about the city. The December 14, 2006, "Letters" section of the *Philadelphia Inquirer* offers a telling example of the ways in which *Gross Clinic* advocacy butted up against other civic concerns. Of the three letters printed that day, one was from James F. Lally, a resident of a wealthy Philadelphia suburb, who argued, "*The Gross Clinic,* then, is just as important to the cultural heritage of Philadelphia as the Elgin Marbles are to Greece." Another came from city resident Jarel Daniels, who struck a remarkably different tone. "Right now," he wrote, "there are over 380 murders that have happened in Philly. What is the reason for all this killing? Why is there so much hatred in the city of brotherly love?"[32] That year, the number of murders in Philadelphia spiked to more than four hundred, drawing concern from the public and politicians alike. In late 2006, anxieties about Philadelphia's skyrocketing homicides appeared to be the only topic to rival the buzz surrounding the sale of *The Gross Clinic.* As the two major news stories of the season, these concurrent concerns sat side by side in the *Inquirer,* followed one another as conversation topics, and intermingled—at least conceptually—in an intense historical moment.

The November 2006 edition of *Philadelphia Magazine,* with a feature story on the city's homicide problem and a cover that placed the word "murder" in large print above a handgun, provoked a concerned response from the local tourism industry. The November issue deviated from the publication's typical appearance. For example, the September 2006 cover featured a well-styled young white man in casual teenager garb alongside the headline, "40 Best High Schools," and the December cover called out to readers with a photo of Sylvester Stallone and the headline, "Admit It: You Still Love Rocky." The September cover did address the rising crime rate by mentioning the article "Murder Rages On: The Tragic Story of One Neighborhood," but it relegated murder to the margins by cloaking the ominous headline in a small font size and tucking it away above the eye-catching magazine title, in the upper-left corner of the page. November put homicide front and center. Executives who feared that the November edition would scare visitors discouraged hotels from giving their guests copies of the magazine, which typically served as an advertisement for all that the city had to offer. The murders made Philadelphia look unappealing to potential vacationers, which posed a problem for the city's reputation and, related, its tourism economy.[33]

That fall, popular discourse informally replaced Philadelphia's nickname, "The City of Brotherly Love," with the harsher label of "Killadelphia." The term itself dates back to at least the mid-1990s. It appeared in reference to 1980s police violence against civilians and is connected to the infamous cases of Mumia Abu-Jamal and the firebombing of the home of members of the radical group MOVE. It has since appeared in hip-hop lyrics, heavy metal albums, and newspaper articles, not necessarily because of its connotation of police corruption. In response to the more recent violence in the region, artists and journalists alike adopted "Killadelphia" to describe civil conflict, not abuse of institutional power per se.[34]

Acquiring the nickname "Killadelphia" could not have helped the self-esteem of a city that seemed continually presented as downtrodden or second-rate in comparison to its neighbor, New York. As I discuss in Chapter 1, Philadelphia held a position of prominence as the nation's capital in the eighteenth century and as a center of American art and science during Eakins's lifetime a hundred years later, but the city lost its distinctive standing over the course of the twentieth century. Late twentieth-century Philadelphia was described instead as a "flyover city," "sandwiched between New York and Washington."[35]

The region began to experience renewal on the eve of the twenty-first century. A significant strand of that transformation involved groups and individuals that sought to establish continuity between the contemporary city

and its previous successes. Around the time of the *Gross Clinic* sale, celebratory accounts of Philadelphia's past put forward by local organizations stressed the city's role as the civic and social model on which the United States was founded.[36] Cultural organizations like PAFA, which dated back to Philadelphia's era of prominence, strengthened the connections between the twenty-first-century city and its historical prestige. Beyond that, the city's strong arts and culture sector played a key role in revitalizing Philadelphia. As a 2007 report from the RAND Corporation indicated, "The contribution of the arts to this renaissance is evident in their ability to attract patrons from the city, suburbs, and outside the region to downtown, in helping to trigger upgrading in the neighborhoods to which artists move, and in instilling a sense of community identity in other neighborhoods."[37]

Two years earlier, the *New York Times* explored a related aspect of Philadelphia's transformation in an article entitled "Philadelphia Story: The Next Borough." Author Jessica Pressler, then a prominent Philadelphia-based journalist, defended her city by noting that young creative types had started abandoning their expensive Brooklyn homes in favor of a more affordable, yet equally satisfying, lifestyle in Philadelphia. Although many Philadelphians dismissed the piece as shallow, it circulated so widely that it would be foolish to ignore its potential impact on the city's reputation. Despite its derogatory positioning of Philadelphia as a mere extension of New York, Pressler's article was part of a campaign to attract positive publicity for the city and, in turn, to continue fueling the migration that she described. In an interview conducted shortly after the piece was published, Pressler identified her article as a "love letter" to Philadelphia. Less than five years later, she moved to New York.[38]

Although Philadelphia had earned a negative reputation, the early twenty-first-century city was home to a burgeoning arts and culture community. The crimes that invited its punning moniker, while severe and significant, mainly occurred in neighborhoods outside of the Center City culture and tourism districts. Like other city boosters, the artists, patrons, administrators, and civic leaders involved in fighting to keep *The Gross Clinic* in Philadelphia may have been eager, even unconsciously, to highlight the city's rich cultural history to call attention to the region for something other than its violent crime statistics. As I indicate in Chapter 2, this concern was reflected in the decision to replace a juvenile detention facility on the Benjamin Franklin Parkway with the new Barnes Foundation galleries, a plan that was in development during the *Gross Clinic* sale.

When Philadelphia Museum of Art curator and Eakins scholar Kathleen Foster proposed "Ten Reasons to Keep *The Gross Clinic* in Philadelphia,"

her tenth reason encapsulated this spirit: "If Philadelphia is to be America's 'Next Great City,' it must protect the special qualities that residents prize and visitors seek, and remain inspired by the city's tradition of excellence in art, science, and education, united in America's greatest nineteenth-century painting, *The Gross Clinic*."[39] Although neither she nor her colleagues ever explicitly connected the effort to retain *The Gross Clinic* with an interest in combating the city's reputation for violence, their discourse implied a desire to present Philadelphia as primed for its comeback, and *The Gross Clinic* offered an appealing rallying point for the movement.

In this spirit, Dr. Gross would not only heal his patient through surgery; he would also repair the broken city and prescribe the antidote for Killadelphia. The formal qualities and iconography of the dramatic painting have the potential to stir feelings of horror similar to those that Philadelphians may have felt when they considered the violence in their city. But violence was not the source of the glistening blood on Gross's hand. Quite the opposite: it was evidence of his thoughtful, careful, clinical attempt at saving a life (or at least a leg). The heroic figure of the white surgeon whose halo of grey hair betrays his age and indicates his wisdom was a striking contrast to the image of the young men of color who were most often the victims and perpetrators of the murders that rocked the city.[40]

Furthermore, because the painting itself transitioned from a position of disrepute to celebration (exiled from the Fine Art Gallery at the Centennial Exhibition, but later exalted as a great American painting), the story of *The Gross Clinic* offered an apt metaphor for the way Philadelphians with cultural capital wanted to see their city. For many years, local leaders in the arts pointed to the sector as a major factor in the economic and social improvements that came to Philadelphia; rallies around the power of *The Gross Clinic* emerged as a particularly recognized component of that broader movement.

Local pride echoed through the public discourse surrounding the Eakins sale. In a darker variant of this trend, Philadelphians who wrote about their frustration with Jefferson University's actions frequently made disparaging comments about Bentonville, Arkansas, as the painting's potential future home. One respected Philadelphia art blog even began a post with a map of the South and a dismissive question: "So where the hell is Bentonville, Arkansas, anyway?"[41] Eventually this kind of attitude prompted an artist with ties in both Philadelphia and Arkansas to publicly comment and scold Philadelphians for the stereotypes of "backward" Arkansans that were circulating unchallenged.[42]

The local pride that emerged around the sale of *The Gross Clinic*, even if declared at the expense of another region, was good for Philadelphia. In a quintessential example of community building, Philadelphians came together as they defined themselves against the other of Arkansas. In the imagined generalized backwoods of the American South, Philadelphians found a site that was markedly different from bustling East Coast cities like their own metropolis and the nearby economic and cultural centers that threatened to eclipse it. By embracing an identity that was presented in stark contrast to a supposedly sleepy region, Philadelphians found a counter to their second-tier reputation in relation to their neighbor New York. Their rhetoric implied that as long as the painting stayed in Philadelphia, it would be accessible to a broad public. For them, Bentonville, not Philadelphia, was stagnant and out of touch. While the city came together in a unified group, debates over the value and meaning of *The Gross Clinic* allowed members from a variety of communities across the city to differentiate themselves as they engaged in a continuous dialogue about issues affecting the region.

The episode also offered a concrete opportunity for Philadelphia to best New York. In 2005, Alice Walton notoriously purchased Asher B. Durand's *Kindred Spirits* (1849) from the New York Public Library. As with the *Gross Clinic* sale, interested parties were invited to compete for the prize of the painting. To the dismay of critics, the sale of *Kindred Spirits* was orchestrated through a sealed-bid auction in which bidders had no knowledge of what prices others proposed. Walton's offer trumped an effort from the Metropolitan Museum of Art and the National Gallery of Art to jointly buy the painting. Leaders at cultural institutions across New York publicly shared their disappointment that the painting would leave the city.[43] An underlying thread of the 2006 *Gross Clinic* discourse suggested that if Philadelphians could intercept Walton's attempt to remove a prominent painting from their city, they would have clear evidence that, at least in this case, Philadelphia could be successful where New York had failed.[44]

Personal Connections

Civic pride was not the only theme that characterized the efforts to keep *The Gross Clinic* in Philadelphia. There was also an enormous outpouring of individual memories about the painting as people tried to understand, reflect on, and shape the historic moment. Taken together, these personal memories played a vital role in transforming *The Gross Clinic* into a city icon.

The following paragraphs examine those memories in detail. As people confronted the potential loss of this artwork, they publicly shared their personal memories. Those memories intertwined to form a collective memory that could have become a substitute for the physical painting once it moved to its new site, whether it was a local gallery space or an out-of-state museum.

It makes sense that memory became an important vehicle for processing the sale of *The Gross Clinic*. Art historians, theorists, and museum studies scholars have long recognized that collecting and exhibiting objects is tied to memory practices. Frankfurt School theorist Walter Benjamin famously illustrated the way this phenomenon plays out for individual collectors in an essay about his personal library.[45] Benjamin's books served as mnemonics for past events in his life and also enabled connections to previous owners. Similarly, objects under the stewardship of a museum become memory aids that the institution's staff and visitors can activate to tell a story. In this process some relevant details are inevitably omitted and, in turn, some narrative strands are forgotten.[46] If collection building is a process through which history or memory can be formed, we can think of deaccessioning (removing objects from a collection) as an act of forgetting. The individual or institution that deaccessions objects determines that those items are no longer crucial for evoking the memories that the collector prioritizes. Although the American Alliance of Museums and the Association of Art Museum Directors do not explicitly state that memory loss that can occur with deaccessioning, professional guidelines in other countries directly note that deaccessioning may lead to a loss of cultural memory.[47] These concepts become particularly useful when considering the case of *The Gross Clinic,* an object connected to individual and collective memory within and beyond the museum.

Just as Benjamin's books became vessels for his memories and experiences, so too did *The Gross Clinic* apparently carry with it episodes from the personal history of many Philadelphians. These accounts circulated during the Eakins media frenzy in 2006. By deaccessioning *The Gross Clinic* and potentially sending it off to Arkansas, Jefferson University threatened to induce a kind of memory loss. One way to protect the memories that the painting evoked was to transfer them from individual to communal recollection.

Personal reflections on *The Gross Clinic* transitioned from private memory to collective consciousness as they were shared in public forums like blogs, newspaper articles, call-in radio programs, and town-hall-style meetings. For example, Steakbellie, a blogger, published a story on November 17, 2006, in which he recounted a spectacular drunken adventure that began with a trip to the Army-Navy football game, involved a Bill Clinton sighting, progressed

to a victorious Penn basketball game, and ended with a midnight trip to Jefferson University, where he and his companion convinced a security guard to let them see *The Gross Clinic*. Steakbellie reflected, "I wish I could remember what the hell he said to them to let two very drunk, very cold twentysomethings into a room so that they could see the most valuable (and in my mind) most important painting in all of Philadelphia."[48]

A few days later, *Philadelphia Inquirer* culture reporter Stephan Salisbury similarly shared personal anecdotes from a number of local artists about inspiration derived from Eakins's work. Painter Larry Francis proudly traced his educational pedigree directly back to Eakins. Outlining his creative ancestry in near-biblical fashion (a practice not uncommon among academic artists and the scholars who study them), Francis recalled studying under Lou Sloan, who trained with Daniel Garber, who was taught by Thomas Anshutz, who was one of Eakins's students. Salisbury reinforced this concern with lineage by introducing readers to Pennsylvania residents descended from Dr. Gross and others who appear in the painting. Personal connections to Eakins and the legacy of *The Gross Clinic* resonated through most of the popular discourse on the subject.[49]

As part of their personal response, Philadelphians discussed the impending loss of the painting in extreme terms. They frequently described their feelings as those of "grief" when lamenting the projected departure of the "cultural heart of the city." Patrick Connors, organizer of a series of protests against the sale of the artwork, stated that "it would [cause] irreparable damage to allow the painting to leave Philadelphia." Local journalist Roberta Fallon felt "heartsick," and explained that the sale was "just depressing and shocking." Others simply referred to the situation as "tragic." Gary Carpenter, an amateur painter and member of Jefferson's faculty, explained, "I like [the painting] more than I like some of the people around here. . . . It's almost like losing a friend."[50]

These personal expressions of grief joined other individuals' reflections to construct what I call a *memory screen:* an intangible prosthetic replacement for the physical painting. Building on the language of the "screen," theorist Michel Foucault referred to a "screen-discourse" as one that obscures its subject by constructing a barrier of scholarship around it.[51] This memory screen functions similarly. The shared personal memories came together to build a collective-memory screen, constructed to conceal the void left where *The Gross Clinic* would have hung.

The memory screen also corresponds to the screen memory, the psychological phenomenon that Sigmund Freud proposed occurs when patients

develop strong memories that vastly differ from the actual events of a traumatic situation. Such a memory, he argued, serves as a barrier, or screen, that protects against a suppressed, distressful, memory. The screen memory, in other words, is a stand-in, a means to cope with a traumatic event that has already occurred.[52] Instead of blocking something too painful to remember, however, the *Gross Clinic* memory screen masked the anticipated trauma of an unwanted future absence. I invoke the concept of the screen memory here not to make assertions about the psychological process of memory making but because this theory provides a useful metaphor and reference point for describing the social process of collective memory making around *The Gross Clinic.*

When the trauma of losing *The Gross Clinic* was ultimately averted, the function of the memory screen shifted. No longer needed as a substitute for the actual painting, it rejoined the artwork as a protective encasement that solidified *The Gross Clinic's* status as a city icon. I return to this concept in more detail at the end of this chapter.

Reopening the Wound

Leaders from across the city convened a press conference on December 21, 2006, to proclaim that "*The Gross Clinic* will stay in Philadelphia forever."[53] Although the fund-raising campaign had procured only about half of the necessary funds, PAFA and the Philadelphia Museum of Art announced that they would, indeed, jointly purchase the painting. As a supplement to the multimillion-dollar contributions from local philanthropists and generous donations from thousands of other people, the institutions took out a loan to foot the rest of the bill.

After only a month of celebrating *The Gross Clinic's* new and local homes, the public received another shock. On February 1, 2007, PAFA revealed that to repay much of the hefty debt it incurred from purchasing *The Gross Clinic,* it had sold *The Cello Player,* an 1896 oil painting also by Eakins, to an anonymous buyer for an undisclosed price. This news sparked another wave of public outcry. Over a year later, the Philadelphia Museum of Art announced that it, too, had deaccessioned works by Eakins to pay off the final portion of its *Gross Clinic* arrears. The Denver Art Museum, in collaboration with the private, Denver-based Anschutz Collection, purchased the oil painting *Cowboy Singing* (c. 1892). The Denver Art Museum additionally purchased two preparatory sketches (c. 1887) for *Cowboy in the Badlands,* a painting held in the Anschutz Collection. Despite the harsh responses to PAFA's art

sale, the Philadelphia Museum of Art received relatively little criticism. The contrasting reactions to these instances of deaccessioning further illustrate the significance of public involvement and the role of local identity in the *Gross Clinic* saga. They also demonstrate the uniqueness of the public rally that formed around *The Gross Clinic.*

Criticism of PAFA's sale of *The Cello Player* grew out of lingering public frustration with the short timeline and high price that Jefferson University had negotiated for the *Gross Clinic* sale. One area resident described the sale of *The Cello Player* as "a classic example of robbing Peter to pay Paul," implying that if PAFA had been granted enough time to fund-raise for its purchase of *The Gross Clinic,* it would not have had to sacrifice another Eakins work for the cause.[54] Bloggers on *The Sixth Square* expressed disappointment that PAFA had sold a whole painting to defray what amounted to the cost of only half of *The Gross Clinic,* as it would be splitting exhibition time and care for the object with the Philadelphia Museum of Art.[55] Critics could have waged the same complaints when the Philadelphia Museum of Art announced its deaccession decisions a year later, but they did not. Perhaps timing was on the museum's side, and by 2008 previously vocal constituents no longer felt the need to belabor the parameters of the *Gross Clinic* sale. Even so, additional concerns related to institutional transparency, the privatization of public art, and the local relevance of art collections did affect reactions to PAFA's and the museum's Eakins deaccessions.

When compared to the sale of *The Gross Clinic,* which featured a publicly oriented fund-raising and advocacy campaign, the lack of transparency surrounding the sale of *The Cello Player* appeared particularly egregious. Critics attacked PAFA for not sharing information about where *The Cello Player* would go when it left the institution's collection. PAFA's representatives avowed that the buyer would lend *The Cello Player* to the school for future exhibitions, but this provision did little to soothe an irate public.[56] When the Philadelphia Museum of Art negotiated the sale of *Cowboy Singing* and preparatory sketches for *Cowboy in the Badlands,* it selected a buyer that agreed to be publicly named. Beyond that, when the museum announced the sale, it took care to provide at least some details about the decision-making process. To minimize the public sense of loss from the deaccessions, the museum's press release discussed similarities between *Cowboy Singing* and *Home Ranch* (Eakins, 1892), a work that would remain in the museum's collection. It also educated readers about the process of deaccessioning by quoting the deed of gift through which the museum had initially obtained the recently deaccessioned works. Although the museum's decision to sell three pieces by Eakins was a

private negotiation conducted behind closed doors, the institution attempted to recognize the public's interest in the process by sharing some information once the deal was complete.[57]

Another sticky feature of PAFA's deaccession arrangement was that it sold an artwork from a publicly accessible collection to a private collector. This transaction marked the object's transition from public trust to private interest. Losing the painting to another publicly accessible collection would have been bad enough; it was far worse to see the painting disappear into unknown private hands. Although Philadelphians were deeply upset by the prospect of *The Gross Clinic* being sold to a museum in Arkansas, they were at least able to imagine what it would be like to have an element of their cultural heritage reframed in that new institutional context. The absence of information regarding *The Cello Player*'s future home suggested that the painting might symbolically vanish into a black hole, removed from public view and erased from both local and larger collective memory. Art critic Lee Rosenbaum did chastise the Philadelphia Museum of Art and the Denver Art Museum for partially privatizing *Cowboy Singing* because at the time the Anschutz Collection had no public galleries, but few others joined her critique.[58] (Incidentally, in 2010, a public exhibition space devoted to displaying the Anschutz Collection opened in Denver.)

A third theme in the deaccessioning cases that resonates particularly strongly with earlier phases of the *Gross Clinic* sale is the notion of the artworks' local significance. Audiences were upset that when PAFA deaccessioned *The Cello Player* it parted with an important piece from its collection. The painting is a large portrait of Rudolph Henning, a preeminent cellist who had strong ties to Philadelphia. It captures an intensity and interiority that is characteristic of Eakins's portraits. Furthermore, it was the first piece by Eakins that PAFA purchased after the artist departed the school on unfavorable terms eleven years earlier. For that reason the painting has been interpreted as part of PAFA's attempt to restore ties with its former faculty member.[59] Like *The Gross Clinic, The Cello Player*'s subject was linked to Philadelphia's nineteenth-century identity, the portrait marked high artistic achievement, and there was a direct and meaningful connection between the artwork and the collection that housed it. With these issues in mind, critics were confused by PAFA's decision to sell *The Cello Player* instead of one or more of the artworks in its collection that did not have such strong ties to the institution and the city.

Art critic Edward Sozanski suggested that, since the Philadelphia Museum of Art had a larger collection of works by Eakins than PAFA did, it

did not damage its collection through deaccessioning as much as PAFA had. Furthermore, in contrast to PAFA, the museum stressed that the works it sold fit well with the local spirit and collections in Denver. In the press release announcing the sale, a quote from Anne d'Harnoncourt explicitly noted that in Denver the artworks "can be seen in the context of other important collections of Western American Art." Just as it had done when acquiring *The Gross Clinic,* the museum successfully defended its collection management decision by emphasizing regional connections between works of art and the environments in which they should be displayed.[60]

Although stakeholders were disappointed to see the departure of other Eakins works from Philadelphia collections, and in the case of *The Cello Player* some were downright outraged, the Eakins deaccessions that occurred in the aftermath of the *Gross Clinic* sale did not spark the extensive and impassioned responses that the prospect of losing *The Gross Clinic* had. It was not just that interested parties wanted Philadelphia to cling to all aspects of its Eakins-related heritage. By 2007, *The Gross Clinic* had unique ties to public memory and the city's reputation, which the other artworks did not possess.

Rereading Eakins

Although *The Gross Clinic* was relocated from its gallery at Jefferson University, it remained in Philadelphia. Periodically rotating between display at PAFA and the Philadelphia Museum of Art, the painting took on different inflections in each institutional context. By nature of its history, the exhibition setting at PAFA (where Eakins had taught for nearly a decade) invited viewers to read *The Gross Clinic* through a thicker lens of artist biography.[61] At the Philadelphia Museum of Art, without those direct ties to Eakins's professional history, the painting was more loosely bound to the historical context in which it was made.

Whether hanging in the Philadelphia Museum of Art or at PAFA, however, the painting became a testament to the twenty-first-century cultural movement through which it was retained for the city. The evidence lies in its new credit line:

Portrait of Dr. Samuel D. Gross (*The Gross Clinic*), 1875, Thomas Eakins. Gift of the Alumni Association to Jefferson Medical College in 1878 and purchased by the Pennsylvania Academy of the Fine Arts and the Philadelphia Museum of Art in 2007 with the generous support of more than 3,600 donors.

By acknowledging the individuals who contributed funds to purchase the painting, this text tethers *The Gross Clinic* to the public campaign from 2006. Since people's personal memories of the artwork played a substantial role in fueling the massive fund-raising effort, the language links those memories to the painting as well. In doing so, the new credit line weaves the memory screen back into the original object to yield a painting that is a monument to itself.

The credit line invites viewers to approach *The Gross Clinic* on a new set of terms where they can read the gruesome surgery in light of the shocking events surrounding the sale of the painting. The onlookers in the amphitheater, with their responses of intrigue, horror, or boredom evoke the varied reactions of Philadelphians during those tumultuous weeks at the end of 2006. As a viewer's eye wanders from the light reflecting off of Dr. Gross's forehead to the bright white of the compress held over the patient's face, the sedated body emerges as the painting in limbo. In this context the extraction of that piece of diseased bone from the patient's thigh becomes a reminder of the personal memories gathered from the public in a moment of trauma as *The Gross Clinic* became a local icon that might redeem Philadelphia's reputation.

This reading of the painting positions *The Gross Clinic* as a palimpsest that accumulates new meanings that it holds in its iconography. Viewers can peel back the layers to find memories that were shared in 2006 or to find ties to nineteenth-century Philadelphia. The image operates as a repository of ideas while simultaneously illustrating precisely how viewers might use it as such an archive. In the 1990s, theorist Jacques Derrida described an archive in terms eerily applicable to *The Gross Clinic* after 2006. In the collection of records that Derrida discussed—and in Eakins's painting—"each layer here seems to gape slightly, as the lips of a wound, permitting glimpses of the abyssal possibility of another depth destined for archaeological excavation."[62] As the doctors in Eakins's painting probe the bloody incision, they invite twenty-first-century readers to dig deeper into the strata of significance that the painting eventually came to hold.

Philadelphians literally looked beneath the layers of *The Gross Clinic* not long after the museum and PAFA acquired it from Jefferson University. In 2009, the conservation team at the Philadelphia Museum of Art undertook an impressive effort to return *The Gross Clinic* to its nineteenth century appearance. In addition to removing coats of overpainting left by previous conservators, the team at the museum used x-radiography to examine the artwork. Seeing past the painting's surface allowed conservators and curators to study Eakins's technique and the compositional changes he made as he worked. A

composite image generated from the x-radiographs appeared in the museum's 2010 exhibition, "Seeing *The Gross Clinic* Anew," where the restored painting was the star of the show.[63]

Mark Tucker, the museum's vice chairman of conservation and lead conservator on the project, explained that one goal of the exhibition was "to show that the narrative bridging 'then' and 'now' need not run in one direction, from Eakins's time to ours. . . . [T]echnical insights gained during the recent study and restoration connected seamlessly back to the painting's earliest days."[64] By employing the most current restoration methods to resurrect nineteenth-century tones and look beneath the surface of the painting, the project connected contemporary audiences more directly to Dr. Gross's surgical techniques and the academic painting techniques that Eakins learned and taught at PAFA.

Looking beyond the role of technical interventions, both the exhibition and a companion publication also acknowledged that the events surrounding the sale of the painting contributed to the twenty-first-century understanding of the piece. They asserted that the transfer of ownership from Jefferson University to PAFA and the Philadelphia Museum of Art generated an opportunity to retouch the artwork. They additionally noted that the widespread public involvement with the purchase expanded contemporary viewers' interest in the object. These points, while valid, articulate only a narrow understanding of the relationship between present and past with regard to *The Gross Clinic.*

The restoration project did not simply use current techniques to preserve *The Gross Clinic* as a nineteenth-century object. It also created a more efficient bridge that shortened the distance between present and past, allowing the nineteenth-century circumstances painted into the artwork to converge with the twenty-first-century concerns that had recently been projected onto it. *The Gross Clinic,* then, was at once a historical and a contemporary object. It belonged as much to the twenty-first century as it did to the nineteenth.

If, by the end of 2006, the painting had come to represent Philadelphia, then restoring the painting to its nineteenth-century appearance can also be understood as an aspirational metaphor for returning Philadelphia, as well, to its earlier glory. In the nineteenth century, Eakins's painting helped challenge the image of the United States as a cultural backwater. In the twenty-first century, his painting reasserted Philadelphia's significance as a place with superb medical facilities, top-notch museums with world-class conservation teams, and audiences who cared deeply about the art on display in their city.

If the Philadelphia Museum of Art and PAFA had lost their bid to purchase *The Gross Clinic* and the painting had gone to Crystal Bridges and the National Gallery instead, its lingering local ties would have been severed. But, through the successful effort to keep the painting in Philadelphia, *The Gross Clinic* finally achieved one of the functions that its maker had initially envisioned. It became a city icon that was deeply tied to contemporary Philadelphians' experiences and the city's changing reputation.

4

Rocky: A Question of Stature

As PHILADELPHIA CELEBRATED its tercentennial in 1982, writer Jerry Adler told readers of *Newsweek* magazine that "there are . . . two Philadelphias, and by coincidence both are on display at the Philadelphia Museum of Art this week."[1] "Patrician Philadelphia" appeared in paintings by Thomas Eakins that the museum had gathered for a special exhibition dedicated to the famed nineteenth-century artist whose life and work were deeply tied to the city. Included in this set was *The Gross Clinic* (1875), a portrait of a world-class surgeon that is the subject of Chapter 3. The other Philadelphia, as Adler implied, had less polish and more passion. It was encapsulated in a larger-than-life sculpture of fictional prizefighter Rocky Balboa that looked out at the city from the museum's East Terrace. In the summer of 1982, Eakins and Rocky drew streams of visitors to the museum's grounds. Over the next quarter-century, *The Gross Clinic* and the Rocky statue would become Philadelphia icons, powerfully intertwined with the city's identity. When *The Gross Clinic* emerged as a city icon in 2006, it enabled Philadelphians to reassert the importance of their city's longstanding tradition of excellence in the arts, embracing and extending the values and accomplishments of "patrician Philadelphia." Although the Rocky statue may have represented "the opposite quality" in Adler's 1982 report, the sculpture's role as a city icon was not simply a counterbalance to the ideals held in *The Gross Clinic*. Instead, the Rocky statue's significance derived from the tensions—both real and perceived— between Adler's two Philadelphias. Through this object, Philadelphians and

other interested parties negotiated which types of cultural achievement should be at the center of Philadelphia's identity as the city sought to redefine itself for the twenty-first century.

Rocky's story had been intertwined with Philadelphia's since the first *Rocky* movie debuted in 1976. Shot on location around the city, the film tells of a down-and-out boxer who beats the odds and holds his own in a widely publicized match against the reigning heavyweight champion. Like the title character, the film, too, achieved unexpected success. The low budget movie, which star and writer Sylvester Stallone apparently drafted in just three days, went on to win an Academy Award for Best Picture. It also sparked a wave of Philadelphia tourism that continues to this day.[2]

Yet for twenty-five years *Rocky* was an especially divisive topic of debate in the city. Much of the friction stemmed from the bronze sculpture of the title character that Stallone commissioned from artist A. Thomas Schomberg in 1980. The piece appeared in the third *Rocky* film (1982) as fictional Philadelphia's monument to the boxer. Stallone offered to donate the sculpture to "real" Philadelphia on completion of the *Rocky III* shoot. He proposed installing the object at the top of the stairway that led to the Philadelphia Museum of Art. Known as the "Rocky Steps," the site was meaningful within the context of the *Rocky* movies. It had also emerged as an informal place of pilgrimage for *Rocky* fans, who flocked to the site to run up the stairs as Rocky had memorably done in the film. Stallone's overture, however, was met with resistance from some members of the Philadelphia community who viewed the object as a publicity tool for the *Rocky* franchise, not an artwork worthy of being showcased alongside some of the most well-known pieces in the city. They suggested instead that the sculpture might be more appropriately located at the city's sports complex. The conflict over where to place the statue persisted for more than a quarter of a century, divided a large public, and received extensive media attention. During that time, the statue was periodically moved to different locations around Philadelphia before it was permanently installed at Eakins Oval near the museum's steps in 2006.

Why did the statue find a lasting home near the museum that year? After decades of debate, arguments about where to place the piece had changed little. No groundbreaking scholarship had revealed the sculpture to be of previously unrecognized quality or importance. Media coverage of debates over the statue told the same types of stories that had been presented for years. Skeptics might argue that the committees that had previously blocked the sculpture's installation at the museum had simply grown tired after the long conflict. Perhaps they acquiesced to allow one final wave of *Rocky* fever that

would coincide with the first film's thirtieth anniversary and the release of the sixth and allegedly final film in the series.[3] But this was no simple decision. The ultimate resolution of the Rocky statue controversy had as much to do with negotiating Philadelphia's reputation as it did with fatigue or box office sales. By installing the statue near the museum in 2006, officials embraced the object not as an advertisement for the film series, but as a city icon—a symbol of Philadelphia.

I begin this chapter by establishing how Philadelphia and *Rocky* came to be associated with one another. I then turn my focus to the arguments about where the statue should be displayed. My analyses demonstrate that these exchanges were part of a broader discourse about the way Philadelphia should present itself to the world, and they culminated at a time when the city's reputation was changing. Like Adler's report to *Newsweek,* many statements about the Rocky statue positioned elite Philadelphia, anchored inside the museum, against blue-collar *Rocky* fans who privileged popular culture over fine art. After parsing the main positions concerning the statue's location, I consider the ways in which Philadelphia's tourism initiatives reflected the city's changing relationship to *Rocky.* In doing so, I show that the Rocky statue is more complex than the simplistic high-low dichotomy presented by journalists and agitated observers. As placement and public discourse shaped the statue's significance, the statue shaped Philadelphia. The sculpture's final location, at Eakins Oval near the Philadelphia Museum of Art, allowed the object to resonate more fully than it could at any of its previous sites. There, as a city icon, it represents an optimistic image of the city that blends the "two Philadelphias" if we let it.

From Movie to Metropolis (and Back Again)

The Rocky statue may remind some readers of the bronze sculptures of famous television characters that appeared in the early 2000s in American cities associated with particular classic TV shows: in Milwaukee, it was the Fonz from *Happy Days*; in Minneapolis, Mary Richards from the *Mary Tyler Moore Show.* Commissioned by the TV Land network, these figures have shaped local identity in their respective cities.[4] Taken together, the TV Land pieces and the Rocky statue raise important questions about the relationship between a place and its representation on screen. But the Rocky statue differs from the other examples in one key way: it first appeared within the fictional world of the movie, while the TV Land monuments were created years after the characters they depict went off the air. The Rocky statue's crossover from

the world of the film to the actual city streetscape transformed the sculpture's significance. For that reason, it is important to begin this discussion of the Rocky statue with a closer look at the relationship between the *Rocky* films and the City of Philadelphia.

Not long after *Rocky* premiered in 1976, the film became deeply associated with the city in which it took place. Despite the important role that this phenomenon played in shaping perceptions of Philadelphia within and beyond the city, it has received remarkably little attention from scholars. One goal of this chapter is to fill in some of the history and theory that has been overlooked regarding the significant connection between *Rocky* and Philadelphia.

The academic texts that have mentioned *Rocky*'s relationship with Philadelphia have typically done so in passing—as a statement of the obvious in order to justify or contextualize the study of a related topic. Take, for example, a 2011 article about the ways in which film production and movie watching affect the sense of local culture in Hong Kong and Philadelphia. Instead of analyzing the role that *Rocky* has played in shaping such perceptions of place, the authors refer to *Rocky* as "one of the most successful and emblematic Philadelphia movies," and use this reference as a jumping-off point for their discussion of other Philadelphia films that romanticize the space of the city.[5] Similarly, the author of a 1997 filmography of Pennsylvania sports movies framed her project by stating that it is important to recognize all the films beyond *Rocky* that also tackle the subject of regional sports. In doing so she implied that *Rocky*'s relationship to Philadelphia sports was already well understood, but that was not the case.[6] I do not raise these examples to fault these authors for their omissions. Instead, these examples reveal a conundrum: although the link between *Rocky* and Philadelphia is taken as a given, there has been little exploration of how and why that link developed or persisted.

In order to understand the Rocky statue's role as a picture for the city, it is necessary to further probe *Rocky*'s role in Philadelphia and provide at least some of that missing context. To do so, I begin by proposing a symbiotic relationship between city and cinema. This proposition intersects with work from tourism studies that examines film-induced tourism and the act of visiting sites that are familiar because they have been depicted in movies and on TV. Much of the work in this area has focused on classifying varieties of film-induced tourism, measuring economic impact, or generating recommendations for how places can invite this type of lucrative travel.[7] I take an alternate approach by focusing on what film texts, public practice, and public discourse can reveal about how the relationship between *Rocky* and Philadelphia developed. Here I offer a model for considering the way other cities have

shaped and have been shaped by the movies set there, but I also recognize that the case of *Rocky* may be unique because of the extent to which the sites on screen and the sites in the city overlapped.

Part of the intricate connection between *Rocky* and Philadelphia occurred because of a blurring between what I call the "movie world," the Philadelphia within the film, and the "metro world," the actuality of the Greater Philadelphia Metropolitan Area. Compounding this phenomenon, city officials and journalists drew parallels between the plot of Stallone's film and the city's changing sense of self.

Since most of the exterior shots in *Rocky* were filmed on location in Philadelphia, important sites and events from the movie overlapped with their metro-world counterparts. When film viewers watched Rocky walk home after a boxing match, they saw actual Philadelphia streets, storefronts, and row houses. Although these depictions of the city had their limitations, locations across town—from South Philadelphia's Ninth Street market to the elevated train line in the Northeast Philadelphia neighborhood of Kensington—provided a backdrop for scenes in the film.

Filmmakers have taken their cameras to the streets since the advent of cinema, but classical Hollywood films produced before World War II were primarily shot in Los Angeles where constructed sets on studio back lots or views of Southern California stood in for other parts of the world. In the 1950s, increasing numbers of filmmakers abandoned the studio for the street. Working in the spirit of Italian Neo-Realism or the French New Wave, they took advantage of technological developments that produced lighter-weight (and therefore more portable) cameras, film stock that could capture images in plain daylight, and tools to conveniently record sound and image simultaneously.

These shifts helped fuel the development of a particular type of gaze, or socially coded way of seeing, which scholars have described as a "mediatized gaze." The mediatized gaze is most often discussed in the context of tourism, where it takes two main forms. One type of mediatized gaze allows viewers to travel vicariously when they look at representations of places in media, such as in films or on television. The other type occurs when people see places or objects in person that they have previously encountered on screen.[8] *Rocky* invited both kinds of mediatized gazing. Scenes set and shot in the city offered viewers an experience of Philadelphia from afar. Viewers in Philadelphia also came to experience the city through their memories of the film.

What is significant about the relationship between the movie world of *Rocky* and the metro world is not a mimetic correlation between what can be

seen in the city and what can be seen on screen. Instead, a notable two-way exchange between the realms developed out of the success of the first *Rocky* film. The film presented a vision of the city that individuals and institutions in the metro world quickly aimed to replicate. In turn, as I demonstrate, later films in the *Rocky* series recognized the change in the metro world that the first movie had catalyzed. The quintessential case of this fusion of movie world and metro world occurred at the steps of the Philadelphia Museum of Art, which co-starred in a climactic scene in *Rocky*.

In a workout session when Rocky is just beginning to prepare for his big fight, his morning run takes him to the museum, where seventy-two broad stairs serve as a passageway from the street to the large neoclassical building. Positioned at the northwest end of the Benjamin Franklin Parkway, the steps punctuate the mile-long boulevard that leads from John F. Kennedy Plaza at City Hall to the Philadelphia Museum of Art. Rocky attempts to run up the steps but is so out of shape that he arrives at the top doubled over and out of breath. Later in the film, at the culmination of an extended training montage that shows Rocky's increasing fitness, he confidently climbs the museum's stairs. The camera records this accomplishment in a single take. In a moment of triumph, Rocky jumps with joy as he looks out over the Philadelphia skyline at dawn (Figure 4.1). To preserve the experience just a little longer, the scene cuts to a medium-close shot of the promising pugilist celebrating in slow motion.

The uplifting scene, made possible through the new technology of the Steadicam, stands out as among the film's most memorable. Publicity posters adopted a still of Rocky gazing out at Philadelphia from atop the stairs as an iconic representation of the character and his story. The scene was so popular that, less than a year after *Rocky* opened in theaters, joggers who incorporated a sprint up the museum's steps into their exercise routine were quickly linked to Rocky.[9] Fans, too, came to the steps to reenact Rocky's run. By 1979, a *New York Times* article could claim that "thousands of children and adults have scaled those steps and raised their fists since 1976." The attraction reportedly drew as many visitors as did the Liberty Bell.[10]

Fifteen years later, the site would become popularly known as the "Rocky Steps," but it took some time for the name to catch on. In 1985 a photographer for the *Philadelphia Inquirer* annotated his assignment sheet by calling the museum's East Steps (their official name) the "Rocky Steps." One 1986 article in the *New York Times* referred to the site as "Rocky's Steps." By 1992 a curator of education at the Philadelphia Museum of Art noted in an essay that "the museum steps [were] now commonly referred to as 'The Rocky Steps.'"[11] Three years later, the term began to appear frequently in the popular press.

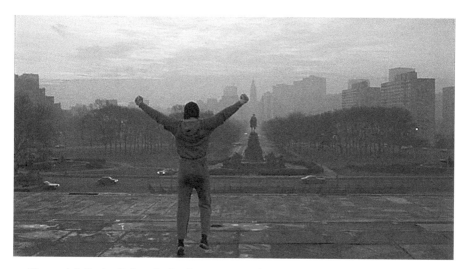

Figure 4.1. Rocky Balboa in the famous scene from *Rocky* (1976) after he completed his successful run up the steps of the Philadelphia Museum of Art. (Film still, *Rocky,* directed by John G. Avildsen. DVD [MGM/UA Home Video, 1996].)

The stairs and the run earned their appeal in large part because *Rocky* injected a common practice from the metro world with a powerful dose of symbolism.[12] Philadelphians used the museum's East Steps as a site for recreation long before Rocky began training for his big fight. It was common for teenagers to race up and down the steps when the weather was nice. In the early 1970s, the stairs doubled as seating for audiences at outdoor concerts on the Parkway.[13] In 1974, Steadicam designer Garrett Brown showcased his new invention's abilities by filming his wife running up and down the museum's stairs. But when Rocky's training routine brought him from his working-class neighborhood of Kensington, in Northeast Philadelphia, to the top of the steps in front of the Center City art museum, he made a literal and symbolic journey from low to high that reflected the two Philadelphias described at the beginning of this chapter. This straightforward imagery paired his physical ascent up the stairs with a boost in self-esteem suggestive of his potential to reach beyond the constraints of his humble background, like one of Horatio Algers's nineteenth-century protagonists. In turn, climbing the steps became widely interpreted as a performance associated with achieving one's goals, a reading certainly embraced by many of the individuals who reenacted Rocky's run.[14]

Rocky was such a sensation that three years after its release a sequel appeared in theaters. In *Rocky II* (1979), the boxer returns to the museum's steps when

he trains for a rematch against his opponent from the first film. This time, a pack of children joins him as he runs; they follow him as he bolts up the stairs. The scene ends with Rocky rejoicing atop the museum's steps, surrounded by a crowd of adoring fans. Those who sprint alongside Rocky in the film evoke the many *Rocky* enthusiasts who flocked to the steps after seeing the first movie.

By incorporating a repeat run up the museum's steps into *Rocky II,* Stallone affirmed the popularity of the act on screen and off. He contributed to blurring the line between the movie world and the metro world by acknowledging in his second *Rocky* film a fan practice that had been sparked by the first. Movie publicity that embraced the steps as a symbol of the film also reinforced the further blending of reality and fiction. For example, a "count the steps" challenge hosted by a Philadelphia radio station sparked local interest in the *Rocky* sequel by inviting listeners to tally the steps in front of the museum and then deposit a ballot containing their answer at a collection site in the lobby of the building. From all of the correct responses, a winner would be randomly selected to receive an invitation to the premiere gala for *Rocky II,* which was to be held inside the museum.[15] The blurring of worlds, facilitated by film publicity as well as by unofficial fan practices, wove *Rocky* into the fabric of Philadelphia's cultural heritage in the late 1970s.

Others who have written about the *Rocky* films have also found a noteworthy relationship between cinema and actuality. Author and journalist Mark Bowden, writing for the *Philadelphia Inquirer* in 1982, remarked, "There's something appealing about a piece of movie fantasy slipping through a particular warp into reality."[16] Similarly, Danielle Rice, who took interest in *Rocky* in the 1980s when she headed the Philadelphia Museum of Art's Education Department, has considered how the fictional character's actions have become more meaningful than the storied heroism of actual individuals. She observed in a 1992 publication, "Rocky is in a sense more real to a large number of people than George Washington or William Penn."[17] That year, local columnist Jim Smith took a similar tack when he chastised the sports media for embracing Rocky, a fictional white athlete, instead of celebrating the accomplishments of actual black champions.[18]

If *Rocky* reflected aspects of the metro world of Philadelphia and also shaped that world in return, it may come as little surprise that many came to read the film as a metaphor for the city. When a *New York Times* article assessed Philadelphia's social climate in July 1977, *Rocky* was a recurring trope. Initially, the article presented a list of challenges that Philadelphia faced at the time. Funding for public schools was limited, there was racial tension in the city, and the police were under federal investigation for using excessive

force with suspects. The article introduced its list of city woes by explaining that "in the movie, Rocky lost the championship fight, but it didn't matter. In Philadelphia, there are plenty of real life losers."[19] The article went on to assert that, despite the many unfortunate aspects of Philadelphia's condition, Philadelphians were proud of their city. One city employee (and self-identi-fied booster) invoked *Rocky* to illustrate Philadelphia's optimistic outlook by stating, "Rocky epitomizes the undefeatable spirit of the Philadelphian."[20] Just as Rocky surpassed expectations by lasting for fifteen rounds in a match that nearly everyone expected him to lose with a quick blow, Philadelphians pushed through the daily challenges of life in their city. The 1970s were a difficult time for many U.S. cities, but while New York was combating fiscal troubles and the Son of Sam serial killer, the *Times* presented nearby Phila-delphia as on the rebound. Only one year after *Rocky*'s premiere, the character and the movie were used to explain both the good and the bad in the city.

In 2005, on the eve of *Rocky*'s thirtieth anniversary, journalist Michael Vitez and photographer Tom Gralish teamed up to catalog a year at the Rocky Steps. Their investigation yielded *Rocky Stories,* a book that recounted personal tales from individuals who were drawn to the symbolic power of the steps. In the introduction to the book, Vitez explained that "many people don't know why they run; they just do it." But he fills the book with story after story of people who come to the steps to celebrate or prompt a personal victory.[21] The spirit of perseverance and hard-won success that had connected Philadelphia with *Rocky* three decades earlier remained. With accounts of pil-grims coming from as far away as California, England, and Australia to climb the steps, Vitez and Gralish's project demonstrated that the Rocky run, and, therefore, the steps' appeal as a special Philadelphia attraction, had become an international phenomenon. By 2005, the relationship between cinema and city was so ingrained and so abstracted that Vitez encountered some runners at the steps who had not seen the *Rocky* films but who nonetheless understood the significance of the steps and the act of running. In response to this observation, he concluded that "Rocky and Philadelphia are like Ben Franklin (and the city); they're just connected and inseparable."[22]

The Bronze Boxer

Rocky III offered another opportunity to combine the movie world and the metro world, but it ultimately carved out a distinction between the two realms. The film features a scene in which the mayor of Philadelphia (played by an actor) honors Rocky's achievements by erecting a bronze statue of the

boxer at the top of the by-then-iconic steps of the Philadelphia Museum of Art. When preparing to shoot the film, Stallone donated the statue to the city and suggested that its metro-world installation replicate what he had planned for the film. Officials in the movie world may have wanted a likeness of Rocky at the top of the art museum's steps, but in the metro world the statue was not met with the same enthusiasm. In the early 1980s, Philadelphians in favor of showing the statue at the museum wanted their city to retain its ties to the one on screen in Stallone's films, but others objected strongly to displaying the bronze sculpture atop the museum's steps. Arguments about the statue came to focus on questions of its artistic merit and the way the city valued high art and popular culture. It proved exceedingly difficult to fully separate the intertwined movie world and metro world, and Stallone's cumbersome gift sparked a controversy that, like his films, revisited Philadelphians every few years. And yet, despite the repetitive and seemingly unconstructive nature of these impassioned debates, these conversations ultimately served as a forum for Philadelphians to negotiate how imagined and actual cultural achievements would contribute to the city's identity at the turn of the twenty-first century.

Stallone engaged the world of popular sports art throughout his *Rocky* series, delving into the genre in *Rocky III* in particular. LeRoy Neiman, the renowned painter of athletes, appeared in several of the *Rocky* films, and two of his paintings figured prominently in *Rocky III*. One piece, a twenty-four-foot-tall portrait of Stallone as Rocky, towers in the background as Rocky trains in a carnivalesque gym packed with adoring fans (Figure 4.2). At the end of the film, as Rocky and Apollo spar amiably, the boxers go in for a punch, and the scene dissolves with a match-on-action in which a full-screen shot of another of Neiman's paintings appears as the credits roll (Figures 4.3 and 4.4). In this final scene, the neutral background of white gym walls transforms into Neiman's brightly colored expressionistic splash of reds, yellows, greens, and blues. The multicolored dabs of paint that render *Rocky and Apollo* (circa 1981)

FACING PAGE, TOP TO BOTTOM:

Figure 4.2. LeRoy Neiman's spot-lighted painting displayed in the background of a boxing scene from *Rocky III* (1982). (Film still, *Rocky III*, directed by Sylvester Stallone. DVD [MGM Home Entertainment, 2004].)

Figure 4.3. The final shot in *Rocky III* (1982), frozen as Rocky and Apollo spar. (Film still. *Rocky III*, directed by Sylvester Stallone. DVD [MGM Home Entertainment, 2004].)

Figure 4.4. The closing credits for *Rocky III* (1982), featuring LeRoy Neiman's painting of Rocky and Apollo. The boxers' gestures closely resemble the film's final shot. (Film still. *Rocky III*, directed by Sylvester Stallone. DVD [MGM Home Entertainment, 2004].)

Art Directors
RONALD K. FOREMAN
DENNIS WASHINGTON

evoke a sense of movement that makes the full-body cutouts of boxers on the gym walls in the previous shot appear all the more static. Neiman has been dismissed in fine art circles as a producer of kitsch, but Stallone highlighted the artistic value of Neiman's work by emphasizing the artist's handling of paint, treatment of color, and ability to capture the dynamic thrill of boxing.[23]

Stallone featured the work of another professional artist in *Rocky III*. In 1980 he commissioned A. Thomas Schomberg, a veteran sculptor of athletes, to craft a bronze likeness of Rocky.[24] According to later reports by the Colorado-based artist, Stallone entered the business arrangement with a clear idea of how he wanted the sculpture to look. Working from Stallone's specifications, Schomberg modeled Rocky's features after Stallone's, even using a cast of the celebrity's face to create the sculpture's visage.[25]

The 8.5-foot figure is dressed for a match: Rocky sports boxing shoes, knee socks, personalized shorts, and little else (Figure 4.5). His crisply shaped abs ripple upward into toned pectorals and biceps, which half-heartedly bulge as he raises his boxing-glove-clad hands in the air. The victorious arm gesture frames a stoic face that gazes ever so slightly downward, to the figure's right, while thick waves of hair swathe the boxer's head in a helmet of locks. Rocky towers stiffly over his audience. His right knee bends as if to suggest the traditional *contrapposto* stance of classical sculptures of athletes, but the weight shift remains incomplete: there is no corresponding tilt in the figure's hips, no contrasting angle in his shoulders.[26] It was appropriate, if only by coincidence, that the figure was frozen in this awkward pose, standing uncomfortably as people fought over him for twenty-five years. After the statue first appeared as a prop in *Rocky III* it was shuffled around the city, occasionally on view atop the Rocky Steps, but most often at the sports complex in South Philadelphia. For a quarter of a century there was neither official agreement nor public consensus about the best place to display the statue. Both the object and its significance in Philadelphia were in flux.

Official responsibility for determining the Rocky statue's location lay in the hands of two local groups. Since 1907, the City of Philadelphia has required that a committee of eight appointed members oversees the management of aesthetics on city property. Initially operating as the Art Jury, the group was renamed in 1952 when a new city charter restructured local government and established the Art Commission as a branch of the Department of Public Property. The Art Commission regulated construction projects that received funding from the city government, determined whether certain signage could appear in specific areas of the city, and managed the city's acquisitions of public art.[27] To recall an episode from the Introduction to this book, this

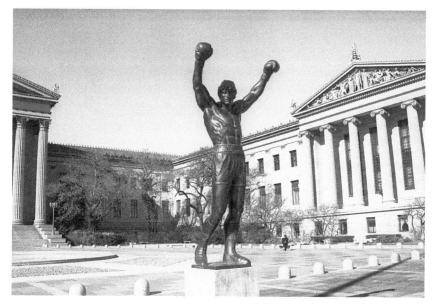

Figure 4.5. A. Thomas Schomberg, *Rocky*, 1980, 8.5 ft. in height. This photograph shows Schomberg's sculpture on the East Terrace of the Philadelphia Museum of Art in 1990. (Unknown photographer, "Rocky Statue and Skyline." Image courtesy of PhillyHistory.org, a project of the Philadelphia Department of Records.)

was the same group whose chair in 1978 purchased Robert Indiana's *LOVE* for Philadelphia. *Rocky III* producers needed to obtain permission from the Art Commission before they could install the Rocky statue at the museum's steps, even temporarily for the film shoot. Stallone's donation of the statue to the city required similar consent. Philadelphia's Fairmount Park Commission also had to approve both proposals because the museum stood on Fairmount Park grounds. In a joint meeting on December 10, 1980, the two delegations determined that the statue could be placed at the steps while the scene for the movie was filmed, but it could not stay there after the shoot because, in the context of the metro world, the sculpture was chiefly a promotional item and therefore had no place on the museum mount. They did not want to perpetually display an advertisement for the *Rocky* films in this prominent location.[28]

The committees' decision received extensive press coverage that spurred and circulated a range of reactions to the Rocky statue's fate. After the completion of the Philadelphia component of the *Rocky III* shoot, Stallone shipped the statue back to Los Angeles. Philadelphians who joined the "Rocky Must Stay" campaign advocated vociferously for the return of the statue to Philadelphia and blamed "'art critic' types" for rejecting an important cultural ob-

ject.[29] Meanwhile, Henry S. McNeil Jr., an emerging local art patron whose uncle was a trustee of the Philadelphia Museum of Art, lamented that the press was paying so much attention to "a poorly wrought promotion" instead of discussing the truly impressive public sculptures that were already part of the city's collection.[30] These points of view are indicative of the two main lines of argument that appeared regarding the Rocky statue: the group that journalists presented as a broad assembly of Philadelphia's working-class public celebrated the statue as a populist monument to the everyman and as a symbol of Philadelphia's national fame, while others, fused together by public opinion into an elite constituency, disparaged the statue as a schlocky publicity tool for the *Rocky* franchise that detracted from the city's reputation of cultural excellence. These conversations were embedded in a broader context shaped by the interplay among race, ethnicity, and class in Philadelphia. Here I focus on the specific concerns about quality, privilege, and popularity that dominated public discourse about the statue.

The Philadelphia Museum of Art was caught in the eye of the storm. Although the institution had no official control over the grounds on which its building was located, it remained informally connected to negotiations about where to install the statue. As museum president Robert Montgomery Scott wrote to City Council representative Joseph E. Coleman in 1981, "The Art Museum Trustees feel that the Museum shares jurisdiction with the Art Commission as to the objects of art to be placed on the 'podium' on which the Art Museum sits. If the Art Commission determines to reconsider its decision, you can be sure that the Board of Trustees of the Museum will be happy to discuss the matter with the Art Commission."[31]

The museum's official "Statement on the Removal of the Rocky Statue" echoed this sentiment in a manner that allowed it to appear neutral in the particular case of the Rocky statue. Instead of addressing the matter of Schomberg's sculpture in particular, the institution made a statement pertaining to all sculpture in general. The official language on the topic declared that "the site at the top of the Museum steps is inappropriate for the permanent placement of any sculpture. It breaks the great sweep of space and line of view between City Hall and the Museum, as intended by the architects and planners of the Benjamin Franklin Parkway."[32]

At the end of the *Rocky III* shoot, the statue was taken down from the museum's steps, but it reappeared there for several weeks in 1982 as publicity for the film's release. When the film's promoters neglected to de-install the sculpture at the end of the agreed-on period of display, the museum arranged to have the statue removed (Figure 4.6). It was sent to South Philadelphia

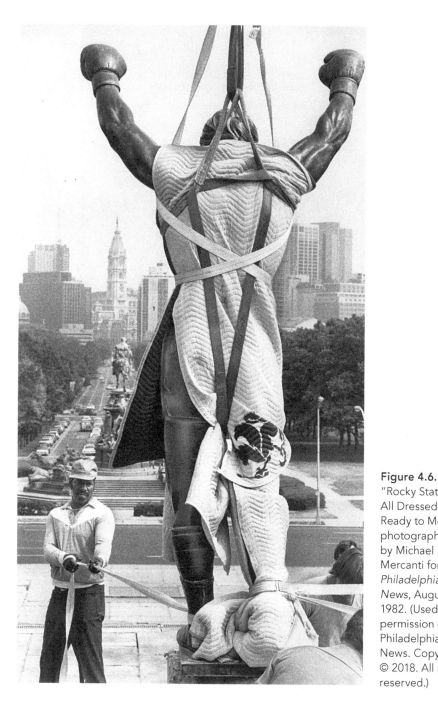

Figure 4.6.
"Rocky Statue
All Dressed and
Ready to Move,"
photograph
by Michael
Mercanti for the
*Philadelphia Daily
News*, August 2,
1982. (Used with
permission of
Philadelphia Daily
News. Copyright
© 2018. All rights
reserved.)

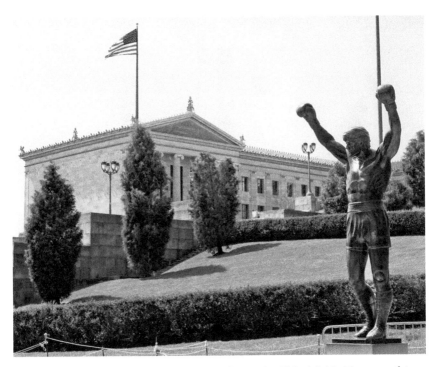

Figure 4.7. The Rocky statue at Eakins Oval near the Philadelphia Museum of Art, installed in 2006. (Photograph: Caitlin Martin © 2010, courtesy Association for Public Art.)

and installed at the Spectrum Arena, which had hosted metro-world boxing matches similar to Rocky's in the movie world and was home to some of the city's professional sports teams. Statue supporters were not entirely satisfied by this change in venue, but they were glad to have the sculpture in Philadelphia.

Questions about where Schomberg's piece should be displayed arose again when *Rocky V* (1990) went into production in 1989, but, after a brief return to the museum's steps for a cameo in the film, the statue was reinstalled at the city's sports arena. It stayed there for sixteen more years before ending up in storage in 2005 while producers debated using it in *Rocky Balboa* (2006). The statue's base had been damaged during its many relocations, and it was determined that conservation was necessary to return the sculpture to a structurally sound condition.[33] In 2006, Stallone offered to arrange for the aging sculpture's restoration, provided that it could once again be displayed atop the museum's steps. The controversy heightened in May of that year. Months of debate followed by a series of Art Commission hearings eventually resulted in a new home for the statue that September: at the foot of the museum mount, to the right of the base of the Rocky Steps (Figure 4.7).

Processing the Statue

In each wave of debate, when Philadelphians and interested parties further afield voiced their opinions about where the statue belonged, they were negotiating the roles that high culture and popular culture should play in shaping Philadelphia's appearance and reputation at a time when the city's identity was changing. Although these conversations occurred periodically and over the course of a quarter-century, the ideas voiced remained relatively consistent. In that way, the three distinct moments of controversy blurred together into a single twenty-five-year-long negotiation.

Writing in a scholarly anthology in the wake of the 1989 episode of Rocky statue controversy, Danielle Rice contended that the then-most-recent outbreak of debate must be understood as distinct from the first phase in the early 1980s. She explained that when advocates for the statue positioned themselves in stark opposition to the art establishment during the second round of controversy, they did so as part of the broader wave of conservative aggression toward the art world that was famously linked to the censorship of works by Robert Mapplethorpe and Andres Serrano around that same time.[34] In Rice's view, this distinguished the second wave of Rocky statue controversy from the first. Rice makes a compelling argument, but when looking at all three periods of dispute—not just the first two—there is also a striking continuity. In each outburst of controversy, Philadelphia's public image was at stake. The location of the Rocky statue became a matter of contention for Philadelphians based on their politicized identities because the statue, like the other pictures for the city featured in this book, offered a way for the City of Philadelphia to make an international statement about its local character.[35] Decades of churning rumination and the context in which it occurred slowly recast the Rocky statue as a Philadelphia icon.

Throughout the debates, those who rejected the Rocky statue on the grounds of its unabashed commercialism implicitly argued that Philadelphia deserved to be recognized foremost for its longstanding highbrow culture. They did not object to promoting Philadelphia as a prominent American city, but they did oppose using a movie prop for the task. Why were the art museum's collections or the other public sculptures around town acceptable candidates for representing the city but the Rocky statue was not?

For the antistatue community, it was most appropriate to understand the present city in terms of its connections to the region's previous cultural achievements. Their Philadelphia was the legacy of painter and collector

Charles Willson Peale, who established the first natural history museum in the United States in 1786 and helped found the Pennsylvania Academy of the Fine Arts two decades later. It was captured in the work of artists such as Thomas Eakins and Cecilia Beaux, who painted images of the city and its residents before Philadelphia lost its premiere cultural standing to New York in the early twentieth century. Evidence of the city's high culture accomplishments lingered in its world-class art collections, the wealthy patrons who supported such institutions, and the less affluent residents and visitors who, based on a shared aesthetic sensibility, felt an affinity with the objects on view. This sector of Philadelphia's cultural landscape was founded and funded by leaders in the fields of law, medicine, and pharmaceuticals. Like art, these industries thrived in nineteenth-century Philadelphia, but they also remained strong long after the city's cultural status declined. The objects and institutions (including *The Gross Clinic* and, to an extent, the Barnes Foundation) that remained affiliated with those individuals and organizations offered turn-of-the-twenty-first-century patrons a connection to the city's earlier prestige.

Patron Henry S. McNeil Jr., whose family fortune derived from the pharmaceutical industry, asserted in 1982 that Philadelphia's handling of the statue controversy would directly affect the region's reputation. He explained that "a self-serving 'Rocky' shrine ensconced on the Art Museum steps [w]as one less negative image for [the] city to avoid."[36] In an open letter to the Art Commission and the Fairmount Park Commission, another concerned Philadelphian wrote that "the presence of such a statue on the terrace of the museum would seem to detract from the character of our fine city."[37] More than twenty years later, the city's public art director received an e-mailed screed with a similar theme. Albeit with a more aggressive tone than had been adopted by her predecessors, this 2006 writer likewise insisted that the "decision to install a worthless used movie prop in a place of honor on the grounds of the Philadelphia Museum of Art marks a new low for Philadelphia and the image we project to the world." She continued, "As a long time working artist I expect our cultural leaders to promote the highest standards when authorizing public art, not celebrate crass commercial interest of the lowest forms of celebrity worshipping pop culture sells everything world we increasingly live in."[38]

When these Philadelphians wrote of the "highest standards" that contributed to "the character of our fine city" they discussed subjective and flexible categories as if they were concretely defined terms. In doing so, they asserted their sense of good taste as superior to that of the statue supporters. This interpretation draws from French sociologist Pierre Bourdieu, whose

work notably demonstrated just how subjective the concept of "good taste" is. Tastemakers might suggest that there is an unequivocal measure of quality and that the ability to discern items of quality occurs naturally. But Bourdieu showed that a person's sense of taste (or, in this case, high standards or good character) usually corresponds to that person's socioeconomic status and level of formal education. When the type of art or culture valued by a particular social group becomes privileged, it legitimizes their lifestyle. Taste appears less arbitrary (and therefore more easily justified as "good") when people with power share that preference or sensibility.[39]

As parties debated the future of the Rocky statue, they were vying for the primacy of their divergent cultural preferences. The statue's detractors emphasized the object's role as a movie prop and an advertisement as leading evidence of its difference from fine art.[40] For them, it threatened to devalue the city's cultural status, and, in turn, the status of the people who wanted Philadelphia to be recognized for its highbrow achievements, not its pop culture fame. At the same time, many people who believed that the statue belonged at the Rocky Steps highlighted the object's pop culture significance as the main justification for their position. They claimed that the statue was an important Philadelphia icon and that it therefore deserved to be displayed at the site in the city with which it was most strongly associated.[41] For the statue supporters, Schomberg's sculpture was evidence of Philadelphia's prominence in late twentieth-century American culture, but what they valued was Philadelphia's widespread visibility (catalyzed by the *Rocky* films), not its sophistication and exclusivity.

This sentiment surfaced intermittently throughout the extended period of debate. A 1981 editorial from Philadelphia's *Times Northeast* explained that the statue was important because "the creator of boxer Rocky Balboa . . . put the Philadelphia Museum of Art on the international map for millions who associate that institution with the City of Brotherly Love."[42] The same opinion came up again years later when a columnist for a New Hampshire newspaper claimed in 2006 that, if it were not for Rocky, the Philadelphia Museum of Art would be as unknown as the Phoenix Museum of Art.[43] These statements may have inaccurately encapsulated the history and reputation of the art museum, but they are important nonetheless. It is significant that these writers emphasized ease of recognition and the institution's popularity over its comprehensive collections. More so, they credited the widespread nature of *Rocky* culture for those achievements.

Even Art Commission member Nancy Kolb, who voted to move the statue to the museum area in 2006, explained that the statue, not just the film char-

acter, had "become a cultural icon for the city." She went on: "I don't think it is demeaning the city, because we have a whole lot of people that are coming to Philadelphia from all over the world to run up and down the museum steps and to try to find Rocky. And for me that is a very compelling reason to put [the statue] back in the context of the Art Museum."[44] For advocates like Kolb, embracing the Rocky statue at the museum site was a way of embracing the perceived boost in popularity that the films created for the city.[45]

When people argued in favor of permanently placing *Rocky* at the museum they, like the statue's detractors, wanted to make their vision for Philadelphia's culture the dominant one. It is significant that individuals who did not identify with the art community placed such importance on a bronze sculpture because it demonstrates the major role that visual culture can play in shaping a sense of civic identity, even for people who do not feel connected to the social sphere that is expressly invested in the acquisition and exchange of cultural capital.

Some statue supporters who emphasized the sculpture's popularity as justification for installing it at the museum also used that information to undermine the perceived tastemakers' ability to judge quality. This mode of argumentation was not new in American discourse about art. For example, many of these statements echoed conversations that occurred decades earlier when European modernist art began to appear in American galleries during the early twentieth century. Publicists for the groundbreaking 1913 Armory Show encouraged visitors to embrace the avant-garde works that critics had dismissed. By doing so, they claimed, visitors could prove that they were even more culturally savvy than the art professionals who had been tasked with evaluating the exhibition.[46] Beginning a decade later, as I describe in Chapter 2, collector Albert Barnes notoriously and aggressively questioned the taste of local arts leaders who criticized his work. But while Barnes and the Armory Show's promoters paired their critiques of so-called elite preferences with an alternative way of appreciating fine art, supporters of the Rocky statue challenged privileged vision without proposing a highbrow alternative.

During the last wave of debate, David Yadgaroff, general manager of local news radio station KYW, offered a typical challenge to the art world's stance on the Rocky statue when he announced that a majority of KYW listeners wanted Rocky at the steps. "Members of the Philadelphia Art Commission are putting the Rocky statue down for the count. They don't think it's art. Come on guys—Andy Warhol's soup can is?!"[47] Yadgaroff could have leveraged Warhol's work to defend the artistry of Schomberg's sculpture. He could have pointed to Warhol's avant-garde mix of high art and popular

culture as a possible forerunner of the Rocky statue's blend of popular subject with fine art materials. But he did not. Instead, he spoke from a position of distrust that questioned the art aficionados' qualifications as tastemakers and therefore their ability to assess the Rocky statue at all.[48] He stated later that "when a statue like Rocky, movie prop or not, gains such universal recognition, it's time to think beyond the narrow community of art sophisticates."[49] In doing so, he devalued the exclusivity of classifying an object as "art." Such a statement suggests an attempt to shift the process for determining cultural value away from "art" and toward another characteristic: popularity.

Yadgaroff's statement echoed a sentiment expressed years earlier, when a 1981 editorial about the statue debate asserted that "Northeast Philadelphia doesn't have an Art Museum."[50] The Philadelphians who challenged how the Art Commission, the Fairmount Park Commission, and, as they understood it, all other members of Philadelphia's cultural elite, determined what was art and what was not, may have been upset because of a wider-reaching feeling that art was identified and exhibited by and for people who were unlike them. Their resistance to the assessment of *Rocky* as movie prop, and therefore "not art," suggests a desire to revise the cultural dominance of Philadelphia's wealthy arts patrons.

The leading argument from those who wanted to see the statue permanently at or near the Rocky Steps was that the statue was a local icon and therefore deserved to be embraced by the city—including by its arts specialists. In 2006, this argument won out.[51] Statements from those who touted the Rocky statue's iconic qualities welcomed the fame and attention that *Rocky* brought to Philadelphia. Members of the City Council and the city's tourism board and a number of *Rocky* fans liked having their city seen on screen in five out of six *Rocky* films, and they liked that the Rocky Steps drew so many visitors to the site at the end of the Benjamin Franklin Parkway. In their opinion, those achievements were worth celebrating.

Tangled Details

Although the Rocky debate suggested a total separation between the elitist "art world" and the rest of Philadelphia, the city was not as sharply divided as public discourse suggested. The discussions about Philadelphia's perceived sense of self were carried out in public forums. In turn, outcomes were ultimately determined by how those discussions *appeared,* rather than by the nuanced layers out of which they were constructed. Even if public conversations about the subject elided those subtleties, it is important to consider

more closely the ostensibly clear split between parties in the debate. It may not be surprising that the controversy's multifaceted publics were reduced to such distinctly partisan camps, but examining some of the perspectives that did not make it into the popular press, as well as some of the odd ideas that did, reveals a remarkable oversimplification in the way the dispute was presented to its audience.

Philadelphia's art community was not as monolithic on this issue as it was made out to be. One convincing piece of evidence supporting this point comes in an e-mail from Philadelphia Museum of Art senior press officer Frank Luzi to his colleagues on staff. When alerting his coworkers to yet another press clip from the 2006 wave of statue controversy he lamented, "I take offense to [the writer's] belief that none of us at the Museum have ever done the Rocky Run. I ran the steps in a suit the day I interviewed for this job!!!"[52] His message attested to the fact that being affiliated with a leading high culture institution in the city did not preclude someone from also being a *Rocky* fan.

Similarly, the pro-statue contingent was not as diametrically opposed to the museum crowd as press coverage suggested. Stallone was one of the most persistent advocates for installing the Rocky statue in front of the museum. Even after a contract between *Rocky V* producers and the Philadelphia Museum of Art stipulated that "the film company not take advantage of the situation with regard to the return of the statue for press purposes and that, if necessary, the film company executives go on record stating that . . . it is inappropriate for [the statue] to remain permanently at the Museum,"[53] Stallone continued to push city committees to vote on whether the statue could appear at the museum on a long-term basis.[54] As Rocky, Stallone's turf was outside of the museum, on the Rocky Steps and in the ring, but as a Hollywood celebrity he appeared at ease inside the museum on numerous occasions.

With the exception of *Rocky* and *Rocky IV,* all of the films in the core series had special premieres in Philadelphia and were celebrated with a private party in the Philadelphia Museum of Art. Photographs from one of the opening festivities show Stallone and his wife at the time, both dressed for the black-tie affair, on *another* prominent staircase associated with the museum. Instead of sprinting up the museum's exterior steps, Stallone glamorously walks down the interior stairs that give the museum's Great Stair Hall its name (Figure 4.8). In that moment, celebrity Stallone did not embody Rocky but was, alternatively, his mirror image—the inverse reflection of his famous character. Rather than ascending to potential success, Stallone descended from on high; at the premiere party the museum was his palace, and he was the elite—a

Figure 4.8. Sylvester Stallone and Sasha Czack entering the Great Stair Hall during the *Rocky II* premiere gala in 1979. ("Rocky" films, 1979–1982, 1989–1990, Marketing and Public Relations Department records, 1927–2006 [bulk: 1960–1995], Philadelphia Museum of Art, Archives.)

far cry from the culturally disenfranchised community that he purported to represent in his endeavor to place the popular Rocky statue permanently at the museum.

In addition to comfortably promenading down the grand staircase inside the Philadelphia Museum of Art during *Rocky* premiere parties, Stallone aligned himself with the art world in more explicit ways. A painter for more than thirty years, Stallone exhibited his expressionist works alongside established artist Fernando Botero at Art Basel Miami Beach in 2009. A fixture in the sector of the contemporary art world that fueled and celebrated bluechip collections, the festival billed itself as "the most important art show in the United States, a cultural and social highlight for the Americas."[55] Articles that covered Art Basel Miami Beach that year (and in other years) read like pieces from the society pages; they offered a smattering of who's who and photographs of artists and collectors socializing.[56] It would be difficult for even the most anti-establishment artist to deny elite status after showing work there.[57] Stallone's Art Basel Miami Beach debut may have come three years after the last phase of Rocky statue controversy, but his interest in fine art was in place long before 2009.[58]

So what are we to make of these examples that upset the strict split between snobs and populists, which nevertheless came to characterize the statue debates? Perhaps the pugilistic spirit of the *Rocky* films made it all too tempting for publicists and journalists to transform what could have been a quiet dispute into an all-out (verbal) brawl that required two distinct sides pitted against one another. After all, nearly every article about the statue included at least one *Rocky*-related pun.[59] At the same time, the very public nature of the debate may have limited the degree of nuance that emerged from the press coverage of the controversy. In all of the excitement, details may have slipped through the cracks. It is hard to quietly dismiss that kind of simplification, however, especially because of the sheer abundance of errors and omissions that pepper journalistic accounts of the conflict.

A particularly egregious example of journalistic inaccuracy regarding the Rocky statue dates from the first phase of the dispute. In the early 1980s, the Philadelphia Museum of Art was blamed for the city commissions' decision to deny the Rocky statue a permanent place on the museum's steps. Throughout the twenty-five years that followed, journalists and members of the broader public repeatedly positioned the museum as a main villain in the statue debate. For example, in a caustic 1982 essay that approached the controversy as a sort of fractured fairy tale, Mark Bowden proclaimed that "the steps where the actor had decided to place his statue actually *belonged* to the art museum! And the famous art museum decided that it did not want the famous actor's statue on its front steps."[60] Contrary to Bowden's report, and as I noted earlier in this chapter, the display of objects on the museum's steps ultimately fell under the jurisdiction of the Philadelphia Art Commission and the Fairmount Park Commission, not the museum. Although museum affiliates may have aided the commissions in making an official decision, the question of where to put the statue was never entirely in the museum's hands.[61] Nevertheless, the false report persisted over the course of the debates, and in 2006 news stories still held "snobby museum bosses" responsible for the statue's uncertain future.[62]

Other news accounts condensed the Rocky statue saga into a single misremembered blur. In May 2006, the *Philadelphia Daily News* announced that "The Fairmount Park Commission voted yesterday to allow the statue, which has inspired thousands of triumphant runs up the museum steps since the first 'Rocky' movie in 1976, returned there from its most recent home outside the Wachovia Spectrum."[63] How could a statue from 1980 have drawn *Rocky* fans to the steps in 1976? Although, as I have shown, fans have been doing the Rocky run since the release of the first *Rocky* film, the statue initially

played no role in motivating the pilgrimage. Commissioned four years later, the sculpture was created partially in response to the popular fan practice. Some readers may prefer to understand this slip simply as an example of sloppy writing, but I find it remarkable that the authors did not take the care to differentiate between distinct phases of *Rocky* history. If this quote were the sole example of such clumsy reporting, I would be inclined to dismiss it as a fluke, but it is not alone.

A different story from 2006 explained that the statue was "stored in a warehouse for years after it was removed from the museum steps."[64] The statue did spend several months in storage between 2005 and 2006, but countless sports references, tourist photos, and official city documents attest to the fact that the statue spent many years on view at the Spectrum between its debut at the museum in 1981 and its 2006 installation at the base of the Rocky Steps.[65]

Another article noted that "Rocky first was placed at the top of the museum steps, but was quickly moved to the city's sports stadium complex in South Philadelphia."[66] If the statue had in fact been "quickly" relocated from the museum to the Spectrum, the controversy might have never erupted into the widespread dispute that it became. The drawn-out process of moving the statue to the Spectrum allowed early frustrations about the statue's location to ferment. To review, the statue first appeared at the Rocky Steps for the *Rocky III* shoot in May 1981. Since the necessary local boards had not approved the statue's continued display in that location, the sculpture was sent to Los Angeles with Stallone after the filming was complete.[67] A group of Philadelphians, disappointed by the statue's departure from the city, responded by organizing the Rocky Must Stay campaign and petitioning Philadelphia to bring back the bronze. Their demands were met when the statue returned to the museum's steps in May 1982 for the premiere of *Rocky III.* The film's producers had been granted permission to temporarily place the statue at the Rocky Steps, but they neglected to de-install the sculpture at the end of the agreed-on period. While the statue lingered at the museum, the debate over whether it should remain there reopened. When the producers and the City of Philadelphia refused to pay to move the sculpture, the museum, a nonprofit organization with a limited budget, had to pay to have the statue removed, transported across the city, and installed at the Spectrum. Local art movers donated their resources to help make the price of relocating the statue more affordable for the museum, which never should have had the responsibility of moving the bronze to begin with.[68] Many of the negative feelings that the city's official arts enthusiasts (including those who worked

at the museum) had toward the Rocky statue resulted from the unfortunate circumstances surrounding its 1982 removal from the museum's steps.

Even if these instances of poor journalism were innocent cases of forgetting, they are also indicative of the dangers that can arise from imprecise accounts of current or historical events. When Bowden and others misreported that the Philadelphia Museum of Art was chiefly responsible for preventing the Rocky statue from becoming a fixture on the museum's steps, they fueled antimuseum sentiment across the city. When journalists glossed over the details of the statue saga, they ignored the layers of complexity within Philadelphia's recent history and denied their readers a fuller understanding of the circumstances that shaped the region's cultural climate. This is a nonnegligible aspect of how public discourse shapes meaning. Issues that marinate in imprecise language and misinformed distinctions can contort and thrive. Once embedded in collective understanding, they persist, informing future acts and opinions.

Rocky *Reclaimed*

The end of the Rocky statue debates in 2006 coincided with two *Rocky* milestones. That year marked the thirtieth anniversary of *Rocky*. It also brought the apparent conclusion of the epic series of *Rocky* films. *Rocky Balboa,* billed as the sixth and final *Rocky* movie, had been shot during the previous year and would premiere that December. As previously discussed, controversy surrounding the statue ebbed and flowed in a pattern that paralleled the production and release of chapters in the *Rocky* saga. It follows, therefore, that the city's decision to reopen the question of where to display the statue may have been just another component of the 2006 *Rocky* fervor. After all, the statue was unveiled in its new location at Eakins Oval during Philly Loves Rocky Week, a festival that featured a Rocky look-alike contest, exhibition boxing, and a screening of the original *Rocky* movie.[69] The festival took place just three months before *Rocky Balboa*'s release. Many people angered by the decision to put *Rocky* at the museum argued that the city's boards had caved to commercialism and pressure from Hollywood publicists.[70]

By returning to the theme of site specificity—a key factor in the emergence of the Barnes collection, *The Gross Clinic,* and the Rocky statue as pictures for the city—I propose a less skeptical reading of the Rocky statue saga and its conclusion. At the Spectrum, the statue primarily served as a monument to the *Rocky* films and as a popular sports symbol. When the Rocky statue appeared in the press between phases of debate, it was mostly discussed

on the pages of the Sports section.[71] The statue may have been iconic while on display at the sports complex, but it was not a city icon, and it was not a picture for the city. When the city moved the statue to the museum's grounds, it embraced Rocky as a picture for the city: as an image for Philadelphia, not just as a piece of publicity for a film franchise or a convenient reference for sports writers. Relocating the sculpture figuratively and literally positioned it to become a city icon.

More than a space reserved for the fine arts, the area in front of the museum was a place of broad civic significance. In 1923, a different dispute over public sculpture confirmed that the Parkway grounds were to fill this larger role. Factions in the city "debat[ed] with more heat than ever" whether it was appropriate to install an equestrian statue of George Washington in front of the new museum building, which was under construction at the time.[72] Although Washington, who had lived in Philadelphia during his presidency, bore an indisputable connection to the city, some who objected to the statue of him suggested that a sculpture of a famous American artist would be more fitting in front of the museum than a figure of the nation's first president.[73] Parkway designers, who favored the Washington statue, ultimately won the dispute, and the sculpture of Washington remains in place near the museum today (Figure 4.9).[74] The resolution of this early twentieth-century controversy implicitly established the grounds outside of the museum as an area for recognizing historically significant aspects of the city, even if they were not directly connected to its legacy of achievements in art. Generations later, the site retained that purpose. For example, even today Philadelphia's annual Welcome America! Fourth of July celebration culminates with a concert and fireworks in front of the museum. By adding the Rocky statue to the grounds at the end of the Parkway, Philadelphia acknowledged the fictional character as significant to the city as a whole.

The apparent conclusion of the core *Rocky* series facilitated the statue's transition from iconic object to city icon. Once there was the sense that there would be no more installments of *Rocky,* the statue could become associated with Philadelphia's history, rather than with Hollywood's hype. Philadelphians were aware that as long as producers continued to churn out *Rocky* movies, the statue and the controversy surrounding its location would build publicity for the films and, in turn, boost box office sales for each new release. Although the city did allow the statue controversy to raise interest in *Rocky* just months before *Rocky Balboa*'s debut, when the statue's ability to directly promote new *Rocky* movies began to decline it was free to serve a different promotional function. Yes, the statue remained associated with the

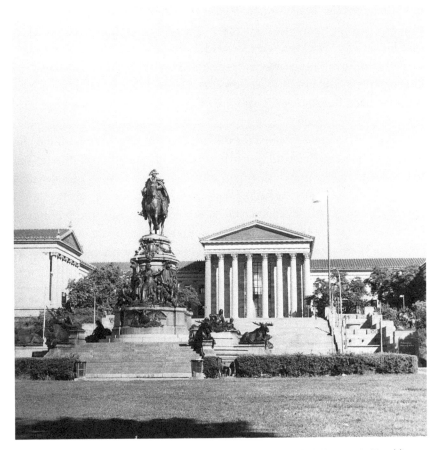

Figure 4.9. Rudolf Siemering, *Washington Monument* (1897), Benjamin Franklin Parkway at Eakins Oval (relocated in 1928). (Photograph: Howard Brunner © 1982, courtesy Association for Public Art.)

Rocky series, but instead of sparking interest in new episodes of the saga, it could operate as a reminder of Philadelphia's past associations with the movies. In other words, emphasis shifted from the films to the city and from the present to the past.

In 2006, the city simultaneously embraced and began to move beyond *Rocky.* The transition is illustrated in the Greater Philadelphia Tourism Marketing Corporation's (GPTMC) annual reports from 2007 and 2008. When GPTMC gave an overview of the previous year's publicity initiatives in 2007, it bragged that it had piggy-backed on recent Hollywood projects in the city: "The films *Invincible* . . . and *Rocky Balboa* allowed us to rev up the marketing machine, generating 900+ stories about moving the *Rocky* statue and the

release of the two films."[75] Just as United Artists may have once used the Rocky statue and the Philadelphia-based controversy to draw moviegoers to the *Rocky* films, GPTMC could now brag about using the movies and the statue to attract publicity foremost for the city. GPTMC also explained that "the *Rocky Balboa* story and image is a part of Philadelphia. It is the story of the underdog, of the grit and authenticity of the city, of a city with heart. The crowds at the *Rocky* statue at the foot of the Philadelphia Museum of Art attest to the power and popularity of his story."[76] As I have shown, the practice of associating *Rocky* with Philadelphia dates back to the 1970s, but in 2007 the bronze sculpture and the crowds it drew offered a tangible indicator of the city's spirit.

It is worth pausing here, briefly, to note that there are real limitations to claiming an "authentic" connection between the Rocky statue and Philadelphia's "grit." As a city icon the Rocky statue may privilege a popular appreciation of Philadelphia, but it would be wrong to suggest that this perspective is any truer to the city's nature than the perspective of those who argued that the sculpture was unworthy of display near the museum. The Rocky statue offers an optimistic, imaginary alternative to the more difficult realities of life in the city. It does not demand, for example, that viewers reflect on drug addiction, housing insecurity, or other challenges associated with financial instability in many of Philadelphia's neighborhoods, including those depicted in the *Rocky* films. Instead, it redirects viewers' attention toward uplift and endurance. It is important to remember that the Rocky statue's emergence as a city icon was less about embracing the city's struggles than it was about celebrating the city's popular culture fame.

By 2008, the Rocky statue remained in Philadelphia's marketing, but it had lost some of its prominent role in representing the city. When the tourism report from that year discussed the success of GPTMC's website, it illustrated its case with a screenshot of gophila.com (later visitphilly.com). The home page featured a large horizontal display with shifting images representing the many great things that Philadelphia and the countryside could offer tourists. Online, the picture changed every few seconds, but the screenshot included in the 2008 *Tourism Monitor* featured a photograph of the Rocky statue (Figure 4.10).[77] No longer explicitly addressed in the report, *Rocky* was an implicit part of the identity that Philadelphia projected to itself and to potential visitors.

Although GPTMC continued to promote *Rocky*-related tourism by referring to *Rocky* and the statue in occasional press releases, after 2007 the organization stopped highlighting its *Rocky*-themed publicity endeavors as evi-

Figure 4.10. Detail from "A Close-up Look at Gophila.com," *Tourism 2008 Report to the Region: More Partners, More Promotions, More People,* Greater Philadelphia Tourism Marketing Corporation, 2008, 41. (Image courtesy of Visit Philadelphia.)

dence of its achievements. Instead, annual reports featured pull-quotes from newspaper and magazine articles that proclaimed that Philadelphia was more than just *Rocky.* In December 2010, the Rocky statue held the number 10 slot on GPTMC's list of "favorite attractions" on the home page of visitphilly.com, but the 2010 annual report placed its emphasis elsewhere.[78] It still mentioned the Rocky statue, but it did so by calling attention to a *Bon Appétit* story that hailed the city as "an urban culinary mecca, with good eating as much of a draw as the Liberty Bell, the Rocky Balboa statue, and the diverse culture."[79]

After Philadelphia formally granted the Rocky statue city icon status by installing it near the Rocky Steps, the statue supporters may have felt that the city had given adequate credibility to their vision for Philadelphia. Although individuals who opposed permanently displaying the sculpture near the museum may have been disappointed by the outcome of the debates, they did not see their vision for the city ignored in Philadelphia's official publicity endeavors. Instead of celebrating Philadelphia purely for its high culture accomplishments or for its pop culture fame, GPTMC invited potential tourists to experience both sides of the city.

Nearly a decade after the sculpture debate was resolved, a new film reopened the movie world of *Rocky*. *Creed* appeared in theaters in late 2015. More spinoff than sequel, the film focused on Adonis, the son of Rocky's rival-turned-friend, Apollo Creed. Just as *Rocky II* reflected changes in the metro world that had occurred since the previous film was released, *Creed* reflected a Philadelphia that had embraced the Rocky statue as a city icon. Early in the film, Adonis (played by Michael B. Jordan) leaves his Southern California home for Philadelphia, where he hopes to connect with his father's old friend. Adonis's introduction to Philadelphia comes in a minute-long sequence scored with music by Philadelphia artists the Roots and John Legend. A taxi takes Adonis into the city. It drops him off at his new apartment. He unpacks his suitcase and begins to get his bearings by looking around his room and looking out his apartment window. The scene cuts to a medium-close shot of the Rocky statue. Beginning at Rocky's head and raised arms, the camera pans down to show a group of tourists posing for a photo. As a man smiles and snaps an image of his family, Adonis approaches in the background. Like the tourists who preceded him, Adonis learns about the city by visiting the Rocky statue. It connects him to his father's past, but it also connects him to Philadelphia's history. By positioning this pilgrimage in the short sequence in which Adonis and viewers first encounter the city, *Creed* treats the Rocky statue not as a promotional item, but as a key signifier of place. Along with shots of the skyline and Adonis's neighborhood, it establishes Philadelphia as Philadelphia.

Significance in Situ

At Eakins Oval, in the wake of a decades-long debate, the Rocky statue should no longer be dismissed as simplistic, even by the strongest culture critics. When the Rocky statue was first made it was a shell of an artwork: an object that could signify "public sculpture" on screen.[80] Over the course of the dispute, as individuals projected their visions of Philadelphia's identity onto the bronze figure, they imbued it with significance and made the sculpture relevant to the city in new ways. Revisiting the statue in the aftermath of the quarter-century conversation that involved movie fans, lovers of fine art, and civic boosters reveals a compelling object that celebrates Philadelphia's film-induced popularity without entirely disavowing the taste preferences of those who wanted the sculpture far from the museum.

By installing the Rocky statue at Eakins Oval, Philadelphia officials recognized the film franchise and the culture that developed around it as an

important aspect of the city's cultural heritage. As twenty-first-century Philadelphia replaced its downtrodden, gritty image with an identity anchored in cultural accomplishments, the Rocky statue indicated that the perspectives of people who enjoyed popular culture were a valued part of the city and its future. But, as a city icon, the statue did not have to speak exclusively for the individuals who wanted it located at the Rocky Steps.

For those invested in carefully studying artworks like the ones on view inside the Philadelphia Museum of Art, the Rocky statue at Eakins Oval offers an engaging exercise in looking and thinking. It is significant that instead of displaying the statue atop the museum's steps or at the sports arena, the city installed the statue to the right of the base of the famed stairs. With its multiplicity of meanings, which are communicated most clearly in the contentious and symbolic environment of the museum, the sculpture could represent the interests of individuals on all sides of the controversy. In that setting, neither atop the steps nor at the Spectrum, the statue acquired its most intriguing function. Like *The Gross Clinic* in 2007 or the Barnes collection in 2012, when placed on the Parkway, the Rocky statue illustrates the layered story of its own history.

The act of running the Rocky Steps places emphasis on the ascent and the arrival at the top of the platform, but what happens after a Rocky runner turns her back to the museum and raises her arms in celebration as she looks out at the Parkway and the city in front of her? Perhaps after posing for a photo-op, she will catch her breath and jog back down the steps to reconvene with friends at the traffic circle below.[81] Relative to the scores of individuals who come to the Rocky Steps, remarkably few people sprint up the museum mount, do their Rocky moves, and then head into the building to wander the galleries.[82] Imagine: a runner bounds up the steps, celebrates his accomplishment, and trots back down to the base of the hill. On his way down, he might pass another set of runners who will follow suit, pausing at the top of the steps for a look out at the skyline before heading back down to street level. With people continually ascending and descending the stairs, a collective body of runners forms. The Rocky Steps become the site of a perpetual up-and-down, like the continual back-and-forth of the discourse over the appropriate location for the sculpture. In their shadow, the Rocky statue, a fixed monument that offers a contrast to the experiential nature of the steps, might seem to halt the repetitive actions of the collective runners nearby and offer a resolution to the controversy.[83] A visit to the Rocky statue, however, simply transforms the two-part up-and-down into a three-part triangle of

activity, like a conductor switching from 2/4 to 3/4 meter. In this way, the statue's supposedly permanent location at Eakins Oval does not announce a fixed and final vision of Philadelphia, but instead can signal to viewers that the city and its reputation, perpetually shaped by the conversations that take place in and about the region, remain in flux.

Conclusion

On August 30, 2007, the Associated Press ran a photograph by George Widman.[1] The caption described the scene as one in which "Mark Schwartz, an attorney representing Friends of the Barnes Foundation, addresses members of the group outside the home of a neighbor of the Barnes Foundation in the Philadelphia suburb of Merion, Pa" (Figure C.1). Schwartz occupies the lower-left quadrant of the image. The balding, grey-haired man wears a suit and tie. With a microphone in one hand and a blue folder tucked under the opposite arm, he gesticulates as much as he can without dropping his props. Instead of looking directly at the photographer, Schwartz gazes off to the right, presumably at the Friends of the Barnes Foundation who have come to hear him speak. Only one member of his audience is visible. The figure stands behind Schwartz, toward the center of the image, and vies with the lawyer for the viewer's attention. It appears that Rocky Balboa has come to support the effort to keep the Barnes collection in Merion.

A cardboard cutout of A. Thomas Schomberg's bronze statue of the fictional boxer shares the frame with Schwartz. Rocky's raised arms, typically understood as a gesture of victory, transform into a gesture of protest as they hold up a sign: "JOIN THE FIGHT TO SAVE THE BARNES." The capital letters and sans-serif typeface boldly and simply call viewers to get involved. Rocky directs his gaze toward the microphone in Schwartz's hand as if concentrating intently on the words emanating from the lawyer's mouth. Although the

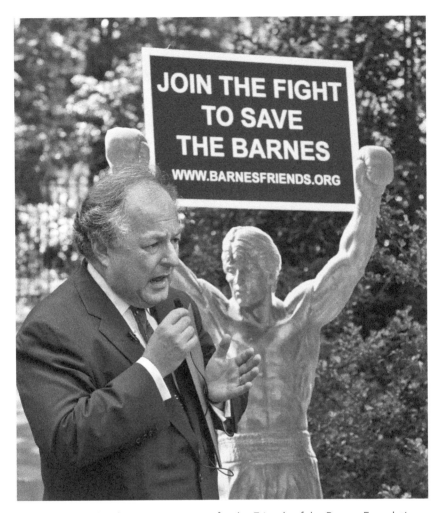

Figure C.1. Mark Schwartz, an attorney for the Friends of the Barnes Foundation, addressing members of the group near the Barnes Foundation in Merion, Pennsylvania. (Photograph by George Widman/Associated Press [2007].)

caption makes no mention of Rocky's presence, the boxer is a key element of this photograph.

For viewers who linger on this image, connections to yet another city icon emerge. Widman's masterfully composed photograph bears a strange familiarity. It's that grey-haired man in a suit, addressing a crowd without making eye contact with the viewer. In Widman's photograph, Schwartz appears as a mirror image of Thomas Eakins's Dr. Gross. Here, Schwartz faces right, whereas Gross faces left, and the surgeon's scalpel has become the lawyer's

microphone. Formally, Widman's photograph echoes the central section of Eakins's painting. Imagine cropping *The Gross Clinic* for a tighter view that removes the surgical tools in the foreground, the seated woman, and the doctor at the lectern behind Gross. In each image, the main figure appears to the right of a rectangular form that attracts our eye, whether it is the shadowy entrance to Dr. Gross's operating room or the declarative sign that Rocky holds at the rally. Just as for some the bloody incision in the patient's thigh upstages the portrait of the surgeon who lends his name to the painting, so, too, does Rocky draw our attention away from Schwartz, the ostensible subject of the photograph. A Friends of the Barnes Foundation press conference framed by the popular appeal of the Rocky statue and the visual vocabulary of *The Gross Clinic* suggests that, by 2007, viewers could read current events in Philadelphia through the new pictures for the city.

This remarkable image brings together the three new pictures for the city in a manner that illustrates the many ways in which they coexisted in a cultural ecosystem around the turn of the twenty-first century. Each picture for the city affected discussions about the others. Rocky's call to help keep the Barnes collection in Merion, for example, offered a retort to the charges of elitism that opponents of the Friends of the Barnes Foundation waged against the group. With Rocky on the side of the Friends of the Barnes Foundation, it would be harder for critics to argue that the group did not represent the interests of the average Philadelphian. Perhaps here Rocky even read as a stand-in for larger crowds of people who were coming together (or who the Friends hoped would come together) to support the effort to prevent the collection's relocation. Now that Rocky had come to represent Philadelphia, his presence at the rally suggested that Philadelphia's residents, if not its leaders, would support keeping the Barnes in Merion. At the same time, by enlisting Rocky to advocate for their cause, the Friends of the Barnes Foundation positioned themselves as the sympathetic underdog matched against the brazen Barnes leaders who were backed by Big Philanthropy and the Philadelphia officials who sought to move the collection to Center City. Whoever obtained the Rocky cutout and equipped him with a sign may have hoped to indicate that, like Rocky, they too could prevail in a fight that they seemed unlikely to win.

Writing in the local *Broad Street Review* in 2006, while Philadelphians were contemplating the sale of *The Gross Clinic,* scholar and community activist Robert Zaller described Eakins's painting as "the treasure that, even more than the *Rocky* statue, defines Philadelphia's civic heritage." In the same article, he also connected the *Gross Clinic* sale to the controversy over the Barnes collection. He argued that "Ms. Walton is trying to make off with a

single painting. Philadelphia is trying to steal an art collection from its closest neighbor."[2] Just a few months earlier, the Friends of the Barnes Foundation circulated a press release with a similar statement. It declared, "What Is Good for Dr. Gross Is Good for Dr. Barnes: Friends of the Barnes Foundation Challenge Double Standard."[3] Elsewhere, representatives of the group argued that while *The Gross Clinic,* a self-contained work, would "continue to exist intact" regardless of its location, the Barnes collection relied so much on context that the piece would be destroyed in some way if it moved.[4] Although *The Gross Clinic* did acquire a site-specific significance in conjunction with its recent emergence as a city icon, the Friends of the Barnes Foundation's claim remains a fascinating indicator of the ways in which Philadelphia's new pictures for the city were intertwined.

Finding traces of each picture for the city in the others underscores the importance of each of these objects in the early twenty-first century. Their stories and symbolism became such potent points of reference that, in addition to their shared role in defining Philadelphia, they also contributed to defining each other. The intense public conversations surrounding these objects created an entangled set of new pictures for the city in which each item bolstered the others' resonance and they all operated in connection with Philadelphia's changing identity.

Contestation, Public Engagement, and Meaning Making

As indicated by the title of this book and by the story arcs of each chapter, contestation was a defining element of the process through which these new pictures for the city emerged. In each case, that contestation developed around specific concerns about the fit between the object and its current or proposed location. Grassroots efforts as well as leadership from local organizations powered each episode. When the Barnes collection began to attract unprecedented numbers of visitors to its Merion galleries, neighbors objected that the traffic was inappropriate for their suburban street. When the Barnes Foundation's leaders began to explore the possibility of moving the collection to Center City, debate erupted over whether the collection should (or could) move to Philadelphia or remain in Merion. When Jefferson University announced that it would sell *The Gross Clinic,* those who rallied to keep the painting in Philadelphia did so in resistance against the fact that it would otherwise be sold jointly to Crystal Bridges and the National Gallery of Art. In those other collections, the painting would retain its national significance, but it would lose some of its specific ties to Philadelphia. When the Art Com-

mission determined that the Rocky statue could appear on the East Terrace of the Philadelphia Museum of Art for the *Rocky III* shoot but that it should not remain a permanent fixture in the city, controversy similarly began to brew. When Stallone shipped the sculpture to Los Angeles after the filming concluded, the Rocky Must Stay campaign increased the intensity of debate over where (if anywhere) in Philadelphia the statue belonged. Conflict resurfaced each time the Art Commission considered proposals to move the sculpture.

The intense public conversations that followed each of these initial outbursts became about defining the significance of Philadelphia as a place as well as about determining the appropriate placement of each object. The shapes of these exchanges, however, were not uniform. The debates surrounding the Barnes collection and the Rocky statue were deeply divisive within Philadelphia and among interested parties outside of the city. In contrast, the impassioned public conversations surrounding *The Gross Clinic* mainly united participants in Philadelphia in a shared effort to keep the painting in the city.

Public engagement of varying types heightened the intensity of each case of contestation. Individuals and institutions published written and verbal statements that included press releases, thoughts shared on call-in radio shows, and comments posted online. Groups like the Friends of the Barnes Foundation, Rocky Must Stay, and the network that rallied to keep *The Gross Clinic* organized campaigns—for fund-raising as well as for protest. Performative practices ranging from mundane (running up the Rocky Steps) to spectacular (painting a full-scale replica of *The Gross Clinic*) reinforced the importance of the objects under discussion.[5] News reports simultaneously tracked and fueled these growing matters of public interest. In some instances, journalists shared thoughtful commentary and provided opportunities for people with different perspectives to constructively make their cases. At other times, misreported details and overly simplified stories irresponsibly elevated tensions.

The public engagement in each act of contestation facilitated a shift in meaning for each object. Considering the merits of displaying the Barnes collection on the Parkway versus in Merion amplified the theme of location in the way that parties discussed and understood the Barnes. The campaign to keep *The Gross Clinic* in Philadelphia touted the painting's importance to the city so vehemently that the artwork finally became the city icon it was designed to be. The drawn-out debates about the Rocky statue transformed the sculpture's role from promoting a movie series to promoting Philadelphia.

These and other shifts occurred because of the physical and historical contexts in which each object came under consideration around the turn of the twenty-first century. They infused each historic object with new contemporary relevance as a picture for the city.

As part of that process, the new pictures for the city expanded Philadelphia's mainstream image to include more than postindustrial urban decay and three-hundred-year-old ties to the colonial era and early republic. The Barnes on the Parkway presented Philadelphia as a verdant, vibrant, and safe place for residents and outsiders to see a world-class modernist art collection. *The Gross Clinic* accentuated Philadelphia's role in fostering fine art and medical excellence during the nineteenth century and the city's recently renewed status as a cultural hub. The Rocky statue provided an idealized emblem of Philadelphia's resilience and celebrated the city's pop culture fame. Taken together, these pictures for the city offered strong symbolic images around which locals and outsiders could construct a new, cohesive vision of Philadelphia. They told the story of a place with historical weight and contemporary relevance. It was a place on the rebound that, like Rocky, held its own in the face of great odds.

A city's identity changes when the story people tell about it shifts. Economists, politicians, and urbanists have different theories about how this happens, but we also must not discount the role that public images play in shaping the identity of a place. In 1996, Philip Stevick published a study of tourists' writings about Philadelphia since 1800. He suggested that one reason there had been so many different interpretations of Philadelphia was that the city had no strong images to guide people's encounters with it. He did not deny the presence of what I would term pictures for the city, but he implied that whatever pictures for the city Philadelphia had were weak.[6] While some might challenge Stevick's assessment of Philadelphia's pictures for the city before the turn of the twenty-first century, it is clear that by 2010 a new, strong set of representative images had emerged.

The Barnes collection, *The Gross Clinic,* and the Rocky statue were powerful pictures for the city because they held contemporary relevance and historical significance, and because they mattered to locals as well as to outsiders. Each of these objects had accumulated social weight and historical baggage over many years. During that time, they had also become famous outside of Philadelphia, which further validated their local importance around the year 2000. Defining Philadelphia for the twenty-first century was a process of negotiating the city's sense of self and its reputation. As Philadelphia's leaders sought to improve quality of life and the city's image, the items that resonated

most as pictures for the city necessarily spoke to people who lived outside of the region as well as to those who lived nearby. The Barnes collection, *The Gross Clinic,* and the Rocky statue contributed to changing the narrative about Philadelphia because of their symbolism, their individual histories, and the meanings they accrued as people discussed where they belonged.

Future Images

In describing the emergence of three notable pictures for the city, my point is neither to provide a recipe for making compelling pictures for the city nor to predict how long the pictures for the city at the center of this book will remain important images for Philadelphia. Instead, my primary aim has been to demonstrate how and why three apparently unrelated historical objects became intertwined with each other and with Philadelphia's changing identity around the turn of the twenty-first century. In the years to come, new pictures for the city will emerge. Some will arise through intense public debate. Some will become as potent as the Barnes collection, *The Gross Clinic,* and the Rocky statue.

The public conversations surrounding these three objects laid a foundation for future public envisioning of place to occur on a shifted set of terms. In this new cultural landscape, the role that arts institutions play in shaping the city's identity can no longer be discounted. It has become evident that even the most apparently permanent or static objects can acquire new meaning in new contexts. The city and its publics are primed to think deliberately about public art and local identity. And, with Philadelphia's new reputation as an internationally relevant center of culture more cemented, future conversations can more explicitly interrogate the gap between Philadelphians included in the city's new success and those excluded from it.

One project that reflects this new approach was Monument Lab, an "ideas festival" curated by Ken Lum, Paul Farber, and A. Will Brown that launched in 2015. Part exhibition, part public survey, and part collaborative art initiative, Monument Lab revolved around one key question: "What is an appropriate monument for the current city of Philadelphia?" It was not about making monuments per se but about considering the nature of and needs for monuments in the city. From May 14 through June 7, 2015, project facilitators transformed the courtyard of City Hall into a creative laboratory where they invited Philadelphians to propose answers to the program's framing question. Over the course of three weeks, artists, scholars, and civic leaders presented formal reflections on the history and future of monuments in Philadelphia. Passersby

and program attendees were invited to propose their own monuments. Taken together, those submissions offer an impressive overview of the people, places, events, and ideas that Philadelphians viewed as worthy of commemoration as well as of the forms that they thought were fitting for the task.[7] Brown explained that this speculative project emerged out of "a need for critical public art, of a temporary and more ephemeral nature, but critically pointed towards examining the city's rich history as a means of thinking about the future of the city."[8] By asking questions rather than prescribing answers, Monument Lab harnessed Philadelphians' demonstrated appetite for participating in conversations about the complexities of the relationships among public representation, the city's history, and its future identity.

When Monument Lab returned in 2017 with a modified leadership team and in partnership with Mural Arts, it had expanded in scale and ambition. In addition to generating opportunities for people to envision their own monuments, it presented a series of well-publicized, temporary public art projects by a combination of local and internationally active artists with varying degrees of name recognition within and beyond the art world. The installations activated selected sites in Center City as well as in neighborhoods further from the tourist district. Echoing the spirit of the 2015 festival, Monument Lab 2017 billed itself as "invit[ing] people to join a citywide conversation about history, memory, and our collective future. . . . Broadening the potential for who creates, appreciates, and feels represented by monuments in the 21st century."[9] Many of the commissioned projects directly questioned whose perspectives are honored by or reflected in public art in Philadelphia. Featured projects in West Philadelphia, Germantown, and other areas outside of Center City demonstrated a wider vision of where internationally relevant culture belongs in Philadelphia. It is too early to draw many conclusions about Monument Lab's lasting effects. But it is clear that the project's structure, geographic scope, and language reflect the new landscape of public envisioning of place in Philadelphia that grew out of the episodes at the center of this book.

As Philadelphia and its pictures for the city continue to change, civic leaders, arts experts, and community activists must ensure that public conversations explicitly recognize the ways in which historical objects and current circumstances intertwine to shape how those objects are valued by contemporary audiences and how those objects can shape local identity. To do this responsibly, there must be room for more creative, historically informed thinking about objects, their publics, and the meanings they make together. Working in this way will involve allowing for more public discourse that complicates, rather than simplifies, interpretations of an object. It will in-

volve studying historical sources in order to tell a more nuanced story. It will involve thinking abstractly as well as concretely to make sense of the issues at hand. It will require being comfortable with open-endedness in lieu of clean resolution. I have tried to model this approach in my analyses of the pictures for the city in this book.

In other parts of the country, the stakeholders, the objects, and the concerns they address may be different, but the point is the same. When we study, exhibit, and interpret historical objects, we have an opportunity to consider the ways in which their meanings continue to evolve in today's contexts. When we resist the urge to downplay the controversy and confusion surrounding contentious objects and instead examine the muddy discourse more closely, a point of entry into these items' contemporary complexity emerges. If we want these items to represent a fuller array of experience, or if we want them to help us understand the perspectives that they overlook, we must be willing to take risks in the way that we talk about them. As we seek to deepen and expand the stories that have been told before, we must also look for new stories in old objects and share what we find.

Notes

INTRODUCTION

1. For an overview of the way Americans have resisted, challenged, and restricted urban life, see Steven Conn, *Americans against the City: Anti-urbanism in the Twentieth Century* (New York: Oxford University Press, 2014).

2. A 2015 poll conducted by the Pew Charitable Trusts ranked education, crime, and jobs/economy as "Top Issues Facing Philadelphia" (*New Pew Poll: Philadelphians View K–12 Education as Top Issue* [Pew Charitable Trusts, March 2015]).

3. Richardson Dilworth, "Way Back When, Philly Didn't Even Try to Love You Back," *Newsworks,* February 19, 2012, https://whyy.org/articles/way-back-when-philly-didnt-even-try-to-love-you-back.

4. For a critical analysis of the tourist- and business-centric revitalization of urban cores in some American cities, see Lynne B. Sagalyn, *Times Square Roulette: Remaking the City Icon* (Cambridge, MA: MIT Press, 2001); Miriam Greenberg, *Branding New York: How a City in Crisis Was Sold to the World* (New York: Routledge, 2008); Greg Foster-Rice, "The Dynamism of the City: Urban Planning and Artistic Responses to the 1960s and 1970s," in *The City Lost and Found: Capturing New York, Chicago, and Los Angeles, 1960–1980,* ed. Katherine A. Bussard, Alison Fisher, and Greg Foster-Rice (New Haven, CT: Yale University Press, 2014), 19–47; Aaron Cowan, *A Nice Place to Visit: Tourism and Urban Revitalization in the Postwar Rustbelt* (Philadelphia: Temple University Press, 2016).

5. Roger D. Simon and Brian Alnutt, "Philadelphia, 1982–2007: Toward the Postindustrial City," *Pennsylvania Magazine of History and Biography* 131, no. 4 (2007): 395–444.

6. These texts include Michele H. Bogart, *The Politics of Urban Beauty: New York and Its Art Commission* (Chicago: University of Chicago Press, 2006); Cécile Whiting,

Pop L.A.: Art and the City in the 1960s (Berkeley: University of California Press, 2006); Sarah Schrank, *Art and the City: Civic Imagination and Cultural Authority in Los Angeles* (Philadelphia: University of Pennsylvania Press, 2009); Katherine A. Bussard, Alison Fisher, and Greg Foster-Rice, eds., *The City Lost and Found: Capturing New York, Chicago, and Los Angeles, 1960–1980* (New Haven, CT: Yale University Press, 2014); Michele H. Bogart, *Sculpture in Gotham: Art and Urban Renewal in New York City* (London: Reaktion Books, 2018). On Philadelphia's cultural resources, see, for example, Morris J. Vogel, *Cultural Connections: Museums and Libraries of Philadelphia and the Delaware Valley* (Philadelphia: Temple University Press, 1991); Penny Balkin Bach, *Public Art in Philadelphia* (Philadelphia: Temple University Press, 1992). Other related texts appear throughout the Notes and Bibliography of this book.

7. Kevin Lynch, *The Image of the City* (Cambridge, MA: MIT Press, 1960). See also, for example, Philip Stevick, *Imagining Philadelphia: Travelers' Views of the City from 1800 to the Present* (Philadelphia: University of Pennsylvania Press, 1996); Rebecca Zurier, *Picturing the City: Urban Vision and the Ashcan School* (Berkeley: University of California Press, 2006); Bussard, Fisher, and Foster-Rice, *The City Lost and Found*; Dora Apel, *Beautiful Terrible Ruins: Detroit and the Anxiety of Decline* (New Brunswick, NJ: Rutgers University Press, 2015).

8. On sense of place and art that works in tandem with place, see Lucy R. Lippard, *The Lure of the Local: Senses of Place in a Multicentered Society* (New York: New Press, 1997). On the flexible functions of objects, see Igor Kopytoff, "The Cultural Biography of Things: Commoditization as Process," in *The Social Life of Things: Commodities in Cultural Perspective,* ed. Arjun Appadurai (Cambridge: Cambridge University Press, 1986), 64–91; James Clifford, "On Collecting Art and Culture," in *The Predicament of Culture: Twentieth-Century Ethnography, Literature, and Art* (Cambridge, MA: Harvard University Press, 1988), 215–252.

9. Martin Kemp, *Christ to Coke: How Image Becomes Icon* (Oxford: Oxford University Press, 2011), 3.

10. Susan Elizabeth Ryan, "Eternal Love," in *Love and the American Dream: The Art of Robert Indiana,* ed. Fronia E. Wissman (Portland, ME: Portland Museum of Art, 1999), 76–101.

11. Despite Indiana's comment, Philadelphia's sculpture, at 6 feet by 6 feet by 3 feet, is not physically the largest *LOVE*. Other versions of the piece measure 12 feet by 12 feet by 6 feet. Thomas Hine, "Love or Die, His Art He'll Ply," *Philadelphia Inquirer,* May 16, 1978, *Inquirer* news clippings collection, Robert Indiana, K3 6-430, 6a-32, Special Collections Research Center, Temple University Libraries, Philadelphia, PA; Bach, *Public Art in Philadelphia,* 166, 242; Maryanne Conheim, "How Phila's Love Was Won at Last," *Philadelphia Inquirer,* April 30, 1978, *Inquirer* news clippings collection, Robert Indiana, K3 6-430, 6a-32, Special Collections Research Center, Temple University Libraries, Philadelphia, PA.

12. On the changing significance of another key item in Philadelphia, see Charlene Mires, *Independence Hall in American Memory* (Philadelphia: University of Pennsylvania Press, 2002). For a selection of recent scholarship that examines how the meaning of public artworks can change over time, see Erika Doss, ed., "The Dilemma of Public Art's Permanence," Special Issue, *Public Art Dialogue* 6, no. 1 (2016).

13. Between 1997, when the Greater Philadelphia Tourism Marketing Corporation was established, and 2010, the number of visitors to Philadelphia grew from twenty-seven million to thirty-six million annually. *Tourism 2010 Report to the Region: Worth the Trip* (Philadelphia: Greater Philadelphia Tourism Marketing Corporation, 2010).

14. On defining the mid-Atlantic region, see Howard Gillette, "Defining a Mid-Atlantic Region," *Pennsylvania History: A Journal of Mid-Atlantic Studies* 82, no. 3 (2015): 378–380.

15. *The Art of Collaboration: Greater Philadelphia Tourism 2012. A Report to the Region* (Philadelphia: Greater Philadelphia Tourism Marketing Corporation, 2012), 16–17.

16. For a critique of this plan, see Kenneth Finkel, "What's Wrong with Philadelphia's 'Museum Mile'?," *The Philly History Blog: Discoveries from the City Archives,* May 15, 2012, http://www.phillyhistory.org/blog/index.php/2012/05/whats-wrong-philadelphias-museum-mile/.

17. David B. Brownlee, *Building the City Beautiful: The Benjamin Franklin Parkway and the Philadelphia Museum of Art* (Philadelphia: Philadelphia Museum of Art, 1989), 17–18.

18. For a review of the literature that emerged from this movement, see Carole Gold Calo, "From Theory to Practice: Review of the Literature on Dialogic Art," *Public Art Dialogue* 2, no. 1 (2012): 64–78. Sources that have particularly informed my thinking about art and dialogue include Erika Doss, *Spirit Poles and Flying Pigs: Public Art and Cultural Democracy in American Communities* (Washington, DC: Smithsonian Institution Press, 1995); Dolores Hayden, *The Power of Place: Urban Landscapes as Public History* (Cambridge, MA: MIT Press, 1995); Suzanne Lacy, ed. *Mapping the Terrain: New Genre Public Art* (Seattle, WA: Bay Press, 1995); Miwon Kwon, *One Place after Another: Site-Specific Art and Locational Identity* (Cambridge, MA: MIT Press, 2002); Grant H. Kester, *Conversation Pieces: Community and Communication in Modern Art* (Berkeley: University of California Press, 2004).

19. Jean-Luc Nancy cautions against presuming that innate qualities unite people in communities. But he also suggests that we must not think of individuals as completely separate entities, either. If "being" is relative, then it is a form of togetherness—a sort of community. Jean-Luc Nancy, *The Inoperative Community* (Minneapolis: University of Minnesota Press, 1991), 1–42.

20. Michael Warner, *Publics and Counterpublics* (New York: Zone Books, 2002), 67–72.

21. Warner's theory describes in broader terms a phenomenon that Thomas Crow presented years earlier in *Painters and Public Life* when he demonstrated that visual culture in eighteenth-century Paris organized its publics in support of or in opposition to the French Revolution. Thomas E. Crow, *Painters and Public Life in Eighteenth-Century Paris* (New Haven, CT: Yale University Press, 1985).

22. Patricia C. Phillips, "Public Constructions," in *Mapping the Terrain: New Genre Public Art,* ed. Suzanne Lacy (Seattle, WA: Bay Press, 1995), 69.

23. Patricia C. Phillips, "Temporality and Public Art," in *Critical Issues in Public Art: Content, Context, and Controversy,* ed. Harriet Senie and Sally Webster (New York: Icon Editions, 1992), 298.

24. Richard Meyer, *What Was Contemporary Art?* (Cambridge, MA: MIT Press, 2013), 24.

25. James Clifford has famously demonstrated that items can serve different roles depending on the cultural, economic, or temporal context in which they appear. When an object becomes part of a collection, it takes on additional significance, but, as Clifford explains, a collection is as much a reflection of its collector as it is of the objects it contains. Writing more explicitly about Philadelphia, historian Gary B. Nash has explored how the practices of collecting and exhibiting organizations have shaped the ways that the city's history has been told. Clifford, "On Collecting Art and Culture"; Gary B. Nash, *First City: Philadelphia and the Forging of Historical Memory* (Philadelphia: University of Pennsylvania Press, 2002).

26. Similar issues have arisen in other American cities. One recent and particularly potent case occurred in Indianapolis, Indiana, between 2007 and 2011, regarding a public sculpture commissioned from renowned artist Fred Wilson. Echoing the spirit of much of Wilson's work, the sculpture, entitled *E Pluribus Unum,* quoted and reinterpreted the image of a just-freed slave from the city's prominently located Soldiers' and Sailors' Monument. Project organizers planned to install *E Pluribus Unum* in the plaza in front of the City-County Building. When some members of the city's African American community decried the sculpture for perpetuating the image of the African-American-as-former-slave, they called for the statue to be installed in an alternate venue: at the Indianapolis Museum of Art instead of in the public square. The project was ultimately cancelled in the wake of public protest. For further analysis of this dispute, see Modupe Labode, ed., "Special Issue—Art, Race, Space," *Indiana Magazine of History* 110, no. 1 (2014).

27. Kwon, *One Place after Another.*

28. On public scholarship, see, for example, Scott J. Peters, Nicholas R. Jordan, Margaret Adamek, and Theodore R. Alter, eds., *Engaging Campus and Community: The Practice of Public Scholarship in the State and Land-Grant University System* (Dayton, OH: Kettering Foundation Press, 2005); John Saltmarsh and Matthew Hartley, eds., *"To Serve a Larger Purpose": Engagement for Democracy and the Transformation of Higher Education* (Philadelphia: Temple University Press, 2012); Ernest L. Boyer, *Scholarship Reconsidered: Priorities of the Professoriate,* expanded ed., ed. Drew Moser, Todd C. Ream, and John M. Braxton (San Francisco: Jossey-Bass, 2016). Some of my colleagues and I describe how we came to public scholarship in Laura Holzman et al., "A Random Walk to Public Scholarship? Exploring Our Convergent Paths," *Public* 2, no. 2 (2014). http://public.imaginingamerica.org/blog/article/a-random-walk-to-public-scholarship-exploring-our-convergent-paths/.

CHAPTER 1

1. Before it was Penn's colony, the area that became Philadelphia was home to native Lenapes and, eventually, settlers from Sweden, Finland, and the Netherlands. For a study of this history, see Jean Soderlund, *Lenape Country: Delaware Valley Society before William Penn* (Philadelphia: University of Pennsylvania Press, 2015).

2. Kenneth Finkel and Susan Oyama, *Philadelphia Then and Now: 60 Matching*

Photographic Views from 1859–1952 and from 1986–1988 (Philadelphia: Library Company of Philadelphia, 1988), iv.

3. For an overview of Philadelphia history, see Roger D. Simon, *Philadelphia: A Brief History,* rev. and updated ed. (Philadelphia: Temple University Press, 2017).

4. Elizabeth Milroy, *The Grid and the River: Philadelphia's Green Places, 1682–1876* (University Park: Pennsylvania State University Press, 2016), 3.

5. For more on Holme's *Portraiture,* see ibid., 11–26.

6. Ibid., 27.

7. Writing about nineteenth-century American painting, Angela Miller proposed the concept of "synecdochic nationalism," in which artists depicted specific locations that stood in for features that were thought of as central to the whole nation. Angela L. Miller, *The Empire of the Eye: Landscape Representation and American Cultural Politics, 1825–1875* (Ithaca, NY: Cornell University Press, 1993). Wendy Bellion examines the relationship between visual culture and anxieties about political (and other) representation during the early republic in *Citizen Spectator: Art, Illusion, and Visual Perception in Early National America* (Chapel Hill: Published for the Omohundro Institute of Early American History and Culture, Williamsburg, Virginia, by the University of North Carolina Press, 2011).

8. Edwin Wolf II, "The Origins of Philadelphia's Self-Depreciation, 1820–1920," *Pennsylvania Magazine of History and Biography* 104, no. 1 (1980): 58–73; Jerome I. Hodos, *Second Cities: Globalization and Local Politics in Manchester and Philadelphia* (Philadelphia: Temple University Press, 2011), 20–43.

9. See, for example, Simon, *Philadelphia,* 1–46.

10. Michael Zuckerman, "Philadelphia—a 'City of Firsts' That Feels Little Need to Brag," *Newsworks,* January 14, 2012, https://whyy.org/articles/philadelphia-a-city-of-firsts-that-feels-little-need-to-brag/. On Philadelphia as a second city, see Hodos, *Second Cities.*

11. On the professional role of the artist in the eighteenth century, see Susan Rather, *The American School: Artists and Status in the Late-Colonial and Early National Era* (New Haven, CT: Yale University Press, 2016). PAFA grew out of an earlier artist association, the Columbianum, which was also based in Philadelphia. Although the Columbianum helped establish Philadelphia's status as a center for artistic training and production in the early republic, its founders were divided over whether the organization should operate as a national academy in the European tradition, where it would expressly represent and dictate cultural norms across the country. Those who rejected the idea of a national academy did so because they thought it was antirepublican to assert one art center as superior to the others. Their position ultimately won out, but the Columbianum and Philadelphia remained an important center of creative activity. Bellion, *Citizen Spectator,* 71.

12. Benjamin Henry Latrobe, "Anniversary Oration, Pronounced before the Society of Artists of the United States, by Appointment of the Society, on the Eighth of May, 1811," *The Port Folio,* June 1811; Alexandra Alevizatos Kirtley, "Athens of America," in *The Encyclopedia of Greater Philadelphia,* ed. Charlene Mires, Howard Gillette, and Randall Miller, accessed September 14, 2011, http://philadelphiaency clopedia.org/archive/athens-of-america/.

13. For more on Philadelphia during this period, see Dorothy Gondos Beers, "The Centennial City, 1865–1876"; and Nathaniel Burt and Wallace E. Davies, "The Iron Age, 1876–1905," both in *Philadelphia: A 300 Year History*, ed. Russell Frank Weigley, Nicholas B. Wainwright, and Edwin Wolf (New York: W. W. Norton, 1982), 417–470 and 471–523.

14. Sarah Gordon, "Prestige, Professionalism, and the Paradox of Eadweard Muybridge's "Animal Locomotion" Nudes," *Pennsylvania Magazine of History and Biography* 130, no. 1 (2006), 90.

15. Historian David C. Ward has proposed that Peale's varied pursuits, from painting to paleontology, are best understood as related attempts to instill order in the world. David C. Ward, *Charles Willson Peale: Art and Selfhood in the Early Republic* (Berkeley: University of California Press, 2004).

16. For more on the relationship between photography and Eakins's paintings, see Darrel Sewell, *Thomas Eakins* (Philadelphia: Philadelphia Museum of Art, 2001).

17. For an overview of the Centennial Exhibition, see Stephanie Grauman Wolf, "Centennial Exhibition (1876)," in *The Encyclopedia of Greater Philadelphia*, ed. Charlene Mires, Howard Gillette, and Randall Miller, accessed August 4, 2016, http://phil adelphiaencyclopedia.org/archive/centennial/; Beers, "The Centennial City, 1865–1876."

18. Rebecca Zurier discusses the unique relationship that these artists and their Ashcan School colleagues had to urban vision and New York city life in *Picturing the City: Urban Vision and the Ashcan School* (Berkeley: University of California Press, 2006).

19. Wanda M. Corn, *The Great American Thing: Modern Art and National Identity, 1915–1935* (Berkeley: University of California Press, 1999). For a discussion of the way New York reinforced its status as a hub for avant-garde art in the wake of World War II, see Serge Guilbaut, *How New York Stole the Idea of Modern Art: Abstract Expressionism, Freedom, and the Cold War* (Chicago: University of Chicago Press, 1983). For more on Philadelphia's conservative elite, see E. Digby Baltzell, *Philadelphia Gentlemen: The Making of a National Upper Class* (Glencoe, IL: Free Press, 1958); Nathaniel Burt, *The Perennial Philadelphians: The Anatomy of an American Aristocracy* (Boston: Little, Brown, 1963).

20. Purchases by Albert C. Barnes from the Pennsylvania Academy of the Fine Arts Annual Exhibitions, n.d., Special exhibition records, Contemporary European Paintings and Sculpture (Barnes Collection), Box 17, RG.02.06.06, Dorothy and Kenneth Woodcock Archives at the Pennsylvania Academy of the Fine Arts.

21. Albert Barnes, Letter to John M. Fogg Jr., January 12, 1950, Mss. Coll. 402, Albert C. Barnes Correspondence with the University of Pennsylvania, box 1, folder 25, University of Pennsylvania Rare Books and Manuscripts Collection.

22. For one example of Philadelphia's under-recognized culture scene in the mid-twentieth century, see Cheryl Harper, ed., *A Happening Place: How the Arts Council Revolutionized the Philadelphia Art Scene in the Sixties* (Philadelphia: Jewish Community Centers of Greater Philadelphia, 2003).

23. For more on these examples, see Joseph C. Schiavo, "Philadelphia Orchestra," Jordan McClain and Amanda McClain, "American Bandstand," and Jack Mc-

Carthy, "Soul Music," all in *The Encyclopedia of Greater Philadelphia,* ed. Charlene Mires, Howard Gillette, and Randall Miller, accessed August 28, 2017, http://phila delphiaencyclopedia.org/.

24. Lincoln Steffens, "Philadelphia: Corrupt and Contented," *McClure's Magazine,* July 1903, 249–263.

25. Martin W. Wilson, "From the Sesquicentennial to the Bicentennial: Changing Attitudes toward Tourism in Philadelphia, 1926–1976" (Ph.D. diss., Temple University, 2000), 53–54, 65; Thomas H. Keels, *Sesqui! Greed, Graft, and the Forgotten World's Fair of 1926* (Philadelphia: Temple University Press, 2017), xxii.

26. Edmund N. Bacon, "Philadelphia in the Year 2009," in *Imagining Philadelphia: Edmund Bacon and the Future of the City,* ed. Scott Gabriel Knowles (Philadelphia: University of Pennsylvania Press, 2009), 14.

27. Ibid., 18.

28. Elliott Curson, "Origins of a Memorable Philadelphia Slogan," *Philadelphia Inquirer,* May 14, 1996.

29. Scott Gabriel Knowles, "Staying Too Long at the Fair: Philadelphia Planning and the Debacle of 1976," in *Imagining Philadelphia: Edmund Bacon and the Future of the City,* ed. Scott Gabriel Knowles (Philadelphia: University of Pennsylvania Press, 2009), 110.

30. For more on Philadelphia during this era, see Stephanie G. Wolf, "The Bicentennial City, 1968–1982," in *Philadelphia: A 300 Year History,* ed. Russell F. Weigley, Nicholas B. Wainwright, and Edwin Wolf II (New York: W. W. Norton, 1982), 704–734.

31. Edwin Wolf II, "Epilogue," in *Philadelphia: A 300 Year History,* ed. Russell F. Weigley, Nicholas B. Wainwright, and Edwin Wolf II (New York: W. W. Norton, 1982), 751; Stephanie Wolf, "The Bicentennial City."

32. Office of the City Controller, City of Philadelphia, *Philadelphia: A New Urban Direction* (Philadelphia: Saint Joseph's University Press, 1999), xxv.

33. For an overview of the Philadelphia 2000 campaign, see Michael F. Smith, "Brand Philadelphia: The Power of Spotlight Events," in *Destination Branding: Creating the Unique Destination Proposition,* ed. Nigel Morgan, Annette Pritchard, and Roger Pride (Oxford: Elsevier Butterworth-Heinemann, 2004), 261–278.

34. H. G. Bissinger, *A Prayer for the City* (New York: Random House, 1997); Roger D. Simon and Brian Alnutt, "Philadelphia, 1982–2007: Toward the Postindustrial City," *Pennsylvania Magazine of History and Biography* 131, no. 4 (2007): 395–444.

35. Miriam Greenberg, *Branding New York: How a City in Crisis Was Sold to the World* (New York: Routledge, 2008), 19–39. On city branding as corporate branding, see Gregory Ashworth and Mihalis Kavaratzis, "Beyond the Logo: Brand Management for Cities," *Journal of Brand Management* 16, no. 8 (2009): 520–531. On the branding of nations, not cities, see Melissa Aronczyk, *Branding the Nation: The Global Business of National Identity* (New York: Oxford University Press, 2013).

36. Some have questioned whether anchoring Philadelphia's tourism in the city's eighteenth-century history unintentionally perpetuated the image of Philadelphia as a place of only the past because it attracted visitors who were interested in a limited

slice of what the city had to offer. Steven Conn, *Metropolitan Philadelphia: Living with the Presence of the Past* (Philadelphia: University of Pennsylvania Press, 2006), 88.

37. Leonard W. Boasberg, "Welcome America! City Celebrates Its New Center and Itself," *Philadelphia Inquirer,* June 20, 1993.

38. Mark J. Stern, *Urban Vitality, Diversity, and Culture: Population Growth and Ethnic Change in Philadelphia: 1990–2000* (Philadelphia: University of Pennsylvania School of Social Work, 2001).

39. Tom Scannapieco and Joe Zuritsky, quoted in *Arts, Culture, and Economic Prosperity in Greater Philadelphia* (Philadelphia: Greater Philadelphia Cultural Alliance, 2007), i.

40. Kevin F. McCarthy, Elizabeth Heneghan Ondaatje, and Jennifer L. Novak, *Arts and Culture in the Metropolis: Strategies for Sustainability,* (Santa Monica, CA: RAND, 2007), 73.

41. On the Mural Arts Program's activities, see Jane Golden, Robin Rice, and Monica Yant Kinney, *Philadelphia Murals and the Stories They Tell* (Philadelphia: Temple University Press, 2002); Jane Golden, Robin Rice, and Natalie Pompilio, *More Philadelphia Murals and the Stories They Tell* (Philadelphia: Temple University Press, 2006); Jane Golden and David Updike, eds., *Philadelphia Mural Arts @ 30* (Philadelphia: Temple University Press, 2014).

42. See, for example, Elissa Cedarleaf Dahl, "My View: Minneapolis Needs a Mural Arts Program," *The Line,* September 28, 2011, http://www.thelinemedia.com/features/myviewmurals092811.aspx; Lauren Silverman, "On Philly's Walls, Murals Painted with Brotherly Love," *All Things Considered,* National Public Radio, August 23, 2010, http://www.npr.org/templates/story/story.php?storyId=129281658; Molly McCartney, "Parachute Cloth Mural Builds Community in South Minneapolis," StreetsMN, May 27, 2015, http://streets.mn/2015/05/27/parachute-cloth-mural-builds-community-in-south-minneapolis/.

43. McCarthy, Ondaatje, and Novak, *Arts and Culture in the Metropolis.*

44. Michael A. Nutter, quoted in *Philadelphia's New Confidence: 2014 Annual Report* (Philadelphia: Visit Philadelphia, 2014), 2.

45. Danielle Cohn and Melanie Johnson, *Implementing the City Brand: Improving Internal and External Customer Service through Consistent Communication,* presented to the Mayor's Executive Team, City of Philadelphia, August 10, 2010.

46. *A Style Guide for the City of Philadelphia* (Philadelphia: Office of the City Representative, 2011).

47. Kosal Sen, "Phail-Adelphia," *Brand New,* Decmber 8, 2009, http://www.underconsideration.com/brandnew/archives/phail-adelphia.php.

48. Gary B. Nash discussed the many forms and functions of what we now call the Liberty Bell in his 2010 book for Yale University Press's Icons of America series. Gary B. Nash, *The Liberty Bell* (New Haven, CT: Yale University Press, 2010).

49. Nash, *Liberty Bell.*

50. City of Philadelphia, "Mayor Michael A. Nutter Unveils City of Philadelphia's New Signature Brand at Philadelphia Convention and Visitors Bureau's Annual Luncheon," news release, November 27, 2009.

CHAPTER 2

1. Stephan Salisbury reported on the Barnes's final day in Merion. Stephan Salisbury, "Last Look at Barnes Galleries in Merion," *Philadelphia Inquirer,* July 3, 2011. Jeremy Braddock described the nature of the Barnes as a modernist collection in *Collecting as Modernist Practice* (Baltimore: Johns Hopkins University Press, 2012).

2. See, for example, Ralph Blumenthal, "Art Museum Outside Philadelphia Plans Move," *New York Times,* September 25, 2002, A16; Stanley R. Ott, *Opinion,* The Court of Common Pleas of Montgomery County, Pennsylvania, Orphans' Court Division, December 13, 2004.

3. Lucy Lippard eloquently describes place as, among other things, "a layered location replete with human histories and memories." Lucy R. Lippard, *The Lure of the Local: Senses of Place in a Multicentered Society* (New York: New Press, 1997), 7.

4. Barnes Foundation Charter, December 4, 1922, Barnes Foundation Archives, Philadelphia, PA, reprinted with permission.

5. See, for example, Jonathan Scott Goldman, "Just What the Doctor Ordered? The Doctrine of Deviation, the Case of Doctor Barnes's Trust and the Future Location of the Barnes Foundation," *Real Property, Probate and Trust Journal* 39, no. 4 (2005): 711–764.

6. Even before the debate over moving the Barnes galleries blossomed into a divisive controversy, publications raised concerns about the actions and intentions of the Barnes's trustees and administrators. See, for example, Richard L. Feigen, "Dr. Barnes and the Devil," in *Tales from the Art Crypt: The Painters, the Museums, the Curators, the Collectors, the Auctions, the Art* (New York: Alfred A. Knopf, 2000), 70–91; John Anderson, *Art Held Hostage: The Story of the Barnes Collection* (New York: W. W. Norton, 2003).

7. See, for example, Michael Rubinkam, "Barnes Foundation Decision Delayed; Judge Wants More Evidence on Whether to Move Artworks," Associated Press, January 29, 2004; Julia M. Klein and Carol Vogel, "Rivals in Court Preach Different Ways to Its Salvation," *New York Times,* September 25, 2004, B11.

8. See, for example, Leslie Lenkowsky, "A Risky End for the Barnes Case," *Wall Street Journal Abstracts,* December 16, 2004; Kathryn Miree and Winton Smith, "The Unraveling of Donor Intent: Lawsuits and Lessons," Planned Giving Design Center, November 12, 2009, http://www.pgdc.com/pgdc/unraveling-donor-intent-lawsuits-and-lessons.

9. Barnes had a volatile relationship with many members of Philadelphia's elite. Among his chief rivals was philanthropist, collector, and media magnate Walter H. Annenberg. When the Barnes Foundation established an art advisory committee years after Barnes's death, Annenberg assumed the role of honorary chair. In this capacity he proposed deaccessioning work from the Barnes collection, much to the chagrin of the Barnes loyalists who hypothesized that Barnes implemented his strict collection management policy specifically to keep his art out of the hands of competitors like Annenberg. In 2002, the Barnes Foundation proposed moving from Merion to Philadelphia after receiving substantial financial support from the Annenberg

Foundation and other philanthropic organizations funded by local families. Don Argott and Sheena Joyce capture this sentiment in their 2009 documentary, *The Art of the Steal*, a film that updated and expanded John Anderson's book, *Art Held Hostage*. Former Barnes Foundation advisor Richard Feigen expressed similar concerns in an opinion piece published in the *Art Newspaper* in 2010. Don Argott, dir., *The Art of the Steal* (New York: IFC in Theaters, 2009); Richard L. Feigen, "A Tale of Institutional Morality: The Barnes Collection Is Not Being Saved, It Is Being Stolen," *Art Newspaper*, January 6, 2010. See also Michael Kimmelman, "Trying to Open up the Barnes, and Pay Some of Its Bills, Too," *New York Times*, February 7, 1991; Lucinda Fleeson, "Barnes Urged by Annenberg to Sell Some Art," *Philadelphia Inquirer*, April 18, 1991.

10. Readers interested in a more comprehensive history of the Barnes should consult Mary Ann Meyers, *Art, Education, and African-American Culture: Albert Barnes and the Science of Philanthropy* (New Brunswick, NJ: Transaction Publishers, 2004); and Neil L. Rudenstine, *House of Barnes: The Man, the Collection, the Controversy* (Philadelphia: American Philosophical Society, 2012). They are among the most well-researched, clearly written, and least sensationalizing books about the Barnes Foundation, although Rudenstine's chapters about moving the collection undoubtedly reflect his position as a member of the foundation's board of trustees.

11. Barnes Foundation Charter.

12. Megan Granda Bahr, "Transferring Values: Albert C. Barnes, Work, and the Work of Art" (Ph.D. diss., University of Texas at Austin, 1998); George E. Hein, "John Dewey and Albert Barnes," in *Progressive Museum Practice: John Dewey and Democracy* (Walnut Creek, CA: Left Coast Press, 2012), 97–122.

13. Barnes and his wife, Laura, had lived near the new Merion site since 1905. On acquiring the grounds for the 1925 building, see Howard Greenfeld, *The Devil and Dr. Barnes: Portrait of an American Art Collector* (New York: Viking, 1987), 72–76. On designing the Merion buildings, see David B. Brownlee, *The Barnes Foundation: Two Buildings, One Mission* (New York: Skira Rizzoli, in association with the Barnes Foundation, 2012), 18–40. Cret's other projects include the Rodin Museum on the Benjamin Franklin Parkway in Philadelphia; the Integrity Trust Company building (717 Chestnut Street) in Philadelphia; the Folger Shakespeare Library in Washington, DC; the Detroit Institute of Arts; and several structures on the University of Texas campus in Austin.

14. Bok was also the leader of the group of Philadelphians described in Chapter 1 who wanted to use the sesquicentennial celebration to elevate Philadelphia's image. Mary Mendenhall Wood and Phyllis C. Maier, *Lower Merion: A History* (Ardmore, PA: Lower Merion Historical Society, 1988). The Merion Civic Association, founded in 1913 by Bok, has made an abbreviated version of Roosevelt's pamphlet available as a PDF: Theodore Roosevelt, "Model Merion" (1917), Merion Civic Association, n.d., http://www.merioncivic.org/about/ModelMerion.pdf.

15. Wood and Maier, *Lower Merion*.

16. Brownlee, *The Barnes Foundation*.

17. On building the Merion galleries, the tense relationship between Barnes and Cret, and the dedication festivities, see "The Early Barnes Foundation, Part 1," *Barnes Foundation Journal* (March 7, 2011).

18. On expanded access to digital images from the Barnes collection, see Claire Voon, "The Famously Photo-Wary Barnes Foundation Makes Its Art More Accessible Online," *Hyperallergic,* November 9, 2017, https://hyperallergic.com/410273/the-famously-photo-wary-barnes-foundation-makes-its-art-more-accessible-online.

19. For more on race and Barnes's employment policies, see Meyers, *Art, Education, and African-American Culture,* 19–26.

20. Glackens is a noted member of the Ashcan School, a group of American artists whose work captured daily city life in the early twentieth century. For further discussion of these artists, see Rebecca Zurier, *Picturing the City: Urban Vision and the Ashcan School* (Berkeley: University of California Press, 2006).

21. Richard J. Wattenmaker, "Dr. Albert C. Barnes and the Barnes Foundation," in *Great French Paintings from the Barnes Foundation: Impressionist, Post-Impressionist, and Early Modern* (New York: Alfred A. Knopf, in association with Lincoln University Press, 1993), 3–28.

22. Albert C. Barnes, *The Art in Painting,* 3rd rev. and enl. ed. (New York: Harcourt, Brace, 1937); Barbara Suplee, "The Eccentric Hanging of the Barnes Foundation," *Art Education* 47, no. 6 (1994): 35–40; Bahr, "Transferring Values"; Rika Burnham, "The Barnes Foundation: A Place for Teaching," *Journal of Museum Education* 32, no. 3 (2007): 221–232.

23. Kristina Wilson, *The Modern Eye: Stieglitz, MoMA, and the Art of the Exhibition, 1925–1934* (New Haven, CT: Yale University Press, 2009), 34, 53.

24. Ralph Blumenthal, "Imparting the Vision behind an Idiosyncratic Collection," *New York Times,* November 12, 2002, E2.

25. Braddock, *Collecting as Modernist Practice,* 106–155.

26. Barnes wrote this letter after a newspaper article quoted an anonymous source from PAFA's faculty who criticized Barnes's work. The letter also described PAFA as "the morgue." This language was particularly aggressive, considering that PAFA had recently hosted an exhibition of works from Barnes's collection. Barnes had previously cheered the institution for its progressive exhibition programs. When PAFA exhibited modernist art in 1921, Barnes told exhibit organizer Arthur B. Carles, "Your present show is the first real move to shake Philadelphia out of the lethargy which has been the reproach to us from artists and collectors of other cities." Albert C. Barnes, Letter to the Pennsylvania Academy of the Fine Arts, May 24, 1924, Albert C. Barnes Correspondence, Barnes Foundation Archives, Philadelphia, PA, reprinted with permission; Albert Barnes, Letter to Arthur B. Carles, April 18, 1921, Special Exhibition Records, box 17, contemporary European paintings and sculpture (Barnes Collection), RG.02.06.06, Dorothy and Kenneth Woodcock Archives at the Pennsylvania Academy of the Fine Arts, Philadelphia, PA. On the backlash against the 1921 PAFA exhibition, see Jeremy Braddock, "Neurotic Cities: Barnes in Philadelphia," *Art Journal* 63, no. 4 (2004): 47–61.

27. JSW Holton, Letter to Albert C. Barnes, March 3, 1927, Albert C. Barnes Correspondence, Barnes Foundation Archives, Philadelphia, PA, reprinted with permission.

28. Albert C. Barnes, Public Statement Made by Dr. Albert C. Barnes, April 14, 1927, Albert C. Barnes Correspondence, Barnes Foundation Archives, Philadelphia, PA, reprinted with permission.

29. Public Statement by Doctor Albert C. Barnes, April 15, 1927, Albert C. Barnes Correspondence, Barnes Foundation Archives, Philadelphia, PA, reprinted with permission.

30. The Pennsylvania Museum of Art changed its name to the Philadelphia Museum of Art in 1938.

31. Albert C. Barnes, "A Disgrace to Philadelphia" (Merion, PA: Self-Published, 1938), reprinted with permission.

32. I calculated this imperfect estimate by plotting the addresses of students listed on Barnes Foundation course rosters in 1927 on a map of Philadelphia issued by the Home Ownership Loan Corporation (HOLC) in 1937. The U.S. government established the HOLC in 1933 in an effort to mitigate the effects of the Depression by granting new mortgages to homeowners at risk of foreclosure. The HOLC map indicated which areas of the city were secure or risky places for investment. There were four levels, A through D, ranging from low risk (A) to high risk (D). The riskiest areas for investment were identified as industrial sectors with deteriorating housing stock and high numbers of working-class immigrant residents. Maps like this were eventually known as "redlining" maps because neighborhoods deemed "high risk" (often because of who lived there) were marked off in red. Thirteen households on the 1927 Barnes Foundation roster (out of forty-two total, and twenty within the Philadelphia city limits) were in areas marked as risky or high risk by 1937. Although the 1937 map is not as reliable as a map from closer to 1927 would be, it does provide an approximate sense of the types of neighborhoods where Barnes Foundation students lived. Roster, Thursday Class, 1927 and Roster, Tuesday Class, 1927–1928, both in Early Education Records, Barnes Foundation Archives, Philadelphia, PA, reprinted with permission; Home Owners' Loan Corporation, "Residential Security Map: New Indexed Guide Map of Philadelphia and Camden, N.J." (Philadelphia: C. S. Wertsner and Son, 1937).

33. Albert C. Barnes, Letter to Glenn R. Morrow, May 22, 1946, Mss. Coll. 402, Albert C. Barnes, correspondence with the University of Pennsylvania, box 1, folder 10, University of Pennsylvania Rare Books and Manuscripts Collection.

34. Richard Huntington, "Long-Buried Treasures for the World to See at Washington's National Gallery, the Gleanings of a Most Private Collector Finally Go before the Public," *Buffalo News,* June 20, 1993; Steven Rosen, "Scheduled Masterpieces Finally Glow in Ideal Setting," *Denver Post,* May 1, 1994.

35. Fidèle also sent letters, penned entirely in French, to the architects who oversaw the renovation of Barnes's country home, Ker-Feal. After the completion of the job, Barnes, writing as Fidèle, invited the architects to come see the finished house and join him for a simple lunch. Fidèle de Port-Manech, Letter to Kneedler, Mirick, and Zantzinger, November 10, 1941, Ms. Coll. 403, Kneedler, Mirick, Zantzinger (Firm) Records Concerning Albert C. Barnes, 1940–1946 (1980), box 1, folder 7, University of Pennsylvania Rare Books and Manuscripts Collection. For references to irreverent letters from Barnes to would-be visitors, see Meyers, *Art, Education, and African-American Culture,* 220; Julia M. Klein, "There's Drama yet in Art Saga Charges Involving Barnes Collection Continue to Roil," *Philadelphia Inquirer,* February 6, 1994; Huntington, "Long-Buried Treasures for the World to See"; Thomas

Huang, "Barnes Exhibit Has Long Legal History," *Dallas Morning News*, April 24, 1994.

36. Barnes Foundation Charter, Section 2, Article 30, amended April 30, 1946, Barnes Foundation Archives, Philadelphia, PA, reprinted with permission.

37. I discuss competing taste preferences in more detail in Chapter 4. See also Pierre Bourdieu, "The Aesthetic Sense as the Sense of Distinction," in *The Consumer Society Reader,* ed. Juliet Schor and Douglas B. Holt (New York: New Press, 2000), 205–211.

38. Kimberly Camp, "Response to Jeremy Braddock," *Art Journal* 63, no. 4 (2004): 62.

39. A 1960 lawsuit initiated by *Philadelphia Inquirer* publisher Walter H. Annenberg and argued by the state's Attorney General challenged the Barnes Foundation's tax-exempt status on the grounds that the organization operated too much like a private club and not enough like a public organization. In 1961, the Supreme Court of Pennsylvania required the Barnes Foundation to open its doors to the public on Friday, Saturday, and Sunday afternoons in order to retain its tax-exempt status. Commonwealth v. Barnes Foundation, 159 Atlantic 2d 500 (1960). The foundation's bylaws stipulated that after the original trustees died or stepped down from the board, Lincoln University, a historically black school in nearby Chester County, would become responsible for nominating new trustees to fill vacancies on the foundation's board. There was a total of five board positions. Lincoln could nominate individuals to fill four of those spots.

40. Albert C. Barnes, Letter to Parker S. Williams, March 22, 1927, Albert C. Barnes Correspondence, Barnes Foundation Archives, Philadelphia, PA, reprinted with permission.

41. Kimmelman, "Trying to Open up the Barnes."

42. Glanton's actions are chronicled in Anderson, *Art Held Hostage.* I cite press coverage from the era of Glanton's leadership throughout this chapter. See also, for example, Lucinda Fleeson, "Museum Seeks to Sell Art," *Philadelphia Inquirer,* March 24, 1991, A01; Michael Kimmelman, "Barnes Foundation Seeks to Sell Some Paintings," *New York Times,* March 29, 1991, C1; Michael Kimmelman, "The Barnes Explores Other Byways," *New York Times,* April 21, 1991, sec. 2, 31; Michelle Osborn, "Barnes Trust May Sell Some Works," *USA Today,* April 10, 1991, 9B; Paul Richard, "To Sell or Not to Sell: Philadelphia's Barnes Battle," *Washington Post,* April 28, 1991, G1.

43. In Re: Barnes Foundation, 12 Fiduc. Rep. 2d 349 (1992); Bill Stieg, "Judge Allows Artworks to Leave Walls Where Late Collector Insisted They Stay," Associated Press, July 22, 1992; Julia M. Klein, "Judge Allows Paintings from Barnes to Go on Tour," *Philadelphia Inquirer,* July 23, 1992.

44. Rudenstine, *House of Barnes,* 159.

45. Joseph Rishel, quoted in Julia M. Klein, "Hung out to Eye: How Will the Art Museum Show the Barnes Foundation Paintings? Curators Looking to 'Dehype' the Show Took a Cue from the Paintings' Home in Merion—and Did the Opposite," *Philadelphia Inquirer,* January 18, 1995, F01.

46. Edward J. Sozanski and Julia M. Klein, "Barnes Exhibit Comes Home: The

Art Museum Has High Hopes for the Show—Especially for Financial Reasons. It Has Gone All out on Marketing," *Philadelphia Inquirer,* January 29, 1995, B01.

47. Keith R. Ihlanfeldt, "The Importance of the Central City to the Regional and National Economy: A Review of the Arguments and Empirical Evidence," *Cityscape* 1, no. 2 (1995): 125–150. On thinking regionally in Philadelphia, see also Conn, *Metropolitan Philadelphia.*

48. Theodore Hershberg, "The Case for Regional Cooperation," *The Regionalist* 1, no. 3 (1995): 1.

49. Ibid., 14.

50. For more on the history of Philadelphia's relationship with its suburbs, see Howard Gillette, "The Emergence of the Modern Metropolis: Philadelphia in the Age of Its Consolidation," in *The Divided Metropolis: Social and Spatial Dimensions of Philadelphia, 1800–1975,* ed. William W. Cutler III and Howard Gillette (Westport, CT: Greenwood Press, 1980), 3–25.

51. For an overview of relatively recent scholarship on the subject of borders and boundaries, see Peter Gilles et al., eds., *Theorizing Borders through Analyses of Power Relationships,* Regional Integration and Social Cohesion, vol. 9 (Brussels: P.I.E. Peter Lang, 2013).

52. David Iams, "At Barnes, a Gala and a Respite from Battles: Guests Saw the Collection in Its Restored Home. Protests and Concerns Were Put on the Back Burner," *Philadelphia Inquirer,* November 12, 1995, B01.

53. Marmon, quoted in Argott, *The Art of the Steal,* 45:54.

54. On public space, private space, and diversity in Philadelphia's Main Line suburbs, see Gary W. McDonogh, "Suburban Place, Mythic Thinking, and the Transformations of Global Cities," *Urban Anthropoplogy and Studies of Cultural Systems and World Economic Development* 35, no. 4 (2006): 471–501. On the neighbors' treatment of the Barnes Foundation in comparison to other nearby institutions, see Michael Janofsky, "Fight Roils Museum and Wealthy Neighbors," *New York Times,* March 17, 1996.

55. Janofsky, "Fight Roils Museum and Wealthy Neighbors."

56. Earle Bradford, quoted in Barnes Foundation, "The Barnes Foundation Breaks Ground for Construction of New Parking Lot; Fifty-Six Car Lot on Premises of Foundation Will Alleviate Need for on-Street Parking," news release, 2001.

57. Rudenstine, *House of Barnes,* 167–178.

58. Doreen Carvajal, "Quirky Art Foundation Ponders Radical Move," *New York Times,* March 16, 2001, A1.

59. Emphasis in original. Stanley R. Ott, *Memorandum Opinion and Order Sur Second Amended Petition to Amend Charter and by-Laws* (Court of Common Pleas of Montgomery County, Pennsylvania, Orphans' Court Division, January 29, 2004).

60. "Backside" in brackets in original. Matthew P. Blanchard, "As Barnes Plans for Exit, Town All but Holds Door; L. Merion Isn't Fighting the Gallery's Effort to Move," *Philadelphia Inquirer,* October 17, 2003, A01.

61. Matthew P. Blanchard and Patricia Horn, "To Retain the Barnes, Neighbors Try Charm; a Light-Hearted Plea: Please Don't Flee," *Philadelphia Inquirer,* March 13, 2004.

62. The Friends of the Barnes Foundation locates its origin in 2004, but press clips from the previous decade refer to a group of Barnes Foundation affiliates known under the same name. This group protested the international tour of selected works from the collection in the 1990s. "Barnes Founddation [*sic*] Paintings Spark Controversy," *Morning Edition* (National Public Radio, 1992); Carol Vogel, "Barnes Gets Go-Ahead on International Art Tour," *New York Times,* July 24, 1992, C18.

63. When Schjeldahl reviewed the Barnes Foundation's Philadelphia campus in 2012 he revisited his statement from 2004. He explained that eight years earlier he "couldn't imagine that the integrity of the collection . . . would survive. But it does, magnificently." I address the new Barnes campus in detail at the end of this chapter. Peter Schjeldahl, "Untouchable: The Barnes Foundation and Its Fate," *New Yorker,* February 16, 2004; Schjeldahl, "Moving Pictures: The Barnes Foundation's New Home," *New Yorker,* May 28, 2012.

64. Patricia Horn, "Decision Concerning Pennsylvania Art Collection's Future Lies with Judge," *Philadelphia Inquirer,* October 1, 2004.

65. Jay Raymond, "Barnes Files: Separating Art, Galleries Wasn't Barnes' Vision," *Main Line Times,* February 1, 2007, http://www.mainlinemedianews.com/articles/2007/02/01/main_line_times/opinion/17789388.txt.

66. Robert Zaller, quoted in Patrick Walters, "City Council Committee Oks Barnes Art Collection's Move from Suburbs to Philadelphia," Associated Press, May 6, 2007.

67. Hershberg, "The Case for Regional Cooperation," 14.

68. Edward J. Sozanski, "Art: Barnes' Soul Will Stay Behind," *Philadelphia Inquirer,* May 22, 2011.

69. Lee Rosenbaum, "Destroying the Museum to Save It," *New York Times,* January 10, 2004, A13.

70. For more on the origins and implications of Philadelphia as a green country town, see Inga Saffron, "Green Country Town," in *The Encyclopedia of Greater Philadelphia,* ed. Charlene Mires, Howard Gillette, and Randall Miller, accessed July 23, 2015, http://philadelphiaencyclopedia.org/archive/green-country-town/.

71. "The Barnes Collection: America's Least-Visited Art," *Voice of America News* (January 22, 2003).

72. Edward J. Sozanski, "Relocation Makes Sense, but It Would Be Wrong," *Philadelphia Inquirer,* May 4, 2003.

73. See, for example, Kyle York Spencer, "Barnes Foundation Denies Any Violation of Zoning," *Philadelphia Inquirer,* January 4, 1996.

74. "Disagreements over the Location and Status of the Barnes Collection, the Most Famous Private Art Collection in the World," *All Things Considered,* National Public Radio, August 21, 2003.

75. Billie Tsien, quoted in Glenn Holsten, dir., *The Barnes Collection* (Philadelphia: WHYY, 2012).

76. Pennsylvania Office of the Governor, "Pennsylvania Governor Rendell Awards $25 Million to Help Make Barnes Foundation Collection a Part of Philadelphia's Cultural Landscape," news release, March 28, 2006.

77. Roger D. Simon and Brian Alnutt, "Philadelphia, 1982–2007: Toward the

Postindustrial City," *Pennsylvania Magazine of History and Biography* 131, no. 4 (2007): 395–444.

78. For a sampling of the many articles that addressed this topic, see Michael Hinkelman, "Rethinking Philadelphia: Barnes Art Museum Is Key to Parkway's Rebirth," *Philadelphia Daily News,* June 15, 2004; Earni Young, "Street Moving Fast on Home for the Barnes; Tags Youth Study Center for Gallery," *Philadelphia Daily News,* December 15, 2004; Patricia Horn, "Detention Hall Site to Be Art Collection's New Home in Philadelphia," *Philadelphia Inquirer,* December 15, 2004; Rita Giordano, "Fairmount Park Commission OKs Lease for Barnes Museum," *Philadelphia Inquirer,* May 25, 2007, B05; Kathy Matheson, "Barnes Foundation Acquires Philly Site for Art Collection," Associated Press, September 5, 2007. For a brief summary of the challenges that the city faced when attempting to relocate the Youth Study Center, see "Political Stalemate Ends over Proposed Barnes Site," Associated Press, November 30, 2007.

79. Pew Charitable Trusts, "Philadelphia's Foundations, Corporations, Citizens Contribute $150 Million to Relocate Barnes Foundation Gallery," news release, May 15, 2006, http://www.pewtrusts.org/en/about/news-room/press-releases/2006/05/15/philadelphias-foundations-corporations-and-citizens-contribute-150-million-to-relocate-the-barnes-foundation-gallery-to-the-benjamin-franklin-parkway.

80. Barbara Rosen, quoted in Giordano, "Fairmount Park Commission OKs Lease for Barnes Museum," B05. See also Barbara Rosen, quoted in Nancy Herman, "Barnes Files: An Artist's Perspective on the Barnes Move," *Main Line Times,* June 14, 2007, http://www.mainlinemedianews.com/articles/2007/06/14/main_line_times/opinion/18470096.txt; Bill Stieg, "Legendary Collection Becoming More Accessible," Associated Press, October 17, 1990.

81. Conn, *Metropolitan Philadelphia,* 106–114; Simon and Alnutt, "Philadelphia, 1982–2007.

82. Hinkelman, "Rethinking Philadelphia."

83. Barnes, Letter to Glenn R. Morrow.

84. Rebecca Rimel, quoted in Hinkelman, "Rethinking Philadelphia."

85. Nina Wright, quoted in Martin Knelman, "The Arts of the Patron: Toronto Snagged the Most Sought-after Art Show of the Decade—the Barnes Collection—Because Joe Rotman Can't Take No for an Answer," *Financial Post,* July 1, 1994, 16.

86. Visit Philadelphia, "GPTMC Changes Organization Name to Visit Philadelphia," news release, November 11, 2013.

87. *2012 Annual Report* (Philadelphia: Barnes Foundation, 2012).

88. Barnes Foundation, "Fact Sheet: New Philadelphia Campus Design," 2012.

89. Marilyn MacGregor, "First Peek at the New Barnes: And the Verdict Is . . . ," *Broad Street Review,* April 6, 2012, http://www.broadstreetreview.com/art-architecture/the_new_barnes_a_sneak_preview#.

90. David Carrier, *Museum Skepticism: A History of the Display of Art in Public Galleries* (Durham, NC: Duke University Press, 2006), 158–159.

91. Barnes Foundation, "Fact Sheet: New Philadelphia Campus Design."

92. Brownlee, *The Barnes Foundation,* 10.

93. Ibid., 44.

94. Barnes Foundation, "The Barnes Foundation's Philadelphia Campus Awarded the Highest Level of Environmental Certification from the U.S. Green Building Council," news release, September 27, 2012.

95. Roberta Smith, "A Museum, Reborn, Remains True to Its Old Self, Only Better," *New York Times,* May 17, 2012, A1.

CHAPTER 3

1. Michael Kimmelman, "Art Review: A Fire Stoking Realism," *New York Times,* June 21, 2002, http://www.nytimes.com/2002/06/21/arts/art-review-a-fire-stoking-realism.html.

2. The title of the painting has changed since 1875. According to art historian Elizabeth Johns, Eakins initially referred to the painting as *Portrait of Professor Gross.* When exhibited in Chicago at the 1893 World's Fair, the artwork was called *Portrait of Dr. Gross.* At the 1904 Universal Exhibition in St. Louis, the painting was titled *The Clinic of Professor Gross.* Exhibition catalogues printed between 1917 and 1919 (following Eakins's death) use the title *Gross Clinic.* Today it is commonly described as *Portrait of Dr. Samuel D. Gross* or *The Gross Clinic.* Elizabeth Johns, *Thomas Eakins: The Heroism of Modern Life* (Princeton, NJ: Princeton University Press, 1983), 80n71.

3. For an analysis of the ways in which Eakins's use of perspective and placement of figures heightens the drama of the scene, see Kathleen A. Foster and Mark S. Tucker, "The Making of *The Gross Clinic*," in *An Eakins Masterpiece Restored: Seeing The Gross Clinic Anew,* ed. Kathleen A. Foster and Mark S. Tucker (Philadelphia: Philadelphia Museum of Art, 2012), 43–70.

4. For an extensive discussion of the doctor as heroic figure, see Johns, *Thomas Eakins.* Michael Fried finds both horror and pleasure in his experience with the visual tension between the prodded incision and the bloody scalpel in Dr. Gross's hand. Fried reads the painting as a tale of castration anxiety and as an unconscious treatise from Eakins on the relationship between painting and writing. Michael Fried, *Realism, Writing, Disfiguration: On Thomas Eakins and Stephen Crane* (Chicago: University of Chicago Press, 1987). Jennifer Doyle and Martin A. Berger both consider the painting through the lens of gender and sexuality. While Doyle's work addresses the gender ambiguity in Gross's patient, Berger's study examines how the painting's style, iconography, and historical reception reveal ideas about manhood in the nineteenth century. Jennifer Doyle, "Sex, Scandal, and Thomas Eakins's 'the Gross Clinic,'" *Representations,* no. 68 (1999): 1–33; Martin A. Berger, *Man Made: Thomas Eakins and the Construction of Gilded Age Manhood* (Berkeley: University of California Press, 2000). For a summary of other prominent interpretations of *The Gross Clinic,* see Henry Adams, *Eakins Revealed: The Secret Life of an American Artist* (Oxford: Oxford University Press, 2005), 222–235.

5. Steven Conn, "Local Hero: *The Gross Clinic* and Our Sense of Civic Iden-

tity," in Foster and Tucker, *An Eakins Masterpiece Restored*, 7–16; Steven Conn, *Do Museums Still Need Objects?* (Philadelphia: University of Pennsylvania Press, 2010), 197–199.

6. Thomas Jefferson University, "Thomas Jefferson University Trustees Agree to Sale of *The Gross Clinic*," news release, November 11, 2006; Stephan Salisbury, "City Art Icon About to Be Sold," *Philadelphia Inquirer*, November 11, 2006, A01.

7. Stephan Salisbury, "'The Gross Clinic' Campaign Reaches One-Third of Goal," *Philadelphia Inquirer*, November 30, 2006; Thomas Jefferson University, "Thomas Jefferson University Trustees Agree."

8. Philadelphia Museum of Art, "City Institutions, Officials Unite to Keep Eakins Masterpiece in Philadelphia," news release, November 17, 2006, https://www.philamuseum.org/press/releases/2006/553.html.

9. Kim Sajet, "From Grove to Garden: The Making of *The Dream Garden* Mosaic," in *Pennsylvania Academy of the Fine Arts: 200 Years of Excellence* (Philadelphia: Pennsylvania Academy of the Fine Arts, 2005), 43–51. Steven Conn discusses the sale of *The Dream Garden* in relation to *The Gross Clinic* campaign in "Local Hero: *The Gross Clinic* and Our Sense of Civic Identity," 13–14.

10. The city of Philadelphia is structured around five public squares. *The Sixth Square*, offering an additional—virtual—gathering place, identified the purpose of the blog in its first post: "Today the Eakins Countdown stands at 40 days. Over this brief stretch of time, this blog, which we are calling The Sixth Square, will serve as a convener of ideas, a framer of issues, and a source of facts relevant to this important civic conversation. We hope you find it informative and useful." "Eakins Countdown: 40 Days," *The Sixth Square* (blog), WHYY, November 16, 2006, http://whyy.wordpress.com/2006/11/16/eakins-countdown-40-days/.

11. Philadelphia Museum of Art, "City Institutions, Officials Unite to Keep Eakins Masterpiece in Philadelphia"; Carol Vogel, "A Fight to Keep an Eakins Is Waged on Two Fronts: Money and Civic Pride," *New York Times*, December 15, 2006, E43.

12. Conn, *Do Museums Still Need Objects?*, 198; Conn, "Local Hero: *The Gross Clinic* and Our Sense of Civic Identity," 9.

13. For a detailed discussion of the controversy, see, for example, Doyle, "Sex, Scandal, and Thomas Eakins's 'the Gross Clinic,'" 8–9. Janine Mileaf contrasts the institutional disapproval of Eakins's study of nudes with the institutional support and praise that Eakins's colleague Eadweard Muybridge received for similar work. Janine Mileaf, "Poses for the Camera: Eadweard Muybridge's Studies of the Human Figure," *American Art* 16, no. 3 (2002): 30–53.

14. Johns, *Thomas Eakins*, 46–81.

15. Ibid., 46, 55–63.

16. All of the known early commentary about *The Gross Clinic* is published in Foster and Tucker, *An Eakins Masterpiece Restored*, 138–158.

17. William J. Clark Jr., "The Fine Arts: Eakins' Portrait of Dr. Gross, *Philadelphia Daily Evening Telegraph*, April 28, 1876*, reprinted in Foster and Tucker, *An Eakins Masterpiece Restored*, 138–139; "Some Recent Art," clipping from an unidentified newspaper, circa April 1876, reprinted in Foster and Tucker, *An Eakins Masterpiece Restored*, 139–140. For more interpretation of the critical reception of

The Gross Clinic, see Kathleen A. Foster, "*The Gross Clinic* in Philadelphia and New York, 1875–79," in Foster and Tucker, *An Eakins Masterpiece Restored,* 71–82.

18. Darrel Sewell, *Thomas Eakins* (Philadelphia: Philadelphia Museum of Art, 2001).

19. Foster and Tucker, *An Eakins Masterpiece Restored,* 143–158.

20. Randall C. Griffin, *Homer, Eakins and Anshutz: The Search for American Identity in the Gilded Age* (University Park: Pennsylvania State University, 2004), 31.

21. On *The Gross Clinic* as an expression of Eakins's civic pride, see Johns, *Thomas Eakins,* 58.

22. Alan C. Braddock, *Thomas Eakins and the Cultures of Modernity* (Berkeley: University of California Press, 2009), 93–148.

23. Griffin, *Homer, Eakins and Anshutz*; Akela Reason, *Thomas Eakins and the Uses of History* (Philadelphia: University of Pennsylvania Press, 2010), 1–7.

24. On the painting's relevance to Jefferson students, see Brian Harrison, "Symbol and Conduit of Jeff's Mission," *Philadelphia Inquirer,* November 11, 2006; Stephan Salisbury, "Jefferson Alums Rip Sale of Eakins," *Philadelphia Inquirer,* November 17, 2006; "Jefferson Establishes Eakins Legacy Fund: Alumni Respond," *Jefferson Alumni Bulletin* (Winter 2006–07): 12–13.

25. "Thomas Eakins: 1844–1916," February 16, 1982, Special Exhibitions Records, Philadelphia Museum of Art, Archives.

26. Jean Sutherland Boggs to Lewis W. Bluemle, June 16, 1980, Special Exhibitions Records, Philadelphia Museum of Art, Archives.

27. For examples of how *The Gross Clinic* was interpreted in 1982, see John Russell, "Is Eakins Our Greatest Painter?," *New York Times,* June 6, 1982, 1; Sewell, *Thomas Eakins.*

28. Philadelphia Museum of Art, "Retrospective Exhibition Surveys the Career of Thomas Eakins from Controversial Native Son to Icon of American Art," news release, 2001.

29. D'Harnoncourt, quoted in "Retrospective Exhibition Surveys the Career of Thomas Eakins."

30. The painting did receive extra attention in the exhibition's audio guide, where it was interpreted in terms of its connection to medical history and its initial rejection from the Centennial Exhibition art gallery. If any single image emerged as iconic from the audio guide text, it was Eakins's other famous medical portrait, *The Agnew Clinic,* which, listeners learned, was so valued by the University of Pennsylvania that it was "featured on every medical student's diploma." "Thomas Eakins: American Realist," Antenna Audio Script, September 20, 2001, American Art Department Files, Philadelphia Museum of Art, Archives. On the painting's role in 2001, see Philadelphia Museum of Art, "Tickets for Thomas Eakins: American Realist Go on Sale Starting September 9," news release, July 9, 2001, https://www.philamuseum.org/press/releases/2001/252.html; Kimmelman, "Art Review: A Fire Stoking Realism."

31. Sister Mary Scullion, "What Not to Sacrifice for Art: Care," *Philadelphia Inquirer,* December 7, 2006, B02.

32. James F. Lally, "'Gross Clinic' Is an Organic Part of Philadelphia," *Philadel-*

phia Inquirer, December 14, 2006, B02; Jarel Daniels, "Make Fathers Stay," *Phila-delphia Inquirer,* December 14, 2006, B02.

33. Michael Currie Schaffer, "A Story on Murder Draws Concern; Cover Story Cover-Up: Hotel Group Makes Plea," *Philadelphia Inquirer,* October 29, 2006, B11.

34. See, for example, Jeremiah Muhsin quoted in Maurice Williams, "3,500 Demonstrate for New Trial for Abu-Jamal: Protest Deals a Blow to Use of the Death Penalty," *The Militant* 59, no. 31 (August 28, 1995), http://www.themilitant .com/1995/5931/5931_1.html; or playwright Sean Christopher Lewis's 2008 project, *Killadelphia: Mixtape of a City.* Information about the play (accessed September 15, 2017) can be found online at http://seanchristopherlewis.com/. The metal band *Lamb of God* released an album entitled *Killadelphia* in 2005. It features recordings from a concert they performed in Philadelphia.

35. Jessica Pressler, "Philadelphia Story: The Next Borough," *New York Times,* August 14, 2005, http://www.nytimes.com/2005/08/14/fashion/sundaystyles/phil adelphia-story-the-next-borough.html.

36. For example, in April 2006, the Greater Philadelphia Tourism Marketing Corporation's page for "History" in Philadelphia asserted that "the paths to under-standing American history all converge in Philadelphia and its historic countryside." "History," gophila.com: The Official Visitor Site for Greater Philadelphia, via Internet Archive, April 8, 2006, https://web.archive.org/web/20060408162144/http://www .gophila.com/C/Things_to_Do/211/History/209.html.

37. Kevin F. McCarthy, Elizabeth Heneghan Ondaatje, and Jennifer L. Novak, *Arts and Culture in the Metropolis: Strategies for Sustainability* (Santa Monica, CA: RAND, 2007), 73.

38. Pressler, "Philadelphia Story: The Next Borough." See also "That Was the Week that Was: Jessica Pressler," *Philebrity,* August 19, 2005, accessed January 26, 2013, http://www.philebrity.com/2005/08/19/that-was-the-week-that-was-jessica-pressler/. Pressler became a senior editor at *New York Magazine* in 2007.

39. "Fact Sheet: *The Gross Clinic,*" Pew Charitable Trusts, December 21, 2006, https://www.pewtrusts.org/en/research-and-analysis/fact-sheets/2006/12/21/fact-sheet-the-gross-clinic; "20 Days: Two Eakins Talks," *The Sixth Square* (blog), De-cember 6, 2006, https://whyy.wordpress.com/2006/12/06/20-days-two-eakins-talks/.

40. For a demographic analysis of Philadelphia's homicide victims, see Phila-delphia Police Department Research and Planning Unit Statistical Section, *Murder Analysis: Philadelphia Police Department 2007–2010,* Philadelphia Police Depart-ment, July 2011. Raw data on crime in Philadelphia dating back to 2006 are avail-able through the Open Data Philly project, "Crime Incidents," accessed September 10, 2018, https://www.opendataphilly.org/dataset/crime-incidents.

41. Roberta Fallon and Libby Rosof, "The Hunt for Bentonville," *Artblog,* De-cember 12, 2006, http://theartblog.org/2006/11/the-hunt-for-bentonville/.

42. Dayton Castleman, "Dayton on Tuttle, Eakins and Arkansas," *Artblog,* December 15, 2006, http://theartblog.org/2006/12/dayton-on-tuttle-eakins-and-arkansas/.

43. Carol Vogel, "New York Public Library's Durand Painting Sold to Wal-Mart

Heiress," *New York Times,* May 13, 2005, http://www.nytimes.com/2005/05/13/
nyregion/13painting.html?_r=0; Eileen Kinsella, "The Durand Sale: Dismay and
Anger Linger," *ArtNews,* June 7, 2005, http://www.artnews.com/2005/06/07/the-
durand-sale-dismay-and-anger-linger/.

44. For another discussion comparing the *Gross Clinic* sale to the sale of *Kindred
Spirits,* see Jayme Yahr, "A Philadelphia Story: Regional Patrimony in the Barnes
Foundation and the Gross Clinic Sagas," *U.S. Studies Online: BAAS Postgraduate
Journal,* no. 15 (2009), http://www.baas.ac.uk/issue-15-autumn-2009-article-2/.

45. Walter Benjamin, "Unpacking My Library," in *Illuminations,* ed. Hannah
Arendt (New York: Schocken Books, 1986), 59–67.

46. See, for example, Susan Crane, *Museums and Memory* (Stanford, CA: Stan-
ford University Press, 2000).

47. *Art Museums and the Practice of Deaccessioning,* Association of Art Museum
Directors, November 2007; *Deaccessioning Activity,* American Alliance of Museums,
2012; *Netherlands Guidelines for Deaccessioning of Museum Objects,* Netherlands In-
stitute for Cultural Heritage, November 2006.

48. Steakbellie, "The Gross Clinic by Thomas Eakins," *Steakbellie* (blog), No-
vember 17, 2006, http://steakbellie.blogspot.com/2006/11/gross-clinic-by-thomas-
eakins.html.

49. Stephan Salisbury, "An Artist, a Painting, and a City's Identity; Eakins' 'the
Gross Clinic' Has Inspired Loyalty, Devotion—and an Effort to Keep It Here,"
Philadelphia Inquirer, November 22, 2006.

50. Roberta Fallon, "Sad, Oh Sad," *Artblog,* November 12, 2006, http://theart
blog.org/2006/11/sad-oh-sad/; Stephan Salisbury, "A Divisive Deal," *Philadelphia
Inquirer,* November 14, 2006, A01; Jan Hefler, "Marchers Protest Plan to Sell Paint-
ing," *Philadelphia Inquirer,* November 20, 2006, A04; K. Sheehan, "Comment Re:
28 Days: Making Heroism American," in *The Sixth Square* (blog), WHYY (Novem-
ber 28, 2006), https://whyy.wordpress.com/2006/11/28/28-days-making-heroism-
american/#comment-17; Marty Moss-Coane, *Radio Times* (Philadelphia: WHYY,
2006); Salisbury, "An Artist, a Painting, and a City's Identity."

51. Michel Foucault, *The History of Sexuality: An Introduction* (Harmondsworth,
UK: Penguin, 1981), 53.

52. Sigmund Freud, "Screen Memories," in *Early Psycho-Analytic Publications,*
ed. James Strachey, vol. 3 (1891–1899) of *The Complete Psychological Works of Sig-
mund Freud* (London: Hogarth Press and Institute of Psycho-Analysis, 1962), 320.

53. Philadelphia Museum of Art, "City Institutions, Officials Unite to Keep
Eakins Masterpiece in Philadelphia."

54. David S. Traub, "Paying a Price for Art," *Philadelphia Inquirer,* February 13,
2007, A14.

55. "Crime, Art and War," *The Sixth Square* (blog), WHYY, February 1, 2007,
http://whyy.wordpress.com/2007/02/01/crime-art-and-war/.

56. Herbert Riband on *Radio Times,* Marty Moss-Coane, host (Philadelphia:
WHYY, February 5, 2007).

57. Philadelphia Museum of Art, "The Philadelphia Museum of Art Completes
Its Share in Joint Acquisition of 'the Gross Clinic,'" news release, April 23, 2008,

https://www.philamuseum.org/press/releases/2008/674.html; Edward J. Sozanski, "Museum of Art Seals Eakins Deal," *Philadelphia Inquirer*, April 24, 2008, A01.

58. Lee Rosenbaum, "What's Gross about the 'Gross Clinic' Deaccessions," *CultureGrrl* (blog), April 30, 2008, http://www.artsjournal.com/culturegrrl/2007/01/the_gross_clinic_deaccession_d.html.

59. For more on Eakins's relationship with PAFA, see Louise Lippincott, "Thomas Eakins and the Academy," in *In This Academy: The Pennsylvania Academy of the Fine Arts 1805–1976* (Philadelphia: Pennsylvania Academy of the Fine Arts, 1976), 162–187.

60. Philadelphia Museum of Art, "The Philadelphia Museum of Art Completes Its Share"; Sozanski, "Museum of Art Seals Eakins Deal," A01.

61. In her "Ten Reasons to Keep *The Gross Clinic* in Philadelphia," Foster asked, "Historically, what could be more satisfying than showing the painting in the building where Eakins taught, amid the largest collection of his papers and study material?" "Fact Sheet: *The Gross Clinic*," 2006.

62. Jacques Derrida, *Archive Fever: A Freudian Impression* (Chicago: University of Chicago Press, 1996), 20.

63. On the restoration project, see Stephan Salisbury, "'Gross Clinic' Undergoes Treatment in Run-up to Show," *Philadelphia Inquirer*, May 2, 2010, A01; Foster and Tucker, *An Eakins Masterpiece Restored*.

64. Mark S. Tucker, "Framing the Gross Clinic," *American Art* 26, no. 1 (2012): 10.

CHAPTER 4

1. Jerry Adler, "The Philadelphia Story," *Newsweek*, June 28, 1982, 58.

2. For a full account of the writing and production process according to *Rocky* lore, see Sylvester Stallone, *The Official Rocky Scrapbook,* ed. Michael Uslan (New York: Grosset and Dunlap, 1977). Stallone's description of the writing process has shifted over the years. While he once bragged about writing the script in three days, more recently he has taken a humbler approach, explaining that he drafted the script quickly, but most of that material was unusable. For an example of Stallone's more recent reflections on *Rocky,* see Ryan Coogler, dir., *From Rocky to Creed: The Legacy Continues* (EPIX, 2015).

3. *Rocky* producers earned a reputation for purporting to release the concluding chapter in the *Rocky* saga and then coming out with yet another *Rocky* movie just a few years later. For example, the treatment that *Rocky III* producers circulated in 1980 described the film as the final episode in a trilogy, and yet, by 1985 a fourth *Rocky* movie was out in theaters. Similarly, although *Rocky Balboa* was long presumed to be the capstone to the series, 2015 saw the release of *Creed,* which revived the character of Rocky. Unlike the previous *Rocky* films, *Creed*'s protagonist was not Rocky but the son of Apollo Creed, the champion who challenged Rocky in the first film and later became a trusted friend.

4. Victoria E. Johnson, *Heartland TV: Prime Time Television and the Struggle for U.S. Identity* (New York: New York University Press, 2008), 112–146; Michael Z. Newman, "The Bronze Fonz: Public Art/Popular Culture in Milwaukee, Wiscon-

sin," FlowTV, March 5, 2010, http://flowtv.org/2010/03/flow-favorites-the-bronze-fonz-public-artpopular-culture-in-milwaukee-wisconsin-michael-z-newman-univer sity-of-wisonsin-milwaukee/.

5. Cindy Hing-Yuk Wong and Gary W. McDonogh, "The Mediated Metropolis: Anthropological Issues in Cities and Mass Communication," *American Anthropologist* 103, no. 1 (2001): 105.

6. Linda K. Fuller, "The Sporting Life in Pennsylvania Caught on Celluloid," *Pennsylvania History* 64, no. 4 (1997): 543–548.

7. See, for example, John Urry and Jonas Larsen, *The Tourist Gaze 3.0*, 3rd ed. (London: Sage, 2011); Sue Beeton, *Film-Induced Tourism* (Clevedon, UK: Channel View Publications, 2005); Hyounggon Kim and Sarah L. Richardson, "Motion Picture Impacts on Destination Images," *Annals of Tourism Research* 30, no. 1 (2003): 216–237.

8. Urry and Larsen, *The Tourist Gaze 3.0*, 100–101.

9. Although the museum's steps were a congregation site and a place for exercise before *Rocky*, running up the stairs took on new significance after the film's release. James F. Clarity, "In Philadelphia, Pride in the City Grows," *New York Times*, July 4, 1977.

10. Gregory Jaynes, "68 Steps to Fame Retraced by Stallone in Philadelphia," *New York Times*, June 15, 1979.

11. James L. McGarrity, Philadelphia Inquirer Assignment Sheet: East Terrace Renovation of the Philadelphia Museum of Art, June 6, 1985, Evening Bulletin Photograph Collection, Special Collections Research Center, Temple University Libraries, Philadelphia, PA; William K. Stevens, "Philadelphia Hopes Rise by 60 Stories," *New York Times*, December 14, 1986, sec. 1, 40; Danielle Rice, "The 'Rocky' Dilemma: Museums, Monuments, and Popular Culture in the Postmodern Era," in *Critical Issues in Public Art: Content, Context, and Controversy*, ed. Harriet Senie and Sally Webster (New York: Icon Editions, 1992), 231.

12. Scholars of cultural tourism have also asked what attracts visitors to metro-world sites that are popularized by works of fiction. In an article about tourism in Iowa, for example, Anna Thomson Hajdik examines the way the field that appeared on screen in *Field of Dreams* became a popular tourist destination even though it carried no cultural significance outside of its role as a set for the Hollywood film. Anna Thompson Hajdik, "'You Really Ought to Give Iowa a Try:' Tourism, Community Identity, and the Impact of Popular Culture in Iowa," *Online Journal of Rural Research and Policy* 4, no. 1 (2009): 1–20.

13. Examples of these activities are documented in photos from the *Philadelphia Bulletin*: Bulletin Photos, box 335, Special Collections Research Center, Temple University Libraries, Philadelphia, PA.

14. Michael Vitez and Tom Gralish offer testimonies that echo this sentiment in their book, *Rocky Stories: Tales of Love, Hope, and Happiness at America's Most Famous Steps* (Philadelphia: Paul Dry Books, 2007). Danielle Rice describes the symbolism of Rocky's run as "thinly veiled" in her 1992 essay about the statue. Rice, "The 'Rocky' Dilemma," 231.

15. Alan Caplan, Letter to Mike Weiss, May 22, 1979, Marketing and Public Relations Records, Philadelphia Museum of Art, Archives.

16. Mark Bowden, "The Fight Rocky Lost," in *Road Work: Among Tyrants, Heroes, Rogues, and Beasts* (Boston: Atlantic Monthly Press, 2004), 338. The essay first appeared in the *Philadelphia Inquirer's Today* magazine on September 5, 1982. For a discussion of Rocky as a prominent figure in real-world boxing, see Francesca Borrione, "Rocky Balboa in the Boxing Hall of Fame: When Fiction Becomes Reality," *Celebrity Studies* 3, no. 3 (2012): 340–342.

17. Of course, Washington's actions and Penn's achievements have been fictionalized in countless romanticized tellings of early American history, but even so, these men did exist in actuality, whereas Rocky was born out of Stallone's imagination. Rice, "The 'Rocky' Dilemma," 233.

18. Jim Smith, "Stop Treating Black Achievement as a Fluke," *Philadelphia Tribune,* July 3, 1992, 5-B.

19. Clarity, "In Philadelphia, Pride in the City Grows."

20. Robert I. Alotta, quoted in ibid.

21. Vitez and Gralish, *Rocky Stories,* 3.

22. Michael Vitez, quoted in Bobbi Booker, "Stallone's Run Goes Beyond the Film," *Philadelphia Tribune,* January 14, 2007.

23. *Rocky and Apollo* appears again in later films, where it hangs as a centerpiece in the restaurant Rocky runs. For more on the tension between critical acclaim and popular appeal regarding Neiman's work, see Robert Rosenblum, "Art Ignored: The Other 20th Century," *Art Journal* 39, no. 4 (1980): 288–289; Travis Vogan, "LeRoy Neiman and the Art of Network Sports Television," *American Art* 30, no. 3 (2016): 55–75.

24. Accounts of the Rocky statue's history show discrepancies in the date of the sculpture's creation. Schomberg's website indicates that the statue was made in 1980, a 2006 *New York Times* article dates the piece to 1982, and a report from the company that conserved the sculpture in 2006 says that the statue is from 1981. Robert Strauss, "'Rocky' Statue Makes Comeback at Museum," *New York Times*, November 19, 2006, 31; Kreilick Conservation, *Rocky* (1981) by A. Thomas Schomberg, September 7, 2006, Art Commission Records, Philadelphia Art Program Office.

25. A. Thomas Schomberg, quoted in "*Rocky* (1980)," *Museum without Walls* (Philadelphia: Association for Public Art), accessed September 5, 2018, https://www.associationforpublicart.org/artwork/rocky/#mww--video.

26. In a 1987 interview for *Sports Illustrated,* Schomberg compared the Rocky statue to work by Phidias, the fifth-century B.C.E. Greek sculptor, and Jean-Antoine Houdon, one of the most celebrated portrait sculptors of the eighteenth century. Schomberg's publicity materials as well as contemporary journalism described the statue's pose as victorious; many documents refer to the figure's "classical contrapposto pose." Franz Lidz, "Capturing Sport's Idols with Feats of Clay," *Sports Illustrated*, March 23, 1987; Peter Cooney, "Sly Goes to the Mat for Rocky Statue," *Toronto Star,* February 28, 1990; "About the Rocky Statue," Official ROCKY Sculpture Store, accessed January 10, 2015, http://www.rockysculpture.com/acatalog/About_the_ROCKY_Statue.html.

27. For more information about the Art Commission, see Philadelphia Art Commission, "History," accessed January 4, 2018, http://www.phila.gov/artcommission/history/Pages/default.aspx.

28. See, for example, Jack Smyth, "Rocky Is the Underdog in Fight over Statue at Phila. Art Museum," *Philadelphia Evening Bulletin*, December 11, 1980, Evening Bulletin Collection, Statues—Rocky, Special Collections Research Center, Temple University Libraries, Philadelphia, PA.

29. Art Gorman, quoted in Fawn Vrazo, "For Art's Sake: Kensington Man Wages a Lonely Fight for Rocky Statue's Return," *Philadelphia Evening Bulletin*, September 8, 1981, Evening Bulletin Collection, Gorman—ART FAN, Special Collections Research Center, Temple University Libraries, Philadelphia, PA.

30. In addition to serving on the Board of Trustees at the Museum, Robert L. McNeil Jr., Henry's uncle, established the Barra Foundation, an organization that supported nonprofit organizations in Philadelphia. The McNeil family fortune derived from McNeil Laboratories, a family-owned company that began as a pharmacy in 1879 and grew to be a leader in the pharmaceutical industry during the twentieth century. Under Robert's leadership, McNeil Laboratories manufactured Tylenol before Johnson and Johnson purchased the company in 1959. Henry S. McNeil Jr., Letter to the Editor, unpublished, n.d., Anne d'Harnoncourt Papers, Philadelphia Museum of Art, Archives; Letter to Anne d'Harnoncourt, September 27, 1982, Anne d'Harnoncourt Papers, Philadelphia Museum of Art, Archives.

31. Robert Montgomery Scott, Letter to Joseph E. Coleman, September 10, 1981, Marketing and Public Relations Records, Philadelphia Museum of Art, Archives.

32. Statement on the Removal of the Rocky Statue, n.d., Marketing and Public Relations Records, Philadelphia Museum of Art, Archives.

33. Kreilick Conservation, *Rocky* (1981).

34. Rice, "The 'Rocky' Dilemma," 233.

35. For a discussion of the ways in which objects of popular culture can become tools for asserting politicized identities, see Andrew Ross, *No Respect: Intellectuals and Popular Culture* (New York: Routledge, 1989).

36. McNeil Jr., Letter to Anne d'Harnoncourt.

37. MCG, Letter to Fairmount Art Commission [*sic*], City of Philadelphia, et al., 1981. Marketing and Public Relations Records, Philadelphia Museum of Art, Archives.

38. The author of this statement was a children's book illustrator. CC, "The Disgrace of Accepting the Rocky Prop," September 10, 2006, Art Commission Records, Philadelphia Art Program Office.

39. Pierre Bourdieu, *Distinction: A Social Critique of the Judgement of Taste*, trans. Richard Nice (Cambridge, MA: Harvard University Press, 1984), 56.

40. For another example of the points of view discussed in this paragraph, see Editorial, "The Art Museum Isn't for Hype," *Philadelphia Evening Bulletin*, May 12, 1981, Evening Bulletin Collection, Statues—Rocky, Special Collections Research Center, Temple University Libraries, Philadelphia, PA.

41. Sal Vittolino, "A TKO for 'Rocky': Two Locations Eyed for Statue," *Philadelphia Evening Bulletin*, December 20, 1981, Evening Bulletin Collection, Statues—Rocky, Special Collections Research Center, Temple University Libraries, Philadelphia, PA.

42. Editorial, "Bring the Statue Back," *Times Northeast*, May 20, 1981, Marketing and Public Relations Records. Philadelphia Museum of Art, Archives.

43. Darren Garnick, "Stallone to Atone for Rocky V, " *Nashua Telegraph*, August 24, 2006, 32.

44. Nancy Kolb, quoted in Michael Vitez, "Rocky Statue Ready to Hit the Steps: With a Win, the Fictional Pugilist Is Back at His Old Haunt—the Art Museum," *Philadelphia Inquirer*, September 7, 2006, B01.

45. For additional discussions of the Rocky Statue as city icon, see Stephanie Naidoff, quoted in Strauss, "'Rocky' Statue Makes Comeback at Museum," 31; Emanuel Kelly, paraphrased in Vitez, "Rocky Statue Ready to Hit the Steps," B01.

46. Dennis Raverty, "Marketing Modernism: Promotional Strategy in the Armory Show," *Prospects*, no. 27 (2002): 359–374.

47. David Yadgaroff, "The 'Rocky' Statue," KYW Newsradio, 2006, Art Commission Records, Philadelphia Art Program Office.

48. Michael Leja discusses the nineteenth-century emergence of a culture of skepticism about art in *Looking Askance: Skepticism and American Art from Eakins to Duchamp* (Berkeley: University of California Press, 2004).

49. Yadgaroff, "The 'Rocky' Statue."

50. Quoted in Noble Smith, Letter to the Editor, *Times Northeast*, June 18, 1981, Marketing and Public Relations Records, Philadelphia Museum of Art, Archives.

51. Journalist Brian X. McCrone attributed a vote in favor of placing Rocky at the steps to the fact that "it is undeniably a cultural icon." Brian X. McCrone, "Rocky's Home at Art Museum," *Metro* (Philadelphia), 2006, Marketing and Public Relations Active Department Files, Philadelphia Museum of Art.

52. Frank Luzi, e-mail to Gail Harrity, Charles Croce, Norman Keyes, and Elisabeth Flynn, Re: Nashua Telegraph Column on Rocky Statue and Rocky Fandom, August 24, 2006, Marketing and Public Relations Active Department Files, Philadelphia Museum of Art.

53. A. Wesley Bryan, Letter of Agreement with Michael Glick, *Rocky V* Executive Producer and Production Manager, May 18, 1990, Marketing and Public Relations Records, Philadelphia Museum of Art, Archives.

54. See, for example, "Rocky Statue Banned from Museum," *Washington Post*, March 28, 1990; Cooney, "Sly Goes to the Mat for Rocky Statue."

55. "Welcome," Art Basel Miami Beach, via Internet Archive, April 6, 2009, https://web.archive.org/web/20090406202458/http://www.artbaselmiamibeach.com.

56. For examples of this type of journalism, see Kate Sutton, "Moon over Miami," *Artforum*, May 12, 2009, https://www.artforum.com/diary/id=24336; Andrew Berardini, "Mas Que Nada," *Artforum*, December 7, 2009, http://artforum.com/diary/id=24353.

57. See, for example, Georgina Adam, Charlotte Burns, and Ossian Ward, "Brighter Mood as Blue-Chip Art Finds Buyers at Miami Beach," *Art Newspaper*, December 3, 2009; "Rocky's Royal Gal," *Art Newspaper*, December 3, 2009.

58. Anthony Haden-Guest, "Rocky Hits the Canvas," *Sunday Times* (London), January 10, 2010, 12–17.

59. See, for example, Smyth, "Rocky Is the Underdog in Fight over Statue at Phila. Art Museum"; Stephan Salisbury, "Comeback for Rocky Statue," *Philadelphia*

Inquirer, May 11, 2006, A01; "Art Museum Site for Rocky Statue Takes It on Chin," Associated Press, August 3, 2006.

60. Bowden, "The Fight Rocky Lost," 337. For additional examples, see "Movies: A Bronze Rocky for the City?," *Philadelphia Inquirer*, December 9, 1980, Evening Bulletin Collection, Statues—Rocky, Special Collections Research Center, Temple University Libraries, Philadelphia, PA; Kim Adams, host, "3-Today, 6am Broadcast—February 26," KYW Philadelphia, February 26, 1990.

61. Smith, "Letter to the Editor."

62. "Fight Goes on for Stallone's Rocky Statue," Hollywood.com, August 5, 2006, http://www.hollywood.com/news/movies/3540133/fight-goes-on-for-sylves ter-stallone-s-rocky-statue.

63. Gloria Campisi and Mark McDonald, "Steps in the Right Direction; 'Rocky' Going Back to Museum, but Not to Famous Spot," *Philadelphia Daily News*, May 5, 2006.

64. "Rocky Statue Returns to Museum of Art Steps," WENN Entertainment News Wire Service, September 7, 2006.

65. In addition to the wealth of evidence cited elsewhere in this chapter, see Rocky Statue Proposed Relocation Presentation Notes, 2006, Art Commission Records, Philadelphia Art Program Office; Virginia N. Naudé, Conservator's Report, Letter to George Young, February 3, 2006, Art Commission Records, Philadelphia Art Program Office.

66. Dan Gelston, "Rocky Is Back Where He Belongs," Associated Press Online, September 9, 2006, http://www.washingtonpost.com/wp-dyn/content/arti cle/2006/09/08/AR2006090801620_pf.html.

67. "Yo Adrian!," *Philadelphia Daily News,* November 21, 1981.

68. Robert Montgomery Scott, Letter to Kitty Caparella, August 11, 1982, Anne d'Harnoncourt Papers, Philadelphia Museum of Art, Archives; Anne d'Harnoncourt, Memo to Bob Scott, Gene Kuthy, and Larry Snyder, Re: Rocky, July 22, 1982, Anne d'Harnoncourt Papers, Philadelphia Museum of Art, Archives; Jill M. Bullock, "As an Extra Precaution This Time, the Curator Has Mr. T. on Retainer," *Wall Street Journal,* 1990, Marketing and Public Relations Records, Philadelphia Museum of Art, Archives.

69. Greater Philadelphia Tourism Marketing Corporation, "'Philly Loves Rocky Week' Honors Sly Stallone: A Week of Rocky-Themed Events to Mark Film's 30th Anniversary," news release, August 31, 2006, http://press.visitphilly.com/releases/ philly-loves-rocky-week-honors-sly-stallone.

70. For examples of critics who accused Philadelphia of giving in to unabashed commercialism, see Anne Fabbri, "The Contrarian: Time for a Change," *Art Matters*, October 2006; Edward J. Sozanski, "Yo, Diana! Rocky's Turn," *Philadelphia Inquirer*, May 28, 2006, H01.

71. Bob Brookover, "Adams: Rocky Must Share the Credit," *Philadelphia Inquirer*, May 14, 2002; Bob Ford, "Inspired Phillies Flying High," *Philadelphia Inquirer*, May 13, 2002, D01; Frank Fitzpatrick, "The New Year of Fun Is Set to Begin," *Philadelphia Inquirer*, January 3, 2003.

72. "War on Washington Monument," *American Art News* 21, no. 13 (1923): 3. The museum, then called the Pennsylvania Museum and School of Industrial Arts, was housed in Memorial Hall from the time it was established as a permanent institution in 1877 until its administrators relocated the collection to the Parkway building, which opened to the public in 1928.

73. See Albert Rosenthal in "War on Washington Monument."

74. For more on the *Washington Monument,* see "Washington Monument," *Museum without Walls* (Philadelphia: Association for Public Art), accessed September 5, 2018, https://www.associationforpublicart.org/artwork/washington-monument/.

75. *Tourism 2007 Report to the Industry: Marketing Gets Personal* (Philadelphia: Greater Philadelphia Tourism Marketing Corporation, 2007).

76. *2007 Greater Philadelphia Tourism Monitor: What's in a Place?* (Philadelphia: Greater Philadelphia Tourism Marketing Corporation, 2007), 29.

77. *Tourism 2008 Report to the Region: More Partners, More Promotions, More People* (Philadelphia: Greater Philadelphia Tourism Marketing Corporation, 2008), 41.

78. "Favorite Attractions," Philadelphia and the Countryside—Official Visitor Site, accessed December 15, 2010, www.visitphilly.com.

79. *Tourism 2010 Report to the Region,* 30.

80. Schomberg reflects on designing the Rocky statue in Barry Avrich's 2009 documentary, *Amerika Idol* (Melbar Entertainment, 2009), 16:39.

81. In *Rocky Stories,* Vitez and Gralish recount several stories that follow this model.

82. See, for example, Sandra Horrocks, in Bullock, "As an Extra Precaution This Time."

83. For a discussion of the experiential monument, which invites visitors to physically engage with space and memory, see Kirk Savage, *Monument Wars: Washington, D.C., the National Mall, and the Transformation of the Memorial Landscape* (Berkeley: University of California Press, 2009), 251–295.

CONCLUSION

1. Widman, whose photojournalism positioned him as a Pulitzer Prize finalist in 1987, also worked for a number of clients in the Philadelphia area, including the Greater Philadelphia Tourism Marketing Corporation.

2. Robert Zaller, "Achin' for Eakins? Count Me Out," *Broad Street Review,* December 2, 2006, http://www.broadstreetreview.com/index.php/main/article/Achin_for_Eakins__Count_me_out/.

3. Friends of the Barnes Foundation, "What Is Good for Dr. Gross Is Good for Dr. Barnes: Friends of the Barnes Foundation Challenge Double Standard," news release, November 30, 2006, http://www.barnesfriends.org/downlload/DrEakins_DrBarnes.pdf. Shari L. Steinberg made a similar argument several months later in a letter to the editor of the *Philadelphia Inquirer.* Writing in response to a recent article in which the journalist casually described the effort to keep the Barnes in Merion as "probably futile," Steinberg asked, "Was it futile for Philadelphians to fight the

secret sale of the Eakins painting? . . . It is no more futile for us to fight even harder to keep the Barnes Foundation in its birthplace, Merion, where it was designed and constructed stone by stone, embellished painting by painting, garden by garden, and willed to remain forever." Shari L. Steinberg, "Barnes Rightfully Belongs in Lower Merion," *Philadelphia Inquirer*, February 22, 2007, B02.

 4. Evelyn Yaari and Sandra Gross Bressler, "Eakins, Barnes, and a Great City" [reprint from *Main Line Times*], n.d., Merion, PA, Friends of the Barnes Foundation.

 5. Local artist Charles Cushing painted a copy of *The Gross Clinic* between December 2006 and March 2007. He often worked publicly, in the lobby of a Center City office building. Stephan Salisbury, "Sincerest Form of Flattery for Eakins: Opponents of a Sale Hope a 'Gross Clinic' Copy Raises Awareness," *Philadelphia Inquirer*, December 12, 2006.

 6. Philip Stevick, *Imagining Philadelphia: Travelers' Views of the City from 1800 to the Present* (Philadelphia: University of Pennsylvania Press, 1996).

 7. These materials are archived at "Speculative Monuments for Philadelphia," Open Data Philly (accessed September 11, 2017), https://www.opendataphilly.org/dataset/speculative-monuments-for-philadelphia.

 8. Christian Malatesta, "Monument Lab at City Hall," *Cross Ties: News and Insights for Humanities Professionals*, May 22, 2015, https://march.rutgers.edu/2015/05/monument-lab-at-city-hall-in-philadelphia/.

 9. "Monument Lab: About," MuralArts.org, accessed July 24, 2017, http://monumentlab.muralarts.org/about/.

Bibliography

"About the Rocky Statue." Official ROCKY Sculpture Store. Accessed January 10, 2015. http://www.rockysculpture.com/acatalog/About_the_ROCKY_Statue .html.

Adam, Georgina, Charlotte Burns, and Ossian Ward. "Brighter Mood as Blue-Chip Art Finds Buyers at Miami Beach." *Art Newspaper,* December 3, 2009.

Adams, Henry. *Eakins Revealed: The Secret Life of an American Artist.* Oxford: Oxford University Press, 2005.

Adams, Kim, host. "3-Today, 6am Broadcast—February 26." KYW Philadelphia, February 26, 1990.

Adler, Jerry. "The Philadelphia Story." *Newsweek,* June 28, 1982, 58.

Anderson, John. *Art Held Hostage: The Story of the Barnes Collection.* New York: W. W. Norton, 2003.

Apel, Dora. *Beautiful Terrible Ruins: Detroit and the Anxiety of Decline.* New Brunswick, NJ: Rutgers University Press, 2015.

Argott, Don, dir. *The Art of the Steal.* New York: IFC in Theaters, 2009.

Aronczyk, Melissa. *Branding the Nation: The Global Business of National Identity.* New York: Oxford University Press, 2013.

Art Museums and the Practice of Deaccessioning. New York: Association of Art Museum Directors, November 2007.

"Art Museum Site for Rocky Statue Takes It on Chin." Associated Press, August 3, 2006.

Arts, Culture, and Economic Prosperity in Greater Philadelphia. Philadelphia: Greater Philadelphia Cultural Alliance, 2007.

Ashworth, Gregory, and Mihalis Kavaratzis. "Beyond the Logo: Brand Management for Cities." *Journal of Brand Management* 16, no. 8 (2009): 520–531.

Avrich, Barry, dir. *Amerika Idol.* Toronto: Melbar Entertainment, 2009.

Bach, Penny Balkin. *Public Art in Philadelphia.* Philadelphia: Temple University Press, 1992.

Bacon, Edmund N. "Philadelphia in the Year 2009." In *Imagining Philadelphia: Edmund Bacon and the Future of the City,* edited by Scott Gabriel Knowles, 8–18. Philadelphia: University of Pennsylvania Press, 2009.

Bahr, Megan Granda. "Transferring Values: Albert C. Barnes, Work, and the Work of Art." Ph.D. diss., University of Texas at Austin, 1998.

Baltzell, E. Digby. *Philadelphia Gentlemen: The Making of a National Upper Class.* Glencoe, IL: Free Press, 1958.

Barnes, Albert C. *The Art in Painting.* 3rd., rev. and enl., ed. New York: Harcourt, Brace, 1937.

———. "A Disgrace to Philadelphia." Merion, PA: Self-published, 1938.

———. Letter to Arthur B. Carles, April 18, 1921. Special Exhibition Records, box 17, contemporary European paintings and sculpture (Barnes Collection). RG.02.06.06. Dorothy and Kenneth Woodcock Archives at the Pennsylvania Academy of the Fine Arts, Philadelphia, PA.

———. Letter to Glenn R. Morrow, May 22, 1946. Mss. Coll. 402. Albert C. Barnes Correspondence with the University of Pennsylvania, box 1, folder 10. University of Pennsylvania Rare Books and Manuscripts Collection.

———. Letter to John M. Fogg Jr., January 12, 1950. Mss. Coll. 402. Albert C. Barnes Correspondence with the University of Pennsylvania, box 1, folder 25. University of Pennsylvania Rare Books and Manuscripts Collection.

———. Letter to Parker S. Williams, March 22, 1927. Albert C. Barnes Correspondence. Barnes Foundation Archives, Philadelphia, PA.

———.. Letter to the Pennsylvania Academy of the Fine Arts, May 24, 1924. Albert C. Barnes Correspondence. Barnes Foundation Archives, Philadelphia, PA.

———. Public Statement by Doctor Albert C. Barnes, April 15, 1927. Albert C. Barnes Correspondence. Barnes Foundation Archives, Philadelphia, PA.

———. Public Statement Made by Dr. Albert C. Barnes, April 14, 1927. Albert C. Barnes Correspondence. Barnes Foundation Archives, Philadelphia, PA.

"The Barnes Collection: America's Least-Visited Art." *Voice of America News,* January 22, 2003.

Barnes Foundation. "The Barnes Foundation Breaks Ground for Construction of New Parking Lot; Fifty-Six Car Lot on Premises of Foundation Will Alleviate Need for on-Street Parking." News release, 2001.

———. Barnes Foundation Charter. December 4, 1922. Barnes Foundation Archives, Philadelphia, PA.

———. "The Barnes Foundation's Philadelphia Campus Awarded the Highest Level of Environmental Certification from the U.S. Green Building Council." News release, September 27, 2012.

———. "Fact Sheet: New Philadelphia Campus Design." 2012.

"Barnes Founddation [*sic*] Paintings Spark Controversy." *Morning Edition.* National Public Radio, July 13, 1992.

Beers, Dorothy Gondos. "The Centennial City, 1865–1876." In *Philadelphia: A 300*

Year History, edited by Russell Frank Weigley, Nicholas B. Wainwright, and Edwin Wolf, 417–470. New York: W. W. Norton, 1982.

Beeton, Sue. *Film-Induced Tourism.* Clevedon, UK: Channel View Publications, 2005.

Bellion, Wendy. *Citizen Spectator: Art, Illusion, and Visual Perception in Early National America.* Chapel Hill: Published for the Omohundro Institute of Early American History and Culture, Williamsburg, Virginia, by the University of North Carolina Press, 2011.

Benjamin, Walter. "Unpacking My Library." In *Illuminations,* edited by Hannah Arendt, 59–67. New York: Schocken Books, 1986.

Berardini, Andrew. "Mas Que Nada." *Artforum,* December 7, 2009. http://artforum .com/diary/id=24353.

Berger, Martin A. *Man Made: Thomas Eakins and the Construction of Gilded Age Manhood.* Berkeley: University of California Press, 2000.

Bissinger, H. G. *A Prayer for the City.* New York: Random House, 1997.

Blanchard, Matthew P. "As Barnes Plans for Exit, Town All but Holds Door; L. Merion Isn't Fighting the Gallery's Effort to Move." *Philadelphia Inquirer,* October 17, 2003, A01.

Blanchard, Matthew P., and Patricia Horn. "To Retain the Barnes, Neighbors Try Charm; a Light-Hearted Plea: Please Don't Flee." *Philadelphia Inquirer,* March 13, 2004.

Blumenthal, Ralph. "Art Museum Outside Philadelphia Plans Move." *New York Times,* September 25, 2002, A16.

———. "Imparting the Vision behind an Idiosyncratic Collection." *New York Times,* November 12, 2002, E2.

Boasberg, Leonard W. "Welcome America! City Celebrates Its New Center and Itself." *Philadelphia Inquirer,* June 20, 1993.

Bogart, Michele H. *The Politics of Urban Beauty: New York and Its Art Commission.* Chicago: University of Chicago Press, 2006.

———. *Sculpture in Gotham: Art and Urban Renewal in New York City.* London: Reaktion Books, 2018.

Boggs, Jean Sutherland. Letter to Lewis W. Bluemle, June 16, 1980. Special Exhibitions Records. Philadelphia Museum of Art, Archives.

Booker, Bobbi. "Stallone's Run Goes beyond the Film." *Philadelphia Tribune,* January 14, 2007.

Borrione, Francesca. "Rocky Balboa in the Boxing Hall of Fame: When Fiction Becomes Reality." *Celebrity Studies* 3, no. 3 (2012): 340–342.

Bourdieu, Pierre. "The Aesthetic Sense as the Sense of Distinction." In *The Consumer Society Reader,* edited by Juliet Schor and Douglas B. Holt, 205–211. New York: New Press, 2000.

———. *Distinction: A Social Critique of the Judgement of Taste.* Trans. Richard Nice. Cambridge, MA: Harvard University Press, 1984.

Bowden, Mark. "The Fight Rocky Lost." In *Road Work: Among Tyrants, Heroes, Rogues, and Beasts.* Boston: Atlantic Monthly Press, 2004.

Boyer, Ernest L. *Scholarship Reconsidered: Priorities of the Professoriate.* Expanded ed.

Edited by Drew Moser, Todd C. Ream, and John M. Braxton. San Francisco: Jossey-Bass, 2016.

Braddock, Alan C. *Thomas Eakins and the Cultures of Modernity.* Berkeley: University of California Press, 2009.

Braddock, Jeremy. *Collecting as Modernist Practice.* Baltimore: Johns Hopkins University Press, 2012.

———. "Neurotic Cities: Barnes in Philadelphia." *Art Journal* 63, no. 4 (2004): 47–61.

Brookover, Bob. "Adams: Rocky Must Share the Credit." *Philadelphia Inquirer,* May 14, 2002.

Brownlee, David B. *The Barnes Foundation: Two Buildings, One Mission.* New York: Skira Rizzoli, in association with the Barnes Foundation, 2012.

———. *Building the City Beautiful: The Benjamin Franklin Parkway and the Philadelphia Museum of Art.* Philadelphia: Philadelphia Museum of Art, 1989.

Bryan, A. Wesley. Letter of Agreement with Michael Glick, *Rocky V* Executive Producer and Production Manager, May 18, 1990. Marketing and Public Relations Records, Philadelphia Museum of Art, Archives.

Bullock, Jill M. "As an Extra Precaution This Time, the Curator Has Mr. T. on Retainer." *Wall Street Journal,* 1990. Marketing and Public Relations Records, Philadelphia Museum of Art, Archives.

Burnham, Rika. "The Barnes Foundation: A Place for Teaching." *Journal of Museum Education* 32, no. 3 (2007): 221–232.

Burt, Nathaniel. *The Perennial Philadelphians: The Anatomy of an American Aristocracy.* Boston: Little, Brown, 1963.

Burt, Nathaniel, and Wallace E. Davies. "The Iron Age, 1876–1905." In *Philadelphia: A 300 Year History,* edited by Russell Frank Weigley, Nicholas B. Wainwright, and Edwin Wolf, 471–523. New York: W. W. Norton, 1982.

Bussard, Katherine A., Alison Fisher, and Greg Foster-Rice, eds. *The City Lost and Found: Capturing New York, Chicago, and Los Angeles, 1960–1980.* New Haven, CT: Yale University Press, 2014.

Calo, Carole Gold. "From Theory to Practice: Review of the Literature on Dialogic Art." *Public Art Dialogue* 2, no. 1 (2012): 64–78.

Camp, Kimberly. "Response to Jeremy Braddock." *Art Journal* 63, no. 4 (2004): 62–67.

Campisi, Gloria, and Mark McDonald. "Steps in the Right Direction; 'Rocky' Going Back to Museum, but Not to Famous Spot." *Philadelphia Daily News,* May 5, 2006.

Caplan, Alan. Letter to Mike Weiss, May 22, 1979. Marketing and Public Relations Records. Philadelphia Museum of Art, Archives.

Carrier, David. *Museum Skepticism: A History of the Display of Art in Public Galleries.* Durham, NC: Duke University Press, 2006.

Carvajal, Doreen. "Quirky Art Foundation Ponders Radical Move." *New York Times,* March 16, 2001, A1.

Castleman, Dayton. "Dayton on Tuttle, Eakins and Arkansas." *Artblog,* December 15, 2006. http://theartblog.org/2006/12/dayton-on-tuttle-eakins-and-arkansas/.

CC. "The Disgrace of Accepting the Rocky Prop," September 10, 2006. Art Commission Records. Philadelphia Art Program Office.

Cedarleaf Dahl, Elissa. "My View: Minneapolis Needs a Mural Arts Program." *The Line,* September 28, 2011. http://www.thelinemedia.com/features/myviewmurals092811.aspx.

City of Philadelphia. "Mayor Michael A. Nutter Unveils City of Philadelphia's New Signature Brand at Philadelphia Convention and Visitors Bureau's Annual Luncheon." News release, November 27, 2009.

Clarity, James F. "In Philadelphia, Pride in the City Grows." *New York Times,* July 4, 1977.

Clark, William J., Jr. "The Fine Arts: Eakins' Portrait of Dr. Gross, April 28, 1876." *Philadelphia Daily Evening Telegraph.* Reprinted in Kathleen A. Foster and Mark S. Tucker, eds. *An Eakins Masterpiece Restored: Seeing The Gross Clinic Anew.* New Haven, CT: Yale University Press in association with the Philadelphia Museum of Art, 2012, 138–139.

Clifford, James. "On Collecting Art and Culture." In *The Predicament of Culture: Twentieth-Century Ethnography, Literature, and Art,* 215–252. Cambridge, MA: Harvard University Press, 1988.

Cohn, Danielle, and Melanie Johnson. *Implementing the City Brand: Improving Internal and External Customer Service through Consistent Communication.* Presented to the Mayor's Executive Team, City of Philadelphia, August 10, 2010.

Commonwealth v. Barnes Foundation. 159 Atlantic 2d 500, 1960.

Conheim, Maryanne. "How Phila's Love Was Won at Last." *Philadelphia Inquirer,* April 30, 1978. *Inquirer* news clippings collection. Robert Indiana, K3 6-430, 6a-32. Special Collections Research Center, Temple University Libraries, Philadelphia, PA.

Conn, Steven. *Americans against the City: Anti-urbanism in the Twentieth Century.* New York: Oxford University Press, 2014.

———. *Do Museums Still Need Objects?* Philadelphia: University of Pennsylvania Press, 2010.

———. "Local Hero: *The Gross Clinic* and Our Sense of Civic Identity." In *An Eakins Masterpiece Restored: Seeing* The Gross Clinic *Anew,* edited by Kathleen A. Foster and Mark S. Tucker, 7–16. New Haven, CT: Yale University Press in association with the Philadelphia Museum of Art, 2012.

———. *Metropolitan Philadelphia: Living with the Presence of the Past.* Philadelphia: University of Pennsylvania Press, 2006.

Coogler, Ryan, dir. *From Rocky to Creed: The Legacy Continues.* New York: EPIX, 2015.

Cooney, Peter. "Sly Goes to the Mat for Rocky Statue." *Toronto Star,* February 28, 1990.

Corn, Wanda M. *The Great American Thing: Modern Art and National Identity, 1915–1935.* Berkeley: University of California Press, 1999.

Cowan, Aaron. *A Nice Place to Visit: Tourism and Urban Revitalization in the Postwar Rustbelt.* Philadelphia: Temple University Press, 2016.

Crane, Susan. *Museums and Memory.* Stanford, CA: Stanford University Press, 2000.

"Crime, Art and War." *The Sixth Square* (blog), WHYY, February 1, 2007. http://whyy.wordpress.com/2007/02/01/crime-art-and-war/.

"Crime Incidents." Open Data Philly. Accessed September 10, 2018. https://www.opendataphilly.org/dataset/crime-incidents.

Crow, Thomas E. *Painters and Public Life in Eighteenth-Century Paris.* New Haven, CT: Yale University Press, 1985.

Curson, Elliott. "Origins of a Memorable Philadelphia Slogan." *Philadelphia Inquirer,* May 14, 1996.

Daniels, Jarel. "Make Fathers Stay." *Philadelphia Inquirer,* December 14, 2006, B2.

Deaccessioning Activity. Washington, DC: American Alliance of Museums, 2012.

de Port-Manech, Fidèle. Letter to Kneedler, Mirick, and Zantzinger, November 10, 1941. Ms. Coll. 403. Kneedler, Mirick, Zantzinger (Firm) Records Concerning Albert C. Barnes, 1940–1946 (1980), box 1, folder 7. University of Pennsylvania Rare Books and Manuscripts Collection.

Derrida, Jacques. *Archive Fever: A Freudian Impression.* Chicago: University of Chicago Press, 1996.

d'Harnoncourt, Anne. Memo to Bob Scott, Gene Kuthy, and Larry Snyder, Re: Rocky, July 22, 1982. Anne d'Harnoncourt Papers. Philadelphia Museum of Art, Archives.

Dilworth, Richardson. "Way Back When, Philly Didn't Even Try to Love You Back." *Newsworks,* February 19, 2012. https://whyy.org/articles/way-back-when-philly-didnt-even-try-to-love-you-back/.

"Disagreements over the Location and Status of the Barnes Collection, the Most Famous Private Art Collection in the World." *All Things Considered.* National Public Radio, August 21, 2003.

Doss, Erika, ed. "The Dilemma of Public Art's Permanence." Special Issue. *Public Art Dialogue* 6, no. 1 (2016).

———. *Spirit Poles and Flying Pigs: Public Art and Cultural Democracy in American Communities.* Washington, DC: Smithsonian Institution Press, 1995.

Doyle, Jennifer. "Sex, Scandal, and Thomas Eakins's 'the Gross Clinic.'" *Representations,* no. 68 (1999): 1–33.

"Eakins Countdown: 40 Days." *The Sixth Square* (blog). WHYY, November 16, 2006. http://whyy.wordpress.com/2006/11/16/eakins-countdown-40-days/.

"The Early Barnes Foundation, Part 1." *Barnes Foundation Journal,* March 7, 2011.

Editorial. "The Art Museum Isn't for Hype." *Philadelphia Evening Bulletin,* May 12, 1981. Evening Bulletin Collection, Statues—Rocky. Special Collections Research Center, Temple University Libraries, Philadelphia, PA.

———. "Bring the Statue Back." *Times Northeast,* May 20, 1981. Marketing and Public Relations Records. Philadelphia Museum of Art, Archives.

Fabbri, Anne. "The Contrarian: Time for a Change." *Art Matters* (October 2006). Marketing and Public Relations Active Department Files, Philadelphia Museum of Art.

"Fact Sheet: *The Gross Clinic.*" Pew Charitable Trusts, December 21, 2006. https://www.pewtrusts.org/en/research-and-analysis/fact-sheets/2006/12/21/fact-sheet-the-gross-clinic.

Fallon, Roberta. "Sad, Oh Sad." *Artblog*, November 12, 2006. http://theartblog
.org/2006/11/sad-oh-sad/.

Fallon, Roberta, and Libby Rosof. "The Hunt for Bentonville." *Artblog*, December
12, 2006. http://theartblog.org/2006/11/the-hunt-for-bentonville/.

"Favorite Attractions." Philadelphia and the Countryside—Official Visitor Site. Ac-
cessed December 15, 2010. http://www.visitphilly.com/.

Feigen, Richard L. "Dr. Barnes and the Devil." In *Tales from the Art Crypt: The Paint-
ers, the Museums, the Curators, the Collectors, the Auctions, the Art*, 70–91. New
York: Alfred A. Knopf, 2000.

———. "A Tale of Institutional Morality: The Barnes Collection Is Not Being
Saved, It Is Being Stolen." *Art Newspaper*, January 6, 2010.

"Fight Goes on for Stallone's Rocky Statue." Hollywood.com, August 5, 2006. http://
www.hollywood.com/news/movies/3540133/fight-goes-on-for-sylvester-stal
lonesrocky-statue.

Finkel, Kenneth. "What's Wrong with Philadelphia's 'Museum Mile'?" *The Philly
History Blog: Discoveries from the City Archives*, May 15, 2012. http://www.philly
history.org/blog/index.php/2012/05/whats-wrong-philadelphias-museum-mile/.

Finkel, Kenneth, and Susan Oyama. *Philadelphia Then and Now: 60 Matching Pho-
tographic Views from 1859–1952 and from 1986–1988*. Philadelphia: Library
Company of Philadelphia, 1988.

Fitzpatrick, Frank. "The New Year of Fun Is Set to Begin." *Philadelphia Inquirer*,
January 3, 2003.

Fleeson, Lucinda. "Barnes Urged by Annenberg to Sell Some Art." *Philadelphia
Inquirer*, April 18, 1991, A01.

———. "Museum Seeks to Sell Art." *Philadelphia Inquirer*, March 24, 1991, A01.

Ford, Bob. "Inspired Phillies Flying High." *Philadelphia Inquirer*, May 13, 2002,
D01.

Foster, Kathleen A. "The Gross Clinic in Philadelphia and New York, 1875–79." In
An Eakins Masterpiece Restored: Seeing The Gross Clinic *Anew*, edited by Kathleen
A. Foster and Mark S. Tucker, 71–82. New Haven, CT: Yale University Press in
association with the Philadelphia Museum of Art, 2012.

Foster, Kathleen A., and Mark S. Tucker, eds. *An Eakins Masterpiece Restored: Seeing*
The Gross Clinic *Anew*. Philadelphia: Philadelphia Museum of Art, 2012.

———. "The Making of The Gross Clinic." In *An Eakins Masterpiece Restored: See-
ing* The Gross Clinic *Anew*, edited by Kathleen A. Foster and Mark S. Tucker,
43–70. New Haven, CT: Yale University Press in association with the Philadel-
phia Museum of Art, 2012.

Foster-Rice, Greg. "The Dynamism of the City: Urban Planning and Artistic Re-
sponses to the 1960s and 1970s." In *The City Lost and Found: Capturing New
York, Chicago, and Los Angeles, 1960–1980*, edited by Katherine A. Bussard,
Alison Fisher, and Greg Foster-Rice, 19–47. New Haven, CT: Yale University
Press, 2014.

Foucault, Michel. *The History of Sexuality: An Introduction*. Harmondsworth, UK:
Penguin, 1981.

Freud, Sigmund. "Screen Memories." In *Early Psycho-Analytic Publications*, edited

by James Strachey. Vol. 3 (1891–1899) of *The Complete Psychological Works of Sigmund Freud*. London: Hogarth Press and Institute of Psycho-Analysis, 1962.

Fried, Michael. *Realism, Writing, Disfiguration: On Thomas Eakins and Stephen Crane*. Chicago: University of Chicago Press, 1987.

Friends of the Barnes Foundation. "What Is Good for Dr. Gross Is Good for Dr. Barnes: Friends of the Barnes Foundation Challenge Double Standard." News release, November 30, 2006. http://www.barnesfriends.org/downlload/DrEa kins_DrBarnes.pdf.

Fuller, Linda K. "The Sporting Life in Pennsylvania Caught on Celluloid." *Pennsylvania History* 64, no. 4 (1997): 543–548.

Garnick, Darren. "Stallone to Atone for Rocky V." *Nashua Telegraph*, August 24, 2006.

Gelston, Dan. "Rocky Is Back Where He Belongs." Associated Press Online, September 9, 2006. http://www.washingtonpost.com/wp-dyn/content/article/2006/09/08/AR2006090801620_pf.html.

Gilles, Peter, Harlan Koff, Carmen Maganda, and Christian Schulz, eds. *Theorizing Borders through Analyses of Power Relationships*. Regional Integration and Social Cohesion, vol. 9. Brussels: P.I.E. Peter Lang, 2013.

Gillette, Howard. "Defining a Mid-Atlantic Region." *Pennsylvania History: A Journal of Mid-Atlantic Studies* 82, no. 3 (2015): 373–380.

———. "The Emergence of the Modern Metropolis: Philadelphia in the Age of Its Consolidation." In *The Divided Metropolis: Social and Spatial Dimensions of Philadelphia, 1800–1975*, edited by William W. Cutler III and Howard Gillette, 3–25. Westport, CT: Greenwood Press, 1980.

Giordano, Rita. "Fairmount Park Commission OKs Lease for Barnes Museum." *Philadelphia Inquirer*, May 25, 2007, B05.

Golden, Jane, Robin Rice, and Monica Yant Kinney. *Philadelphia Murals and the Stories They Tell*. Philadelphia: Temple University Press, 2002.

Golden, Jane, Robin Rice, and Natalie Pompilio. *More Philadelphia Murals and the Stories They Tell*. Philadelphia: Temple University Press, 2006.

Golden, Jane, and David Updike, eds. *Philadelphia Mural Arts @ 30*. Philadelphia: Temple University Press, 2014.

Goldman, Jonathan Scott. "Just What the Doctor Ordered? The Doctrine of Deviation, the Case of Doctor Barnes's Trust and the Future Location of the Barnes Foundation." *Real Property, Probate and Trust Journal* 39, no. 4 (Winter 2005): 711–764.

Gordon, Sarah. "Prestige, Professionalism, and the Paradox of Eadweard Muybridge's 'Animal Locomotion' Nudes." *Pennsylvania Magazine of History and Biography* 130, no. 1 (2006): 79–104.

Greater Philadelphia Tourism Marketing Corporation. "'Philly Loves Rocky Week' Honors Sly Stallone: A Week of Rocky-Themed Events to Mark Film's 30th Anniversary." News release, August 31, 2006. http://press.visitphilly.com/releases/philly-loves-rocky-week-honors-sly-stallone.

Greenberg, Miriam. *Branding New York: How a City in Crisis Was Sold to the World*. New York: Routledge, 2008.

Greenfeld, Howard. *The Devil and Dr. Barnes: Portrait of an American Art Collector*. New York: Viking, 1987.

Griffin, Randall C. *Homer, Eakins and Anshutz: The Search for American Identity in the Gilded Age.* University Park: Pennsylvania State University, 2004.

Guilbaut, Serge. *How New York Stole the Idea of Modern Art: Abstract Expressionism, Freedom, and the Cold War.* Chicago: University of Chicago Press, 1983.

Haden-Guest, Anthony. "Rocky Hits the Canvas." *Sunday Times* (London), January 10, 2010, 12–17.

Hajdik, Anna Thompson. "'You Really Ought to Give Iowa a Try:' Tourism, Community Identity, and the Impact of Popular Culture in Iowa." *Online Journal of Rural Research and Policy* 4, no. 1 (2009): 1–20.

Harper, Cheryl, ed. *A Happening Place: How the Arts Council Revolutionized the Philadelphia Art Scene in the Sixties.* Philadelphia: Jewish Community Centers of Greater Philadelphia, 2003.

Harrison, Brian. "Symbol and Conduit of Jeff's Mission." *Philadelphia Inquirer,* November 11, 2006.

Hayden, Dolores. *The Power of Place: Urban Landscapes as Public History.* Cambridge, MA: MIT Press, 1995.

Hefler, Jan. "Marchers Protest Plan to Sell Painting." *Philadelphia Inquirer,* November 20, 2006, A04.

Hein, George E. "John Dewey and Albert Barnes." In *Progressive Museum Practice: John Dewey and Democracy,* 97–122. Walnut Creek, CA: Left Coast Press, 2012.

Herman, Nancy. "Barnes Files: An Artist's Perspective on the Barnes Move." *Main Line Times,* June 14, 2007. http://www.mainlinemedianews.com/articles/2007/06/14/main_line_times/opinion/18470096.txt.

Hershberg, Theodore. "The Case for Regional Cooperation." *The Regionalist* 1, no. 3 (December 1995).

Hine, Thomas. "Love or Die, His Art He'll Ply." *Philadelphia Inquirer,* May 16, 1978. *Inquirer* news clippings collection. Robert Indiana, K3 6-430, 6a-32. Special Collections Research Center, Temple University Libraries, Philadelphia, PA.

Hinkelman, Michael. "Rethinking Philadelphia: Barnes Art Museum Is Key to Parkway's Rebirth." *Philadelphia Daily News,* June 15, 2004.

"History." gophila.com: The Official Visitor Site for Greater Philadelphia, via Internet Archive, April 8, 2006. https://web.archive.org/web/20060408162144/http://www.gophila.com/C/Things_to_Do/211/History/209.html.

Hodos, Jerome I. *Second Cities: Globalization and Local Politics in Manchester and Philadelphia.* Philadelphia: Temple University Press, 2011.

Holsten, Glenn, dir. *The Barnes Collection.* Philadelphia: WHYY, 2012.

Holton, JSW. Letter to Albert C. Barnes, March 3, 1927. Albert C. Barnes Correspondence. Barnes Foundation Archives, Philadelphia, PA.

Holzman, Laura, Elizabeth Wood, Holly Cusack-McVeigh, Elizabeth Kryder-Reid, Modupe Labode, and Larry J. Zimmerman. "A Random Walk to Public Scholarship? Exploring Our Convergent Paths." *Public* 2, no. 2 (2014). http://public.imaginingamerica.org/blog/article/a-random-walk-to-public-scholarship-exploring-our-convergent-paths/.

Home Owners' Loan Corporation. "Residential Security Map: New Indexed Guide Map of Philadelphia and Camden, N.J." Philadelphia: C. S. Wertsner and Son, 1937.

Horn, Patricia. "Decision Concerning Pennsylvania Art Collection's Future Lies with Judge." *Philadelphia Inquirer,* October 1, 2004.

———. "Detention Hall Site to Be Art Collection's New Home in Philadelphia." *Philadelphia Inquirer,* December 15, 2004.

Huang, Thomas. "Barnes Exhibit Has Long Legal History." *Dallas Morning News,* April 24, 1994.

Huntington, Richard. "Long-Buried Treasures for the World to See at Washington's National Gallery, the Gleanings of a Most Private Collector Finally Go before the Public." *Buffalo News,* June 20, 1993.

Iams, David. "At Barnes, a Gala and a Respite from Battles: Guests Saw the Collection in Its Restored Home. Protests and Concerns Were Put on the Back Burner." *Philadelphia Inquirer,* November 12, 1995, B01.

Ihlanfeldt, Keith R. "The Importance of the Central City to the Regional and National Economy: A Review of the Arguments and Empirical Evidence." *Cityscape* 1, no. 2 (June 1995): 125–150.

In Re: Barnes Foundation, 12 Fiduc. Rep. 2d 349 (1992).

Janofsky, Michael. "Fight Roils Museum and Wealthy Neighbors." *New York Times,* March 17, 1996.

Jaynes, Gregory. "68 Steps to Fame Retraced by Stallone in Philadelphia." *New York Times,* June 15, 1979.

"Jefferson Establishes Eakins Legacy Fund: Alumni Respond." *Jefferson Alumni Bulletin* (Winter 2006–2007): 12–13.

Johns, Elizabeth. *Thomas Eakins: The Heroism of Modern Life.* Princeton, NJ: Princeton University Press, 1983.

Johnson, Victoria E. *Heartland TV: Prime Time Television and the Struggle for U.S. Identity.* New York: New York University Press, 2008.

Keels, Thomas H. *Sesqui! Greed, Graft, and the Forgotten World's Fair of 1926.* Philadelphia: Temple University Press, 2017.

Kemp, Martin. *Christ to Coke: How Image Becomes Icon.* Oxford: Oxford University Press, 2011.

Kester, Grant H. *Conversation Pieces: Community and Communication in Modern Art.* Berkeley: University of California Press, 2004.

Kim, Hyounggon, and Sarah L. Richardson. "Motion Picture Impacts on Destination Images." *Annals of Tourism Research* 30, no. 1 (2003): 216–237.

Kimmelman, Michael. "Art Review: A Fire Stoking Realism." *New York Times,* June 21, 2002.

———. "The Barnes Explores Other Byways." *New York Times,* April 21, 1991, sec. 2, 31.

———. "Barnes Foundation Seeks to Sell Some Paintings." *New York Times,* March 29, 1991, C1.

———. "Trying to Open up the Barnes, and Pay Some of Its Bills, Too." *New York Times,* February 7, 1991.

Kinsella, Eileen. "The Durand Sale: Dismay and Anger Linger." *ArtNews,* June 7, 2005. http://www.artnews.com/2005/06/07/the-durand-sale-dismay-and-anger-linger/.

Kirtley, Alexandra Alevizatos. "Athens of America." In *The Encyclopedia of Greater Philadelphia,* edited by Charlene Mires, Howard Gillette, and Randall Miller. Accessed September 14, 2011. http://philadelphiaencyclopedia.org/archive/athens-of-america/.

Klein, Julia M. "Hung out to Eye: How Will the Art Museum Show the Barnes Foundation Paintings? Curators Looking to 'Dehype' the Show Took a Cue from the Paintings' Home in Merion—and Did the Opposite." *Philadelphia Inquirer,* January 18, 1995, F01.

———. "Judge Allows Paintings from Barnes to Go on Tour." *Philadelphia Inquirer,* July 23, 1992.

———. "There's Drama yet in Art Saga: Charges Involving Barnes Collection Continue to Roil." *Philadelphia Inquirer,* February 6, 1994.

Klein, Julia M., and Carol Vogel. "Rivals in Court Preach Different Ways to Its Salvation." *New York Times,* September 25, 2004, B11.

Knelman, Martin. "The Arts of the Patron: Toronto Snagged the Most Sought-after Art Show of the Decade—the Barnes Collection—Because Joe Rotman Can't Take No for an Answer." *Financial Post,* July 1, 1994, 16.

Knowles, Scott Gabriel. "Staying Too Long at the Fair: Philadelphia Planning and the Debacle of 1976." In *Imagining Philadelphia: Edmund Bacon and the Future of the City,* edited by Scott Gabriel Knowles, 78–111. Philadelphia: University of Pennsylvania Press, 2009.

Kopytoff, Igor. "The Cultural Biography of Things: Commoditization as Process." In *The Social Life of Things: Commodities in Cultural Perspective,* edited by Arjun Appadurai, 64–91. Cambridge: Cambridge University Press, 1986.

Kreilick Conservation. *Rocky* (1981) by A. Thomas Schomberg, September 7, 2006. Art Commission Records. Philadelphia Art Program Office.

Kwon, Miwon. *One Place after Another: Site-Specific Art and Locational Identity.* Cambridge, MA: MIT Press, 2002.

Labode, Modupe, ed. "Special Issue—Art, Race, Space." *Indiana Magazine of History* 110, no. 1 (2014).

Lacy, Suzanne, ed. *Mapping the Terrain: New Genre Public Art.* Seattle, WA: Bay Press, 1995.

Lally, James F. "'Gross Clinic' Is an Organic Part of Philadelphia." *Philadelphia Inquirer,* December 14, 2006, B2.

Latrobe, Benjamin Henry. "Anniversary Oration, Pronounced before the Society of Artists of the United States, by Appointment of the Society, on the Eighth of May, 1811." *The Port Folio,* June 1811.

Leja, Michael. *Looking Askance: Skepticism and American Art from Eakins to Duchamp.* Berkeley: University of California Press, 2004.

Lenkowsky, Leslie. "A Risky End for the Barnes Case." *Wall Street Journal Abstracts,* December 16, 2004.

Lidz, Franz. "Capturing Sport's Idols with Feats of Clay." *Sports Illustrated,* March 23, 1987.

Lippard, Lucy R. *The Lure of the Local: Senses of Place in a Multicentered Society.* New York: New Press, 1997.

Lippincott, Louise. "Thomas Eakins and the Academy." In *In This Academy: The Pennsylvania Academy of the Fine Arts 1805–1976,* 162–187. Philadelphia: Pennsylvania Academy of the Fine Arts, 1976.

Luzi, Frank. E-mail to Gail Harrity, Charles Croce, Norman Keyes, and Elisabeth Flynn, Re: Nashua Telegraph Column on Rocky Statue and Rocky Fandom, August 24, 2006. Marketing and Public Relations Active Department Files, Philadelphia Museum of Art.

Lynch, Kevin. *The Image of the City.* Cambridge, MA: MIT Press, 1960.

MacGregor, Marilyn. "First Peek at the New Barnes: And the Verdict Is. . . ." *Broad Street Review,* April 6, 2012. http://www.broadstreetreview.com/art-architec ture/the_new_barnes_a_sneak_preview.

Malatesta, Christian. "Monument Lab at City Hall." *Cross Ties: News and Insights for Humanities Professionals,* May 22, 2015. https://march.rutgers.edu/2015/05/ monument-lab-at-city-hall-in-philadelphia/.

Matheson, Kathy. "Barnes Foundation Acquires Philly Site for Art Collection." Associated Press, September 5, 2007.

McCarthy, Jack. "Soul Music." In *The Encyclopedia of Greater Philadelphia,* edited by Charlene Mires, Howard Gillette and Randall Miller. Accessed August 28, 2017. http://philadelphiaencyclopedia.org/archive/soul-music/.

McCarthy, Kevin F., Elizabeth Heneghan Ondaatje, and Jennifer L. Novak. *Arts and Culture in the Metropolis: Strategies for Sustainability.* Santa Monica, CA: RAND, 2007.

McCartney, Molly. "Parachute Cloth Mural Builds Community in South Minneapolis." *StreetsMN,* May 27, 2015. http://streets.mn/2015/05/27/parachute-cloth-mural-builds-community-in-south-minneapolis/.

McClain, Jordan, and Amanda McClain. "American Bandstand." In *The Encyclopedia of Greater Philadelphia,* edited by Charlene Mires, Howard Gillette and Randall Miller. Accessed August 28, 2017. http://philadelphiaencyclopedia.org/ archive/american-bandstand/.

McCrone, Brian X. "Rocky's Home at Art Museum." *Metro* (Philadelphia), 2006. Marketing and Public Relations Active Department Files, Philadelphia Museum of Art.

McDonogh, Gary W. "Suburban Place, Mythic Thinking, and the Transformations of Global Cities." *Urban Anthropoplogy and Studies of Cultural Systems and World Economic Development* 35, no. 4 (2006): 471–501.

MCG. Letter to Fairmount Art Commission [*sic*], City of Philadelphia, et al., 1981. Marketing and Public Relations Records. Philadelphia Museum of Art, Archives.

McGarrity, James L. *Philadelphia Inquirer* Assignment Sheet: East Terrace Renovation of the Philadelphia Museum of Art, June 6, 1985. Evening Bulletin Photograph Collection. Special Collections Research Center, Temple University Libraries, Philadelphia, PA.

McNeil, Henry S., Jr. Letter to Anne d'Harnoncourt, September 27, 1982. Anne d'Harnoncourt Papers. Philadelphia Museum of Art, Archives.

————. Letter to the Editor, unpublished, n.d. Anne d'Harnoncourt Papers. Philadelphia Museum of Art, Archives.

Meyer, Richard. *What Was Contemporary Art?* Cambridge, MA: MIT Press, 2013.

Meyers, Mary Ann. *Art, Education, and African-American Culture: Albert Barnes and the Science of Philanthropy.* New Brunswick, NJ: Transaction Publishers, 2004.

Mileaf, Janine. "Poses for the Camera: Eadweard Muybridge's Studies of the Human Figure." *American Art* 16, no. 3 (Autumn 2002): 30–53.

Miller, Angela L. *The Empire of the Eye: Landscape Representation and American Cultural Politics, 1825–1875.* Ithaca, NY: Cornell University Press, 1993.

Milroy, Elizabeth. *The Grid and the River: Philadelphia's Green Places, 1682–1876.* University Park: Pennsylvania State University Press, 2016.

Miree, Kathryn, and Winton Smith. "The Unraveling of Donor Intent: Lawsuits and Lessons." Planned Giving Design Center, November 12, 2009. http://www .pgdc.com/pgdc/unraveling-donor-intent-lawsuits-and-lessons.

Mires, Charlene. *Independence Hall in American Memory.* Philadelphia: University of Pennsylvania Press, 2002.

"Monument Lab: About." MuralArts.org. Accessed July 24, 2017. http://monument lab.muralarts.org/about/.

Moss-Coane, Marty, host. *Radio Times.* Philadelphia: WHYY. November 15, 2006.

————. *Radio Times.* Philadelphia: WHYY. February 5, 2007.

"Movies: A Bronze Rocky for the City?" *Philadelphia Inquirer,* December 9, 1980. Evening Bulletin Collection, Statues—Rocky. Special Collections Research Center, Temple University Libraries, Philadelphia, PA.

Nancy, Jean-Luc. *The Inoperative Community.* Minneapolis: University of Minnesota Press, 1991.

Nash, Gary B. *First City: Philadelphia and the Forging of Historical Memory.* Philadelphia: University of Pennsylvania Press, 2002.

————. *The Liberty Bell.* New Haven, CT: Yale University Press, 2010.

Naudé, Virginia N. Conservator's Report, Letter to George Young, February 3, 2006. Art Commission Records. Philadelphia Art Program Office.

Netherlands Guidelines for Deaccessioning of Museum Objects. Netherlands Institute for Cultural Heritage, November 2006.

Newman, Michael Z. "The Bronze Fonz: Public Art/Popular Culture in Milwaukee, Wisconsin." *FlowTV,* March 5, 2010. http://flowtv.org/2010/03/flow-favorites-the-bronze-fonz-public-artpopular-culture-in-milwaukee-wisconsin-michael-z-newman-university-of-wisonsin-milwaukee/.

New Pew Poll: Philadelphians View K-12 Education as Top Issue. Philadelphia: Pew Charitable Trusts, March 2015. http://www.pewtrusts.org/en/research-and-analysis/issue-briefs/2015/03/new-pew-poll-philadelphians-view-k-12-education-as-top-issue.

Office of the City Controller, City of Philadelphia. *Philadelphia: A New Urban Direction.* Philadelphia: Saint Joseph's University Press, 1999.

Osborn, Michelle. "Barnes Trust May Sell Some Works: Foundation Cites Needs for Cash." *USA Today,* April 10, 1991, 9B.

Ott, Stanley R. *Memorandum Opinion and Order Sur Second Amended Petition to Amend Charter and by-Laws.* The Court of Common Pleas of Montgomery County, Pennsylvania, Orphans' Court Division, January 29, 2004.

———. *Opinion.* The Court of Common Pleas of Montgomery County, Pennsylvania, Orphans' Court Division, December 13, 2004.

Pennsylvania Office of the Governor. "Pennsylvania Governor Rendell Awards $25 Million to Help Make Barnes Foundation Collection a Part of Philadelphia's Cultural Landscape." News release, March 28, 2006.

Peters, Scott J., Nicholas R. Jordan, Margaret Adamek, and Theodore R. Alter, eds. *Engaging Campus and Community: The Practice of Public Scholarship in the State and Land-Grant University System.* Dayton, OH: Kettering Foundation Press, 2005.

Pew Charitable Trusts. "Philadelphia's Foundations, Corporations, Citizens Contribute $150 Million to Relocate Barnes Foundation Gallery." News release, May 15, 2006. http://www.pewtrusts.org/en/about/news-room/press-releases/2006/05/15/philadelphias-foundations-corporations-and-citizens-contribute-150-million-to-relocate-the-barnes-foundation-gallery-to-the-benjamin-franklin-parkway.

Philadelphia Art Commission. "History." Accessed January 4, 2018. http://www.phila.gov/artcommission/history/Pages/default.aspx.

Philadelphia Museum of Art. "City Institutions, Officials Unite to Keep Eakins Masterpiece in Philadelphia." News release, November 17, 2006. https://www.philamuseum.org/press/releases/2006/553.html.

———. "The Philadelphia Museum of Art Completes Its Share in Joint Acquisition of 'the Gross Clinic.'" News release, April 23, 2008. https://www.philamuseum.org/press/releases/2008/674.html.

———. "Retrospective Exhibition Surveys the Career of Thomas Eakins from Controversial Native Son to Icon of American Art." News release, 2001.

———. "Tickets for Thomas Eakins: American Realist Go on Sale Starting September 9." News release, July 9, 2001. https://www.philamuseum.org/press/releases/2001/252.html.

Philadelphia Police Department Research and Planning Unit Statistical Section. *Murder Analysis: Philadelphia Police Department 2007–2010.* Philadelphia Police Department, July 2011.

Philadelphia's New Confidence: 2014 Annual Report. Philadelphia: Visit Philadelphia, 2014.

Phillips, Patricia C. "Public Constructions." In *Mapping the Terrain: New Genre Public Art,* edited by Suzanne Lacy, 60–71. Seattle, WA: Bay Press, 1995.

———. "Temporality and Public Art." In *Critical Issues in Public Art: Content, Context, and Controversy,* edited by Harriet Senie and Sally Webster, 295–304. New York: Icon Editions, 1992.

"Political Stalemate Ends over Proposed Barnes Site." Associated Press, November 30, 2007.

Pressler, Jessica. "Philadelphia Story: The Next Borough." *New York Times,* August 14, 2005. http://www.nytimes.com/2005/08/14/fashion/sundaystyles/philadelphia-story-the-next-borough.html.

Purchases by Albert C. Barnes from the Pennsylvania Academy of the Fine Arts Annual Exhibitions. n.d. Special exhibition records, Contemporary European Paintings and Sculpture (Barnes Collection), Box 17, RG.02.06.06. Dorothy and Kenneth Woodcock Archives at the Pennsylvania Academy of the Fine Arts.

Rather, Susan. *The American School: Artists and Status in the Late-Colonial and Early National Era*. New Haven, CT: Yale University Press, 2016.

Raverty, Dennis. "Marketing Modernism: Promotional Strategy in the Armory Show." *Prospects,* no. 27 (2002): 359–374.

Raymond, Jay. "Barnes Files: Separating Art, Galleries Wasn't Barnes' Vision." *Main Line Times,* February 1, 2007. http://www.mainlinemedianews.com/ar ticles/2007/02/01/main_line_times/opinion/17789388.txt.

Reason, Akela. *Thomas Eakins and the Uses of History*. Philadelphia: University of Pennsylvania Press, 2010.

Rice, Danielle. "The 'Rocky' Dilemma: Museums, Monuments, and Popular Culture in the Postmodern Era." In *Critical Issues in Public Art: Content, Context, and Controversy,* edited by Harriet Senie and Sally Webster, 228–236. New York: Icon Editions, 1992.

Richard, Paul. "To Sell or Not to Sell: Philadelphia's Barnes Battle." *Washington Post,* April 28, 1991, G1.

"*Rocky* (1980)." *Museum without Walls*. Philadelphia: Association for Public Art. Accessed September 5, 2018. https://www.associationforpublicart.org/artwork/rocky/#mww--video.

"Rocky's Royal Gal." *Art Newspaper,* December 3, 2009.

"Rocky Statue Banned from Museum." *Washington Post,* March 28, 1990.

Rocky Statue Proposed Relocation Presentation Notes. 2006. Art Commission Records. Philadelphia Art Program Office.

"Rocky Statue Returns to Museum of Art Steps." WENN Entertainment News Wire Service, September 7, 2006.

Roosevelt, Theodore. "Model Merion," 1917. Merion Civic Association. http://www.merioncivic.org/about/ModelMerion.pdf.

Rosen, Steven. "Scheduled Masterpieces Finally Glow in Ideal Setting." *Denver Post,* May 1, 1994.

Rosenbaum, Lee. "Destroying the Museum to Save It." *New York Times,* January 10, 2004, A13.

———. "What's Gross about the 'Gross Clinic' Deaccessions." *CultureGrrl* (blog), April 30, 2008. http://www.artsjournal.com/culturegrrl/2007/01/the_gross_clinic_deaccession_d.html.

Rosenblum, Robert. "Art Ignored: The Other 20th Century." *Art Journal* 39, no. 4 (1980): 288–289.

Ross, Andrew. *No Respect: Intellectuals and Popular Culture*. New York: Routledge, 1989.

Roster, Thursday Class, 1927. Early Education Records. Barnes Foundation Archives, Philadelphia, PA.

Roster, Tuesday Class, 1927–1928. Early Education Records. Barnes Foundation Archives, Philadelphia, PA.

Rubinkam, Michael. "Barnes Foundation Decision Delayed; Judge Wants More Evidence on Whether to Move Artworks." Associated Press, January 29, 2004.

Rudenstine, Neil L. *House of Barnes: The Man, the Collection, the Controversy.* Philadelphia: American Philosophical Society, 2012.

Russell, John. "Is Eakins Our Greatest Painter?" *New York Times,* June 6, 1982, 1.

Ryan, Susan Elizabeth. "Eternal Love." In *Love and the American Dream: The Art of Robert Indiana,* edited by Fronia E. Wissman, 76–101. Portland, ME: Portland Museum of Art, 1999.

Saffron, Inga. "Green Country Town." In *The Encyclopedia of Greater Philadelphia,* edited by Charlene Mires, Howard Gillette, and Randall Miller. Accessed July 23, 2015. http://philadelphiaencyclopedia.org/archive/green-country-town/.

Sagalyn, Lynne B. *Times Square Roulette: Remaking the City Icon.* Cambridge, MA: MIT Press, 2001.

Sajet, Kim. "From Grove to Garden: The Making of *The Dream Garden* Mosaic." In *Pennsylvania Academy of the Fine Arts: 200 Years of Excellence,* 43–51. Philadelphia: Pennsylvania Academy of the Fine Arts, 2005.

Salisbury, Stephan. "An Artist, a Painting, and a City's Identity; Eakins' 'The Gross Clinic' Has Inspired Loyalty, Devotion—and an Effort to Keep It Here." *Philadelphia Inquirer,* November 22, 2006.

———. "City Art Icon about to Be Sold." *Philadelphia Inquirer,* November 11, 2006, A01.

———. "Comeback for Rocky Statue." *Philadelphia Inquirer,* May 11, 2006, A01.

———. "A Divisive Deal." *Philadelphia Inquirer,* November 14, 2006, A01.

———. "The 'Gross Clinic' Campaign Reaches One-Third of Goal." *Philadelphia Inquirer,* November 30, 2006.

———. "'Gross Clinic' Undergoes Treatment in Run-up to Show." *Philadelphia Inquirer,* May 2, 2010, A01.

———. "Jefferson Alums Rip Sale of Eakins." *Philadelphia Inquirer,* November 17, 2006.

———. "Last Look at Barnes Galleries in Merion." *Philadelphia Inquirer,* July 3, 2011.

———. "Sincerest Form of Flattery for Eakins: Opponents of a Sale Hope a 'Gross Clinic' Copy Raises Awareness." *Philadelphia Inquirer,* December 12, 2006.

Saltmarsh, John, and Matthew Hartley, eds. *"To Serve a Larger Purpose": Engagement for Democracy and the Transformation of Higher Education.* Philadelphia: Temple University Press, 2012.

Savage, Kirk. *Monument Wars: Washington, D.C., the National Mall, and the Transformation of the Memorial Landscape.* Berkeley: University of California Press, 2009.

Schaffer, Michael Currie. "A Story on Murder Draws Concern; Cover Story Cover-Up: Hotel Group Makes Plea." *Philadelphia Inquirer,* October 29, 2006, B11.

Schiavo, Joseph C. "Philadelphia Orchestra." In *The Encyclopedia of Greater Philadelphia,* edited by Charlene Mires, Howard Gillette, and Randall Miller. Accessed August 28, 2017. http://philadelphiaencyclopedia.org/archive/philadelphia-orchestra-2/.

Schjeldahl, Peter. "Moving Pictures: The Barnes Foundation's New Home." *New Yorker,* May 28, 2012.

———. "Untouchable: The Barnes Foundation and Its Fate." *New Yorker,* February 16, 2004.

Schrank, Sarah. *Art and the City: Civic Imagination and Cultural Authority in Los Angeles.* Philadelphia: University of Pennsylvania Press, 2009.

Scott, Robert Montgomery. Letter to Joseph E. Coleman, September 10, 1981. Marketing and Public Relations Records. Philadelphia Museum of Art, Archives.

———. Letter to Kitty Caparella, August 11, 1982. Anne d'Harnoncourt Papers. Philadelphia Museum of Art, Archives.

Scullion, Sister Mary. "What Not to Sacrifice for Art: Care." *Philadelphia Inquirer,* December 7, 2006, B02.

Sen, Kosal. "Phail-Adelphia." *Brand New,* December 8, 2009. http://www.undercon sideration.com/brandnew/archives/phail-adelphia.php.

Sewell, Darrel. *Thomas Eakins.* Philadelphia: Philadelphia Museum of Art, 2001.

Sheehan, K. "Comment Re: 28 Days: Making Heroism American." In *The Sixth Square* (blog), WHYY, November 28, 2006. http://whyy.wordpress.com/2006/11/28/28-days-making-heroism-american/#comment-17.

Silverman, Lauren. "On Philly's Walls, Murals Painted with Brotherly Love." *All Things Considered.* National Public Radio, August 23, 2010. http://www.npr .org/templates/story/story.php?storyId=129281658.

Simon, Roger D. *Philadelphia: A Brief History.* Rev. and updated ed. Philadelphia: Temple University Press, 2017.

Simon, Roger D., and Brian Alnutt. "Philadelphia, 1982–2007: Toward the Postindustrial City." *Pennsylvania Magazine of History and Biography* 131, no. 4 (2007): 395–444.

Smith, Jim. "Stop Treating Black Achievement as a Fluke." *Philadelphia Tribune,* July 3, 1992, 5-B.

Smith, Michael F. "Brand Philadelphia: The Power of Spotlight Events." In *Destination Branding: Creating the Unique Destination Proposition,* edited by Nigel Morgan, Annette Pritchard, and Roger Pride, 261–278. Oxford: Elsevier Butterworth-Heinemann, 2004.

Smith, Noble. Letter to the Editor, *Times Northeast,* June 18, 1981. Marketing and Public Relations Records. Philadelphia Museum of Art, Archives.

Smith, Roberta. "A Museum, Reborn, Remains True to Its Old Self, Only Better." *New York Times,* May 17, 2012, A1.

Smyth, Jack. "Rocky Is the Underdog in Fight over Statue at Phila. Art Museum." *Philadelphia Evening Bulletin,* December 11, 1980. Evening Bulletin Collection, Statues—Rocky. Special Collections Research Center, Temple University Libraries, Philadelphia, PA.

Soderlund, Jean. *Lenape Country: Delaware Valley Society before William Penn.* Philadelphia: University of Pennsylvania Press, 2015.

"Some Recent Art." Clipping from an Unidentified Newspaper, circa April 1876. Reprinted in Kathleen A. Foster and Mark S. Tucker, eds. *An Eakins Masterpiece Restored: Seeing* The Gross Clinic *Anew.* New Haven, CT: Yale University Press, 2012, 139–140.

Sozanski, Edward J. "Art: Barnes' Soul Will Stay Behind." *Philadelphia Inquirer,* May 22, 2011.

———. "Museum of Art Seals Eakins Deal." *Philadelphia Inquirer,* April 24, 2008, A01.

———. "Relocation Makes Sense, but It Would Be Wrong." *Philadelphia Inquirer,* May 4, 2003.

———. "Yo, Diana! Rocky's Turn." *Philadelphia Inquirer,* May 28, 2006, H01.

Sozanski, Edward J., and Julia M. Klein. "Barnes Exhibit Comes Home: The Art Museum Has High Hopes for the Show—Especially for Financial Reasons. It Has Gone All out on Marketing." *Philadelphia Inquirer,* January 29, 1995, B01.

"Speculative Monuments for Philadelphia." Open Data Philly. Accessed September 11, 2017. https://www.opendataphilly.org/dataset/speculative-monuments-for-philadelphia.

Spencer, Kyle York. "Barnes Foundation Denies Any Violation of Zoning." *Philadelphia Inquirer,* January 4, 1996.

Stallone, Sylvester. *The Official Rocky Scrapbook.* Edited by Michael Uslan. New York: Grosset and Dunlap, 1977.

Statement on the Removal of the Rocky Statue, n.d. Marketing and Public Relations Records. Philadelphia Museum of Art, Archives.

Steakbellie. "The Gross Clinic by Thomas Eakins." *Steakbellie* (blog), November 17, 2006. http://steakbellie.blogspot.com/2006/11/gross-clinic-by-thomas-eakins.html.

Steffens, Lincoln. "Philadelphia: Corrupt and Contented." *McClure's Magazine,* July 1903, 249–263.

Steinberg, Shari L. "Barnes Rightfully Belongs in Lower Merion." *Philadelphia Inquirer,* February 22, 2007, B02.

Stern, Mark J. *Urban Vitality, Diversity, and Culture: Population Growth and Ethnic Change in Philadelphia: 1990–2000.* Philadelphia: University of Pennsylvania School of Social Work, 2001.

Stevens, William K. "Philadelphia Hopes Rise by 60 Stories." *New York Times,* December 14, 1986, sec. 1, 40.

Stevick, Philip. *Imagining Philadelphia: Travelers' Views of the City from 1800 to the Present.* Philadelphia: University of Pennsylvania Press, 1996.

Stieg, Bill. "Judge Allows Artworks to Leave Walls Where Late Collector Insisted They Stay." Associated Press, July 22, 1992.

———. "Legendary Collection Becoming More Accessible." Associated Press, October 17, 1990.

Strauss, Robert. "'Rocky' Statue Makes Comeback at Museum." *New York Times,* November 19, 2006, 31.

A Style Guide for the City of Philadelphia. Philadelphia: Office of the City Representative, 2011.

Suplee, Barbara. "The Eccentric Hanging of the Barnes Foundation." *Art Education* 47, no. 6 (1994): 35–40.

Sutton, Kate. "Moon over Miami." *Artforum,* May 12, 2009. http://artforum.com/diary/id=24336.

"Thomas Eakins: American Realist." Antenna Audio Script. September 20, 2001. American Art Department Files. Philadelphia Museum of Art, Archives.

"Thomas Eakins: 1844–1916." February 16, 1982. Special Exhibitions Records. Philadelphia Museum of Art, Archives.

Thomas Jefferson University. "Thomas Jefferson University Trustees Agree to Sale of *The Gross Clinic.*" News release, November 11, 2006.

Tourism 2007 Report to the Industry: Marketing Gets Personal. Philadelphia: Greater Philadelphia Tourism Marketing Corporation, 2007.

Tourism 2008 Report to the Region: More Partners, More Promotions, More People. Philadelphia: Greater Philadelphia Tourism Marketing Corporation, 2008.

Tourism 2010 Report to the Region: Worth the Trip. Philadelphia: Greater Philadelphia Tourism Marketing Corporation, 2010.

Traub, David S. "Paying a Price for Art." *Philadelphia Inquirer,* February 13, 2007, A14.

Tucker, Mark S. "Framing the Gross Clinic." *American Art* 26, no. 1 (2012): 10–13.

"20 Days: Two Eakins Talks." *The Sixth Square* (blog), WHYY, December 6, 2006. https://whyy.wordpress.com/2006/12/06/20-days-two-eakins-talks/.

2007 Greater Philadelphia Tourism Monitor: What's in a Place? Philadelphia: Greater Philadelphia Tourism Marketing Corporation, 2007.

2012 Annual Report. Philadelphia: Barnes Foundation, 2012.

Urry, John, and Jonas Larsen. *The Tourist Gaze 3.0.* 3rd ed. London: Sage, 2011.

Visit Philadelphia. "GPTMC Changes Organization Name to Visit Philadelphia." News release, November 11, 2013.

Vitez, Michael. "Rocky Statue Ready to Hit the Steps: With a Win, the Fictional Pugilist Is Back at His Old Haunt—the Art Museum." *Philadelphia Inquirer,* September 7, 2006.

———. "Rocky Wins Split Decision to Stand near Art Museum." *Philadelphia Inquirer,* September 6, 2006.

Vitez, Michael, and Tom Gralish. *Rocky Stories: Tales of Love, Hope, and Happiness at America's Most Famous Steps.* Philadelphia: Paul Dry Books, 2007.

Vittolino, Sal. "A TKO for 'Rocky': Two Locations Eyed for Statue." *Philadelphia Evening Bulletin,* December 20, 1981. Evening Bulletin Collection, Statues—Rocky, Special Collections Research Center, Temple University Libraries, Philadelphia, PA.

Vogan, Travis. "LeRoy Neiman and the Art of Network Sports Television." *American Art* 30, no. 3 (2016): 55–75.

Vogel, Carol. "Barnes Gets Go-Ahead on International Art Tour." *New York Times,* July 24, 1992, C18.

———. "A Fight to Keep an Eakins Is Waged on Two Fronts: Money and Civic Pride." *New York Times,* December 15, 2006, E43.

———. "New York Public Library's Durand Painting Sold to Wal-Mart Heiress." *New York Times,* May 13, 2005. http://www.nytimes.com/2005/05/13/nyregion/13painting.html?_r=0.

Vogel, Morris J. *Cultural Connections: Museums and Libraries of Philadelphia and the Delaware Valley.* Philadelphia: Temple University Press, 1991.

Voon, Claire. "The Famously Photo-Wary Barnes Foundation Makes Its Art More Accessible Online." *Hyperallergic,* November 9, 2017. https://hyperallergic. com/410273/the-famously-photo-wary-barnes-foundation-makes-its-art-more-accessible-online/.

Vrazo, Fawn. "For Art's Sake: Kensington Man Wages a Lonely Fight for Rocky Statue's Return." *Philadelphia Evening Bulletin,* September 8, 1981. Evening Bulletin Collection, Gorman—ART FAN. Special Collections Research Center, Temple University Libraries, Philadelphia, PA.

Walters, Patrick. "City Council Committee Oks Barnes Art Collection's Move from Suburbs to Philadelphia." Associated Press, May 6, 2007.

Ward, David C. *Charles Willson Peale: Art and Selfhood in the Early Republic.* Berkeley: University of California Press, 2004.

Warner, Michael. *Publics and Counterpublics.* New York: Zone Books, 2002.

"War on Washington Monument." *American Art News* 21, no. 13 (1923): 1–10.

"Washington Monument." *Museum without Walls.* Philadelphia: Association for Public Art. Accessed September 5, 2018. https://www.associationforpublicart .org/artwork/washington-monument/.

Wattenmaker, Richard J. "Dr. Albert C. Barnes and the Barnes Foundation." In *Great French Paintings from the Barnes Foundation: Impressionist, Post-Impressionist, and Early Modern,* 3–28. New York: Alfred A. Knopf, in association with Lincoln University Press, 1993.

"Welcome." Art Basel Miami Beach, via Internet Archive, April 6, 2009. https:// web.archive.org/web/20090406202458/http://www.artbaselmiamibeach.com.

Whiting, Cécile. *Pop L.A.: Art and the City in the 1960s.* Berkeley: University of California Press, 2006.

Williams, Maurice. "3,500 Demonstrate for New Trial for Abu-Jamal: Protest Deals a Blow to Use of the Death Penalty." *The Militant* 59, no. 31 (August 28, 1995). http://www.themilitant.com/1995/5931/5931_1.html.

Wilson, Kristina. *The Modern Eye: Stieglitz, MoMA, and the Art of the Exhibition, 1925–1934.* New Haven, CT: Yale University Press, 2009.

Wilson, Martin W. "From the Sesquicentennial to the Bicentennial: Changing Attitudes toward Tourism in Philadelphia, 1926–1976." Ph.D. diss., Temple University, 2000.

Wolf, Edwin, II. "Epilogue." In *Philadelphia: A 300 Year History,* edited by Russell F. Weigley, Nicholas B. Wainwright, and Edwin Wolf II, 735–751. New York: W. W. Norton, 1982.

———. "The Origins of Philadelphia's Self-Depreciation, 1820–1920." *Pennsylvania Magazine of History and Biography* 104, no. 1 (January 1980): 58–73.

Wolf, Stephanie G. "The Bicentennial City, 1968–1982." In *Philadelphia: A 300 Year History,* edited by Russell F. Weigley, Nicholas B. Wainwright, and Edwin Wolf II, 704–734. New York: W. W. Norton, 1982.

———. "Centennial Exhibition (1876)." In *The Encyclopedia of Greater Philadelphia,* edited by Charlene Mires, Howard Gillette, and Randall Miller. Accessed August 4, 2016. http://philadelphiaencyclopedia.org/archive/centennial/.

Wong, Cindy Hing-Yuk, and Gary W. McDonogh. "The Mediated Metropolis: Anthropological Issues in Cities and Mass Communication." *American Anthropologist* 103, no. 1 (March 2001): 96–111.

Wood, Mary Mendenhall, and Phyllis C. Maier. *Lower Merion: A History.* Ardmore, PA: Lower Merion Historical Society, 1988.

Yaari, Evelyn, and Sandra Gross Bressler. "Eakins, Barnes, and a Great City" [reprint from *Main Line Times*], n.d. Merion, PA: Friends of the Barnes Foundation.

Yadgaroff, David. "The 'Rocky' Statue." KYW Newsradio, 2006. Art Commission Records. Philadelphia Art Program Office.

Yahr, Jayme. "A Philadelphia Story: Regional Patrimony in the Barnes Foundation and the Gross Clinic Sagas." *U.S. Studies Online: The BAAS Postgraduate Journal,* no. 15 (2009). http://www.baas.ac.uk/issue-15-autumn-2009-article-2/.

"Yo Adrian!" *Philadelphia Daily News,* November 21, 1981.

Young, Earni. "Street Moving Fast on Home for the Barnes; Tags Youth Study Center for Gallery." *Philadelphia Daily News,* December 15, 2004.

Zaller, Robert. "Achin' for Eakins? Count Me Out." *Broad Street Review,* December 2, 2006. http://www.broadstreetreview.com/index.php/main/article/Achin_for_Eakins__Count_me_out/.

Zuckerman, Michael. "Philadelphia—a 'City of Firsts' That Feels Little Need to Brag." *Newsworks,* January 14, 2012. https://whyy.org/articles/philadelphia-a-city-of-firsts-that-feels-little-need-to-brag/.

Zurier, Rebecca. *Picturing the City: Urban Vision and the Ashcan School.* Berkeley: University of California Press, 2006.

Index

Laura M. Holzman is an Associate Professor of Art History and Museum Studies and Public Scholar of Curatorial Practices and Visual Art at Indiana University, IUPUI.